The
# House
of
# Hidden
# Meanings

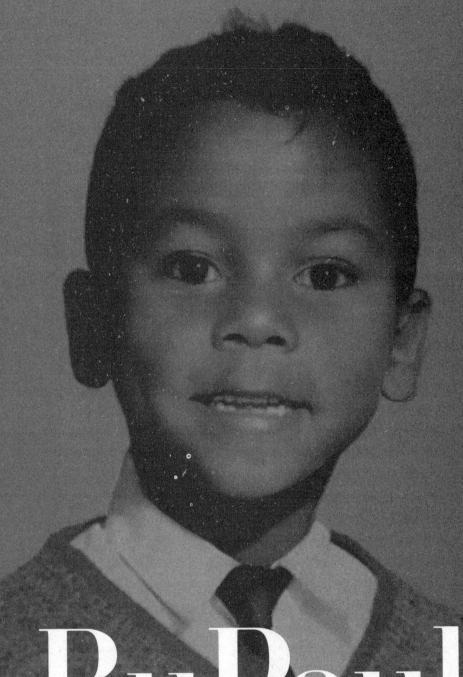

RuPaul

A MEMOIR

# The
# House
of
# Hidden
# Meanings

**DEY**ST.

*An Imprint of* WILLIAM MORROW

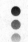

**DEY**ST.

HarperCollins books may be purchased for educational, business, or
sales promotional use. For information, please email the Special Markets
Department at SPsales@harpercollins.com.

FIRST EDITION

*Designed by Alison Bloomer*

PHOTO CREDITS: *pages ii, 6, 28, 50, 66, 104, 192, 200, 214 courtesy of
RuPaul; pages 86, 118, 138, 156 © Jon Witherspoon; page 174 © Paul Ordway;
page 228 © Albert Sanchez. Every effort has been made to contact copyright
holders of photographs reproduced in this book. We would be grateful for the
opportunity to rectify any omissions in subsequent editions should they be
drawn to our attention.*

Library of Congress Cataloging-in-Publication Data has been applied for.

ISBN 978-0-06-326390-1

24 25 26 27 28  LBC  5 4 3 2 1

*For the love of my life, Georges LeBar.*
*Thank you for the love, laughter, sweetness,*
*and kindness. You are my favorite.*

# Contents

# Author's Note

The events and experiences detailed here are all true and have been faithfully rendered as I remember them. I have changed the names and identifying details of some individuals to protect their privacy. Though conversations come from my keen recollection of them, they are not written to represent word-for-word documentation; rather, I've retold them in a way that evokes the real feeling and meaning of what was said.

# Prologue

I t still feels like summer when I arrive in Atlanta late in September, that stifling humidity just starting to give way to the first hint of fall. I am sixty-one years old, and nearly half a century separates me from the boy I was when I first came here in the back of my sister Renetta's sky-blue Mercedes 450, but I still know my way around: The streets feel the same, even if many of the buildings have been torn down and replaced with something different. And more, even, than the sight of a few familiar brick facades and traffic lights, the taste of the place is familiar to me, the way a long-ago sense memory can get unlocked so easily. Atlanta tastes like butter—salty, with a hint of sweetness, the kind that's gone a little soft sitting out. It's deliberate, meant to be savored. That flavor, that tang, it's everywhere. It's in the radio streaming from an open car window. It's in the singsong voices of the women you'd hear, their accents unhurried and musical. It's in the way those muggy summers make everything slow and sticky as molasses.

I rent a bike and ride through the city to see what I can remember, and pretty quickly it comes back to me: There's the bench where I sat, rolled a joint, and watched as some men carved a tree that had been struck by lightning into a totem pole to commemorate the Piedmont Park Arts Festival. I had attended that summer for the first time, booths of people selling homemade crafts, a picture of bohemian creativity. That's the club where I danced all night in a dress made out of Renetta's shiny gold plastic curtains, the heat of bodies around me and the joyous sound of disco filling up my soul. There was the unit of Grady Memorial Hospital where I said goodbye to my friend Cherry as she lay dying of AIDS, where I kept it together for the final moments, squeezing her hand, then collapsed in the hallway outside, sobbing, knowing that I would never see her again. And there was the corner where, on a Christmas Eve years earlier, getting off my shift go-go dancing at the club, I walked past a bag of toys that somebody had donated to charity, contents spilled out onto the street, and looking up at me was a stuffed donkey with one button eye. For whatever reason I felt a rush of tenderness so big and so potent that I picked it up off the ground and carried it home with me, and I have slept with it for the last forty years. Isn't that strange? I'm so much older now, but I still remember the way it was to know the ache inside me, even before I was wise enough to be able to name it—that child within who was craving that comfort—and realize that I could give him precisely what he needed.

And there is the lawn in Piedmont Park where my friend Larry Tee and I lay on the grass one morning as the sun came up, the acid we'd taken the night before finally wearing off. It was the year of the Harmonic Convergence, and the energy of change was in the air. Larry was wearing a bowling shirt, and

his pupils were enormous. "Libra represents the twelfth house of Scorpio's hidden meanings," he told me, as if this were hugely important. After the drugs wore off, I realized it was nonsense. But it was beautiful nonsense, and it stayed with me forever, maybe because I liked the way it sounded—*the house of hidden meanings*. Or maybe it was because of how I saw myself—as a detective of the universe, searching the house for clues, trying to understand what it all meant.

Or maybe it was because Larry was my friend. Months later, when he said he was moving to New York, I realized it was time for me to leave Atlanta, too, although I could never say for sure if it was really my time to go or if I was just afraid of being left behind.

—————

I didn't just come here for a walk down memory lane. I'm here because there's something I need in the place where I was born—not the hospital in San Diego where my mother gave birth to me, but an apartment building in Southwest Atlanta that I haven't been back to in over thirty years. My old friend James is waiting for me at the door as I pull up in my rental car. I remember James from when this was his mother's apartment; he lived in the basement, which we used as an informal studio and clubhouse, getting high and shooting episodes of a public access series called *The American Music Show*. Now he pulls up to the door in a metal walker, but he greets me just as warmly as he always did back then.

Downstairs, the basement looks the same, only everything is covered in a bit more dust: file cabinets stuffed with papers, old televisions, record players, memorabilia. I pick up a postcard with my picture on it, and a memory cuts through me—I had

sold these postcards in my early twenties and given one to James as a gift in this very basement. He'd set it gently on the shelf as if it was a rare treasure. Now, over forty years later, it is in the exact same place. It had been eaten away by time, or insects; maybe both. But it hadn't ever been moved.

Buried at the bottom of a bookshelf is what I came here for. With an old T-shirt, I wipe away the dust to expose the label stuck on the first tape I see: *The American Music Show, Season 5, Episode 6, 1982.* There are hours and hours of footage of the show James and I recorded here in this very basement on VHS tapes. I begin pulling them off the shelf, only to discover they're stacked two tapes deep, and as I move another pile, I find there's even more hidden behind that—dozens, maybe hundreds of tapes, for every episode we made over the course of several years, each labeled with the date it aired. These tapes are a living document of how I became who I am—a transformation that nobody's seen in forty years, the only record of which is right here in this basement.

"Did you find them?" James calls down, and I tell him I did.

I load the tapes into cardboard boxes that I lug one at a time back up the stairs. Before I turn off the light, I look back at the room again—preserving it in my memory. I will have the tapes shipped back to Los Angeles and digitized. It's long overdue, this expedition; I know that. But it wasn't something I needed to do until just now.

————

Life comes in seasons. There are the seasons where you are driving through a snowstorm, just trying to keep your eye on the road ahead to stay alive. Your ego stands in the doorway of every

good idea, keeping them from you. We avoid the pain. We put our blinders on and stay focused on what's right ahead, turning away from the thing we need to see in our periphery, because we know accepting it will force us to question everything we hold so tightly.

But then there are those seasons when the snow globe is being shaken all around you, and you're standing in place, looking up to try to see where the scattered world is all going to fall. When it finally settles, that's when you find yourself in the house of hidden meanings. You study the patterns that keep coming up. You allow them to show you something different, even if it's the thing you've been running from your whole life. You run into the fire, run through the pain, trusting that the only way out is through.

Back at my hotel, I look out the window at a demolition site, a skyscraper that has now been reduced to a pile of rubble. I remember when it was built, forty years ago. Now it is being torn down. Soon, something new will be constructed in its place.

It makes sense: Atlanta taught me this, and life reminds me, again and again.

You have to dismantle the old to make the space for something new.

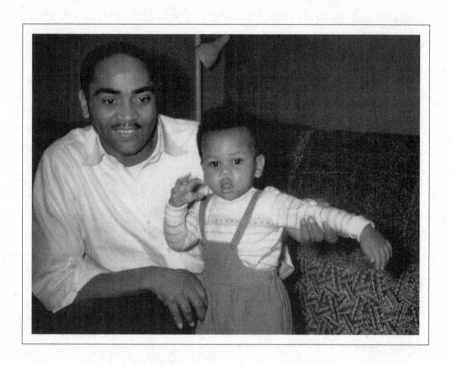

"*I go out onstage. I leave home,*

*over and over again, and then I sit*

*on that porch, waiting for my*

# Goodbye

*father, knowing that he will never*

*come, and then I let him go, time*

*after time. I say goodbye.*"

First, a memory. I can see it in my mind like a snapshot, clear as a photograph. I was five years old, and I was in the backyard of the house where I grew up in San Diego with my older sister Renetta. She spread a blanket out on the grass, took out a brown paper bag, and from the paper bag poured some homemade peanut butter cookies, which were my favorite. I was wearing a blue-and-white-striped shirt and green cotton pants.

We sat on the blanket and ate the cookies. I ate mine slow, savoring every bite, feeling under my thumb the latticework of the forkprint pressed into the top of the cookie. The sun was shining, but the sun always shone in Southern California. That just meant the gray days were the ones you remembered the most.

"This is a picnic," Renetta said.

"A picnic," I repeated. She nodded.

In this moment, I could feel that she was telling me something important, even if I wasn't yet old enough to grasp the meaning in its fullest form. But eventually, I would come to see: By naming it, she was making the moment something more than it was. We weren't just eating cookies on a blanket. The ceremony, the theater of it—that was what anointed this as something extraordinary, the creation of a kind of magic. Reality was suspended; the rules here were different. Eating cookies on a blanket was a regular thing to do, but a *picnic*? Now that was something special.

Magic, I saw for the first time, was a choice. And it must be created.

Renetta and I looked at each other. "I love it," I said. "I can't wait to do it again."

I think about this moment often because it was an awakening of something within me—the discovery that you can create your own magic. Developing the ability to create it out of necessity, even out of survival, teaches you how to be a magician for the pure love of it. We all have that magic within us. But it's the faculty to harness it—to turn something seemingly meaningless into something special, to be loose and spontaneous with it—that makes life most worth living.

I needed that, as a little boy growing up in San Diego—because I felt magical, but my immediate surroundings did not. The house where I grew up was in a development called Michelle Manor. It was less than ten miles from the beach, but folks from around there never went near the ocean. The neighborhood was all canyon back then, filled with little houses like the one my mother and father bought on Hal Street for $14,500 in 1958. From the front yard, on a clear day, you could see Mexico. On a cloudy day, you could still see the drive-in movie theater where they played blaxploitation films: Even if you couldn't hear the audio, you could make out just enough to keep up.

It was easiest to find the magic on the television set, which was the epicenter of possibility in our house. When I was very young, my parents kept it in their bedroom. All of us would crowd into my parents' bed and watch it, the gray light dancing across the chenille bedspread. I would sit on my father's shoulders and lick the top of his head, which was salty; it must have been sweat. Maybe he thought it was cute. I remember it so vividly because it was one of the only times I felt close to him, physically or otherwise.

On television, people were usually doing things in places that seemed much bigger than the world in San Diego, which always felt like a tiny tributary separated from the flow of the

wide, rushing river of life. The television set represented a window into something greater, a portal to new worlds.

In commercials, people were glamorous and adult, like Edie Adams vamping in a spot for Muriel Cigars in the style of Mae West: "Why don't you pick one up and smoke it sometime?" she intoned, standing in a surreal musical set wearing a gown and a fur coat. Her hair was a helmet, and she had liquid eyeliner drawn to her temples and dark, painted lips. I wanted to be just like her: gorgeous, in control, performing to a rapt audience. And, perhaps, feminine—in control of a man's attention. Though at that time I didn't have the vocabulary to describe any of that.

Anne Francis had a detective show for one season called *Honey West* that rocked my world; she kept a pet ocelot, and she didn't play by society's rules. On *Mission: Impossible*, the heroes—members of a top-secret intelligence agency—would target people based on their particular vulnerabilities, building entire set pieces to entrap them, using elaborate disguises and deceptions. I loved what this indicated to me about the world and the people who moved through it: You could cater to them, if only you understood who they were, to get what you need.

There were terrors on the television, too, images that spoke to my anxieties. On an episode of *East Side West Side*, there was a couple whose baby was bitten by a rat while lying peacefully in its bassinet. Because of this, I developed a thing about rats. There was a woman in the neighborhood named Irene who was friends with my mother, and there was a distinctive smell in her house—mothballs, rat shit—that turned my stomach. Plus, I knew that rats were smart and sneaky, and that made me see them as dangerous—maybe because I thought of myself as both of those things, too.

On that screen, there was also a sense of righteousness—of progress that was reflected in the shows we watched. In the products for which commercials were broadcast, technological advancements were improving things for all of us, all the time. I understood from the way my parents talked about it that there were more Black people on television than there had been before. My older sisters told me that the people in charge would make it so that one day, everyone on the planet would have thirteen pairs of shoes—unlike me, who had only one pair, or my sisters, who had three pairs each at most. The world was getting better all the time! In the meantime, in the programs we watched, there was a kind of moral clarity that the real world didn't have. Right and wrong. Good and bad.

I loved television. Television, to me, represented the platonic ideal of reality. First of all, there was a moral code. The good guys vanquishing the bad guys. Good triumphing over evil.

But even more crucially, the fact that it was all a performance was acknowledged. We knew these were actors playing roles because their names appeared in the credits. In the real world, everyone played parts, too, but nobody talked about it.

At the picnic, as was the case on television, Renetta and I had both played our roles. She was the facilitator of magic, and I was the beneficiary of it. She had created a show and then invited me onto the set.

———

I was the one who was always putting on a show for my mother. I would take a broom, wrap a towel or a scarf around my head, and make an outfit, impersonating Tina Turner, or Carol Burnett, or

LaWanda Page, who played Aunt Esther on *Sanford and Son*. I would impersonate people in the neighborhood, like our neighbors across the street, the Wafer kids—Thelma, Shirley, Raleigh, and Bruce—who talked real country, in a thick drawl. If she sat down to watch me, I knew I would be able to make my mother laugh, but it was still satisfying whenever it happened.

My mother was a stoic woman. In the neighborhood, she was known as Mean Miss Charles. She had been named Ernestine after her mother. When she was sixteen, during a fight with her mother—my grandmother—the elder Ernestine said, "I wish I hadn't given you my name."

"Fine," my mother said. "It's not my name anymore." From then on, everyone called her Toni.

This was classic her: stubborn, proud. She wasn't an easy woman. But if she liked you, she liked you. And she liked me because I was easy. Yet her coldness meant that I never stopped trying to earn her affection. She had never gotten along with her mother, but she revered her father; she was his favorite, and she knew it.

She was descended from freed slaves, and both her parents were mixed-race; back then, she would have been called "mulatto." Her hair was sandy brown and mostly straight, although it had a curl to it; she put it in rollers so it would curl from the front to the back, the hairstyle Suzanne Pleshette wore on *The Bob Newhart Show*, which we called a Beethoven. Growing up, kids at school would tease, "Your mama's white," but she didn't look white to me.

Maybe because she was contrarian, she loved dark-skinned people, like my father, Irving, who she met in Beaumont, Texas, while she was working as a secretary. They met on a blind date. He was serving in the army—there was a base there—but they

were both originally from Louisiana; my mother from a town called St. Martinville, my father from Mansfield. They must have had an incredible connection at first, something physically electric, the tension that comes from two people who are so unlike each other. He didn't believe they could get pregnant the first time they had sex, but she did—with twins. Upon his return from Germany, they married.

My parents were bound to end up at odds with each other. She was so world-weary, and he was such a charmer. In the beginning, I think, she must have represented a challenge to him: When she did smile, or laugh, there was such a payoff. For her, he was a jolt of fun. He took her out of that world-weariness that she'd had since she was a little girl. But when all that burned out, there was nothing left to hold them together. Often when people get together because of sex or some animal magnetism and that wears off, they end up thinking: *I don't like this motherfucker.*

While my father was serving in Germany, my mother gave birth to my older sisters, Renae and Renetta. She was overwhelmed raising two children alone, so for a time, she sent Renae, who was lighter-skinned, to live with my grandmother. I understood it to be a kind of peace offering to her mother for having children with a darker-skinned man. But it created a fissure in my mother's relationship with Renae that never healed—that she sent her away and separated her from her twin sister for two years. Their relationship was always contentious after that. Renetta, meanwhile, was my mother's favorite, which was funny, because she was optimistic to a fault, and my mother was such a pessimist. A year after I was born, my mother gave birth to my sister Rozy, who was somewhere in between temperamentally: She ran hot and cold. But none of my sisters performed for my mother the way I did: imitations, bits, sketches, little scraps of makeshift theater.

I would sit in her bedroom, gazing into her big art deco vanity mirror—at least, I think it was art deco; it could have just been old—with rounded curves and little engraved flowers, and do commercials for Coty cosmetics. I put her powder on and whipped a towel around my head as if it were a lustrous head of hair. *"Yes! It's Coty!"* She would have been in a bad mood because she was always in a bad mood, but when I did that, she would break character and laugh. That was my single goal: to pierce the dark cloud of her unhappiness for just long enough to help her forget that anything was wrong.

————

I will never know exactly what happened to my mother when she was young. She wouldn't tell us much; her narrative was very edited. But I had the sense, intuitively, that she'd been sexually compromised early on. She also intimated that she'd had a horseback riding accident when she was fourteen that had given her issues with her left eye, but after she died, I discovered that she'd had a glass eye my entire life. The fact that I'd never known that astonished me.

She was hotheaded, a Leo. Once she got mad, all bets were off. If we were goofing about in the grocery store, she would let us have it with no concern for how embarrassing it might be. "Shut the fuck up!" she'd yell from across an aisle of canned foods.

All the kids in the neighborhood knew you didn't fuck with Mean Miss Charles. She didn't have time for bullshit. God help the Jehovah's Witnesses who approached the house to find her sitting at the table, drinking her coffee and smoking a cigarette, in full view of their approach. They'd knock on the door, wave to

her through the window. She wouldn't even get up. She would just look at them and say, "Get off my fuckin' property."

I knew that she felt justified in being so flinty because of what had been done to her throughout her life, but it was also where she came from; her background was Acadian French. As an adult, when I began spending time in France, I would see shades of my mother in the people I met, who could be haughty and superior, or even downright rude. But back then, I had no context. When I heard her on the phone with her sisters, speaking Creole French, it was like an alien had landed in the kitchen.

She felt like the game was rigged against her, so she was tough, and then people were unkind to her because she was tough, which reinforced her belief that the game was rigged against her. My father's family disliked her: They thought she was purposefully ornery, that she thought she was better than them, and she probably gave them plenty of reason to think so.

The rift between my mother and my father's sisters was solidified one New Year's, when my parents went up to Los Angeles to his sister's house. They were staying with her—my aunt—and my mother had sewn a beautiful look—a sleeveless, tailored black crepe wool cocktail dress, with pearls and jewels embroidered around the empire waist—to wear that night for the holiday. She laid it on the bed in the morning and left the room. Later in the day, when she went to change into the dress, she found it in ribbons. Someone had slashed it with a razor.

She said nothing. She just wore a different dress instead. But she held on to that act for years—and to those shredded pieces of shimmering black wool. In every possible way she held on to that dress, and she allowed it to fuel her. It represented all the world-weariness she had experienced. It was proof positive that

she was not wrong in how hideous and cruel this world could be. And this—her belief in the cruelty of the world—was like a drug to her, something that she returned to again and again, reminding herself that she had been right all along.

My mother had been raised Catholic. She still read the Bible, sometimes with her friend Sister Harris, and I knew she believed in God, but I understood that her relationship with faith was as a moral touchstone, not as dogma. She didn't fuck with organized religion once she was an adult. She would never have given her power away to a preacher. She believed they were all crooks and hypocrites. I think she knew I was gay from the very beginning, but I never felt any judgment from her about it. Her life philosophy was laissez-faire. "If they ain't paying your bills, pay them bitches no mind," she would say.

To her, mantras like that were a form of religion: to speak out loud, to remind herself of her own truth. They were totems to help her remember where she came from, where she was going, and not to fall prey to the manipulations of others. I inherited my fondness for turns of phrase from her, but perhaps with more skepticism for the Bible. I can remember being young and hearing stories from the Bible and thinking they didn't sound quite right. In my mind, religion simplifies complicated concepts so people can understand them more easily. "The devil" is the ego; "God" is a frequency that cannot be explained; "Jesus" is a term for the potential that we all have, the potential for us to transcend the physical illusion and to remember who we are, which is an extension of the God-force. The truth is, I don't think either of us took any Biblical doctrine too literally.

From my mother I learned independence and self-sufficiency, the invaluable skill of being able to be on your own, to finish a job without requiring anyone's help. My mother could get shit done:

When the front yard needed tending, she would go out there and pull weeds and prune bushes, wearing a durable, machine-washable polyester caftan in an abstract black-and-white print that gave the impression of flowers. But even with her very hard shell, I understood that depression sometimes got the best of her.

"Ru, you're too goddamn sensitive, and you reminisce too much," she told me once when I was only five years old.

Years later, I realized what she was doing—she was telling on herself. She was trying to protect me from the mistakes she had made. My father's charms had allowed her to access within herself a sentimentality that she, tough as she was, couldn't feel otherwise. But once he disappointed her, she came to see that softness as her Achilles' heel. I knew she indulged it privately, living in nostalgia, the romantic fantasy of what was or could be again, but it seemed she only knew how to harden herself against the world. We had both been glamoured by my father, and she didn't want me to fall for it—getting hooked on his lure only to end up hurt, the way he had hurt her. Instead, she tried to prune the tendency out of me like it was a weed in the front yard.

I can see her now in my memory, the way she looked taking me to my first day of kindergarten at Horton Elementary. She was wearing a dress that, later, I would come to discover was a knockoff of a Dior silhouette: It was cinched at the waist then gathered out, with buttons down the front, a popped collar, and a three-quarter sleeve. It was deep brown, light brown, and beige, with geometric shapes—overlapping circles that created a pattern. She was so glamorous to me. I was holding her hand as I looked up at her.

I must have known on some level that this was the end of my being with her all the time. I was traveling through a portal to a different world now, and my life would never be the same again.

One of the hardest things for me to accept about life, still, is saying goodbye.

———————

Nobody ended up in San Diego by accident. Back then, it was very white, very conservative, and very segregated. It was a sleepy place to live, provincial—a military town. People from all over the country who conceived of being in the armed forces as a career plan wound up there.

The military culture converged with the old mission culture from when the Spaniards took over Mexico. But the missions built by priests crumbled, and in their place men built aerospace factories to send us rocketing toward the heavens. I didn't find that particularly poetic at the time; if anything, it bored me senseless. But in hindsight, it was useful. Being in San Diego gave me such a long period of gestation to become who I was meant to be.

My father had decided to come to San Diego as part of the Great Migration, as Black people moved first North and then across the country in waves. It had begun with Baltimore, then farther out into the Midwest to cities like Chicago and Detroit. The last wave of the migration was Black people from Texas and Louisiana moving West and settling out in California. My father had fourteen brothers and sisters, and of those fourteen, I'd guess ten of them moved to San Francisco, Los Angeles, or San Diego. He worked at McDonnell Douglas, which meant he, too, was part of the war machine, making airplanes.

All the Black people in our neighborhood were transplants from the South, and so they had inherited a kind of slave mentality, which was based on fear. When you hear stereotypes about Black people who can't swim or are afraid of dogs, it's because for so many generations, they were afraid of swimming across bod-

ies of water to flee, or afraid of dogs because they were scared of being chased. Those fears are epigenetic—they burrow deep into the subconscious, creating an internal paradigm of rules that you forget can be broken. Systemic oppression creates walls that can feel impossible to scale, but so, too, does the inherited belief that you are a victim. People hold on to that victim mentality so fiercely; it becomes a defining feature of their identity. Nobody's going to take that away from them. It runs too deeply to take out and examine under the light.

My father had it, too. As charismatic as he could be, he was ultimately shallow, afraid, unable to transcend the strictures of what he saw as his reality. He was too ruled by his fears of being truly himself to allow me to be myself. Maybe I illuminated the pieces of him that were feminine, that pushed the boundaries. I could see myself in him and his side of the family, in the way they laughed and danced and had a good time. But it wasn't recip-rocal: They could not give themselves permission to see their reflections in me.

My inheritance from my father was a stage presence. It's true that he performed warmly for the girls. Even if it was a routine—just a kind of stand-up set—he'd perform for them but never for me. It was as if he didn't know what to do with me. He'd take me down to Tijuana, which was only twelve miles from where we lived but felt like another world, to get my hair cut for fifty cents, then out for an orange soda as a reward. Or we'd go to Nati's for chicken tacos or beans and rice and chorizo so good it makes my mouth water just thinking about it. But I always felt the distance from my father. Physically, I was a replica of him—a mirror he couldn't stand to look in for too long.

———

When I was a kid, I used to think about the smartest people in the world. What were they doing? What were they thinking about? I felt certain that they weren't people with platforms—the politicians in Washington or the movie stars in Hollywood. The smartest people in the world, I believed, weren't people you would ever hear from, because the smartest people in the world were smart enough to keep their mouths shut. They understood that you would be burned at the stake if you showed how much you knew.

In nearly every Western, the good guy—the sheriff—goes off running after the bad guy while the deputy has the innocent person locked up. Somehow, the townspeople get the wrongly accused person out of jail, string them up, and hang them before the sheriff can come back to town. The sheriff comes back with the real killer and says: "What have you done?"

I understood what this motif meant: Mob mentality is dumb and dangerous. And the mob is never out for justice—they're only ever out for blood. The number one evil that we face is unconsciousness. And I knew early on that it could be perilous to show that you could pierce the veil.

My father's family, like the people in my neighborhood in San Diego, like my father himself, were all still slaves. They were afraid of everything. They sought validation to assuage their fears, and it made them feel good for a minute, but they were not free. I knew that these were not my people; I shared a sense of humor with them, but only that. In sensibility, I saw more of myself in my mother's French heritage.

I can remember being five years old and standing in a group with some other kids when one of them called me a sissy for the first time. What did that even mean? I wasn't sure, but I knew it was an accusation from which I had to defend myself. As with

the picnic, and just like on television, I understood in a wordless way that there was a play going on, and in that play, roles were assigned. Now, as long as I was in San Diego, I had to navigate the role that had been assigned to me, which at the time was "sissy." Everyone else had roles, too, and it was vital that I figure out what they were, because I had just been born into a game with rules that I had to learn in order to win.

The problem was that being a sissy was not a significant part of what anyone deemed the bigger picture. I had been assigned a role that was not important within the value system of the world at large, especially since I didn't have the meaning to assign to the word. I knew that I had my own magic, but most people couldn't see it. I'd have to prove my value another way.

And yet, even if I was seen as a sissy, I felt that I had always been provided for—protected, even. When I was in the second grade, kids would either eat a packed lunch in the cafeteria or walk home to have lunch, then come back in time for recess. Most days, I went home to eat oatmeal with raisins. One day I reached for the doorknob and found that the door was locked. I knocked, and no one arrived. I thought it was odd; my mother would normally be at home. Immediately, I thought that something must have happened, and it probably had to do with my mother and father—something with their relationship that had caused my mother to not be home. There was no other reason she would be out; she didn't even drive.

I sat on the porch waiting for her to come. I waited for a long time—long enough for whatever recess I would have enjoyed by coming back to end. By the time I returned to school, I was hungry, and as we lined up to go back into the classroom, I began to cry. It wasn't for attention—even at that age, I was good at keeping it together. But I couldn't hold back the tears.

A girl behind me saw me. "Mrs. Lang!" she called. "RuPaul is crying!" All the other kids stopped chattering and roughhousing as their attention turned toward me.

Mrs. Lang was a long-limbed white woman who wore a colorless dress and cat-eye glasses and had hair like Mamie Eisenhower. She came over, pulled a pad and pencil out of a pocket, and scribbled a note down. "Take this to the cafeteria," she said.

I walked to the empty cafeteria and handed the note to the lunch lady, who gave me a tray with a hot dog and some potato chips on it. I went to sit down at a table, and saw that the principal was sitting there already, wearing a short-sleeved white shirt tucked into slacks and a long skinny tie. I put my tray down next to him and we ate lunch side by side, and I knew that I was taken care of. My needs were met.

Why has this memory stuck with me all these years? The close call of a crisis averted; the visceral fear of not knowing where my mother was; the physical discomfort of my hunger and the embarrassment of my tears—all of that, sure. But above all else, I remember it because it was the first time the world had reorganized itself to accommodate the way I felt, which was different, apart from others. I was the only kid in the cafeteria eating lunch with the principal.

In this, I was special. But I was also alone.

————

Another memory: My family was together at Belmont Park, an amusement park near Pacific Beach. That was where we would go for an outing on a summer Sunday; television and movies let us know that the beach was where the action happened. This was

the choice, most coveted space. This was why the town existed in the first place: so everyone could be close to this beach.

I was five or six years old, and the boardwalk was teeming with white, middle-class navy families, lured here to San Diego by the promise of war propaganda. There was cotton candy residue around my mouth, the aroma of funnel cake in the air, and beneath it, with a sour tang, the lingering stench of throw-up. The sun in San Diego had a silvery hue, hot in its directness but cool in the shade. Everyone was looking up at the rides, which towered overhead—especially the Giant Dipper, an enormous, historic wooden roller coaster. I was looking from my father to my mother, and there was a feeling between us, my family. If I could put words to the feeling, they were: *We can't go on much longer like this.*

And then we were heading back on Highway 94, back to the house on Hal Street in my father's 1954 Plymouth. He was driving, with my mother in the passenger seat holding baby Rozy. I was in the back seat, in the middle between Renae and Renetta.

There was dead silence in the car. And in that moment, I knew this wasn't good. I knew that these people did not like each other. In fact, they fucking hated each other. There was no joy—only hostility. Looking back, I think maybe we all felt, somewhere deep within us, that it was the last time we would ever do anything like that—this performance of family.

My father was self-centered and a cheater, but my mother would be the one to escalate things, picking up a lamp and throwing it across the room. We would run into the back room of the house and hunker down in the corner like refugees. Renetta, who was always a bleeding heart, would huddle us together; it was very cinematic, and she knew it. I never saw my mother

bruised; maybe just one on her arm, from him holding her off. He must have hit her, though, because after he left, she would tell all of us, my sisters and me: "If a man hits you once, leave. It's never going to get any better."

Someone simply sitting on the retaining wall outside the house on Hal Street would be enough to incite my mom to anger: "Get the fuck up out my yard!" she'd yell from the window. So when my father got a convertible, a white Oldsmobile Delta 88, and started cheating on her with a woman named Betty who looked like a young Nichelle Nichols and had a cute little gap in her teeth, it was game over. One night when he came home late, she took a can of red paint and spray-painted the word BETTY on the side of his car. For years after, there was a little smudge of red paint on the garage door.

———

That garage door comes back not long later, in my memory, after the incident with the paint. But here I remember it open. My mother was angry with my father, as angry as she'd ever been. Renetta, Renae, Rozy, and I were standing on the other side of the street, watching a scene play out inside the garage.

She had poured gasoline all over his car. She was standing on the passenger side at the tail, holding a book of matches. "Motherfucker, I will light this bitch on fire," she said. "I will light it on fire." He was standing on the other side of his convertible, begging her not to. "Toni, please. Please, Toni."

Everyone in the neighborhood was gathered around us, watching this scene. She had a captive audience, and she was willing to set the whole house on fire in her rage.

When I play this scene back in my memory, I see it as if I am a camera and I'm looking at me. Then I cut to my sisters' shocked faces. There's a dolly shot, then a crane shot. It's spectacularly cinematic. Years later, I would understand that I had fully dissociated. I was too young to absorb what was really happening; it would have been shattering to me. So I simply left my body.

Eventually, Sister Harris came from up the street and convinced my mother to put the matches down. The fire trucks left, and nothing more happened. I'm not sure if my dad went back in the house or went to Betty's. But we were all used to my mother pulling stunts like that.

He moved out not long after, into a little bungalow off Highway 94. I don't remember saying goodbye to him, but I remember visiting him at his new place. I didn't realize they made houses that small; even though I was just a little boy, it still felt tiny. You could barely navigate around the furniture in the living room.

On days he was scheduled to come visit us kids, I would sit outside and wait on the porch for him to show up. But often he didn't. He was all about himself. I knew that we were not a priority for him. That had always been so. I could feel it, in his demeanor, that he was determined not to change the way he lived just because he had a wife and kids.

———

My mother loved it every time I performed for her. When I go onstage now, I remind myself, like a little mantra before the cameras roll or the curtain lifts: *It's just Mama's living room. There's nothing to be nervous about. She's going to love everything you do.* Her encour-

agement was my training as a performer; I knew that she was rooting for me. And when I remember her, any anxiety I might feel just melts away as I imagine the audience as my mother cheering me on.

And afterward, when I am in a dressing room by myself, I often find within myself the sudden urge to be at home with my mother. A mirror can serve as the passageway, or it might be the empty black box of a television set. Then I am standing on Hal Street again, at the moment where I walked through that portal—where I said goodbye. I accept that life will always be that way. I accept that I will always be packing up a dressing room, heading off from the safety and security of the place that feels like home. I learned when I was young that there can be no constants.

Home, I know, is right in this moment—in this body. We have houses everywhere. So I keep my bags packed, to make me resourceful such that I can make magic wherever I am. I let go of my mother's hand. I go off to school. I go to work. I go out onstage. I leave home, over and over again, and then I come back. I sit on that porch, waiting for my father, knowing that he will never come, and then I let him go, time after time. I say goodbye.

How could he be so cruel as to leave me waiting there on that stoop? But I project onto him the consciousness that I have now. I would never make my child wait for me on the front porch—it would be cruel, and I know better. But he didn't know any better. It never would have occurred to him, because he wasn't awake. Unlike my mother, who saw me, my father could not. The number one evil that we face is unconsciousness. And now that I am older, I understand the wisdom that was always waiting for me, so simple and so obvious but so hard to learn—

*His loss.*

_____

In my memory, I see that open garage door. My mother holding a book of matches, the smell of gasoline. Peanut butter cookies on a blanket, the silvery San Diego sun.

Years later, I went back to the house on Hal Street, just to remember. I stood across from the house on the curb where I'd stood decades earlier with my sisters, watching my mother threaten to burn everything down. I saw, in my mind's eye, a long tracking shot of the street, of all the neighbors gathered around, and then me, watching it happen. How funny—I hadn't realized. Watching the scene playing out inside the rectangular box of the open garage door, it was just like looking at a television.

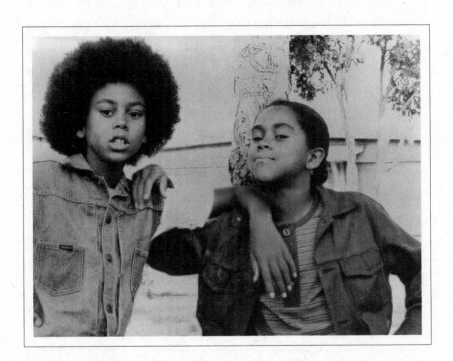

"Many of us have a secret girl

living within us. Mine awakened

when I was twelve years old

# Cerritos

and the film Cleopatra Jones

came out amid the

blaxploitation film explosion."

The first time I flew on a plane was to go visit my father. I couldn't have been older than ten. Everything about it already felt so familiar: looking down at the ground, feeling free; the exhilaration of the speed, the velocity of the ride. And how high up we were! I loved it up there—the sense of limitless potential, of going faster than anyone else.

If the journey was exciting, time spent with my father was more fraught. He had moved to Cerritos, a suburb of Los Angeles about two hours north of San Diego, and he had left his job making airplanes and gotten a different one as an engineer at Best Foods, which made all the products that were advertised on television: Skippy peanut butter, Argo Corn Starch, and Karo corn syrup. I always hoped that he would bring back Entenmann's donuts for us, but he never did.

He would go on to date Betty for the next ten years, although I don't believe it was ever serious. I think he saw other women, too, and she never moved in with him. He kept his own place, while she lived in an apartment in the Jungle, a predominantly Black neighborhood near Baldwin Hills, not far from LAX. In my memory, she is lovely; I never felt animosity toward her. Strangely, I could feel Betty in a way that I was unable to feel my father. She seemed contrite, as though she felt badly about the role she'd played in the dissolution of my parents' marriage. She never said anything to that effect; it was just something I knew intuitively. Betty's daughter worked in an office on one of the Warner Brothers lots in Burbank, and Betty brought me there once when I was eleven years old to see what it was like. That day on the lot they were filming an afterschool special called *The Toothpaste Millionaire*. As I watched them tape, the whir of activity on that set, I felt as if I was peeking into my future. The star of

the film even looked a bit like me; we were around the same age. *That could be me right now*, I thought. Someday, I imagined, it would be: I would become the person performing on a set. I was as grateful to Betty for that exposure as I was for the apology in her eyes.

Show business was never too far from my thoughts. I remember writing my first song after seeing the television show *The Partridge Family*; it was called "Love, Love, Love." I shared it with the kids in the neighborhood to start a singing group.

My father had bought a tract home up in Cerritos, and we'd go visit him from time to time, especially in the summer, when we might stay for a few weeks. But he was mostly a ghost, so checked-out and self-absorbed that from the age of eleven, I could take the keys to his 1969 Toyota Corona and drive it around the neighborhood, making only right-hand turns—turning left intimidated me—without him ever noticing. He never paid child support, which was why my mother got to keep the house in the divorce.

After my father left, my mother took to her bed and stayed there for a long time—several years. When I was an adult, I would learn that she had been to see a doctor who had prescribed her both Valium and lithium. But all I knew then was that she had checked out in a different way from my dad.

When I was eight years old, a white girl who went to San Diego State rented a duplex in the canyon about a block from our house, and she drove a moped. I would see her sailing past the house on it, looking so free—free in the way that I wanted to be. One day she rode past me and stopped. She must have seen the desire in my eyes. "Do you want to go for a ride?" she asked me.

"Yes!" I said.

"Go ask your mother if it's all right," she told me.

I went into the house and counted to ten. Then I ran back outside. "She said it's okay!" I shouted.

I climbed on the back, and she started the bike. I felt the rush of the wind on my face, the sun overhead. I was exhilarated; I was awake. We rode up to the zoo, up to El Cajon Boulevard. It made the world feel bigger than it did in my little neighborhood, like more things were possible than I had imagined. My mother never found out.

It felt exciting to have a secret from her, like the beginnings of an adult life of which she had no awareness. I knew that she was battling her own demons. She was so devastated by the end of the marriage, by the fact that she had allowed her Achilles' heel to be exposed like that—to have let my father break her heart. For the rest of her life, she would see him as her nemesis: the architect of her harm.

For my mother, being on her own was a kind of kneecapping; the loneliness was debilitating to her. But I was never afraid of venturing off on my own; I always felt like I was alone anyway. As much as I was protected by my sisters, they had their own lives to lead, and so it was incumbent on me to become independent. After the incident with the moped, I began catching the bus and taking it all over San Diego to see more of what I'd had a glimpse of. The bus stop on our corner, at Hilltop Drive and Forty-Seventh Street, was a portal to the rest of the world, next to the stairs that led to Sally's Candy Store, where I would buy ChocoStix when I had the money, and the record store that sold the latest 45s.

One day I took the bus to the beach and spent the entire day there, walking up and down along the sand, watching the people whose lives felt so much bigger than my own. I must have told one of the boys who lived on my block that I was doing this, because when I got off at the bus stop near my house, there were a bunch

of neighborhood kids waiting for me with their arms crossed. They were looking at me like I had done something wrong.

To them, I had. I had violated the parameters of the universe of our neighborhood and the people in it. We were supposed to know our place; this showed that I refused to accept mine. The kids I knew might go up to a reservoir and try to catch some fish, then come back with welts on their backs from being in the sun all day; I might even go with them. But that was man-made, familiar—a practice that was known to everyone. Those kids stayed where they were supposed to stay, and they stayed with people who were like them. Very rarely did they break out of those grooves.

By wanting something as vast and untamable as the ocean, I had revealed my own desire to experience the fullness of life. And they didn't like that one bit.

———

My mother's heart was broken. The only thing that had given her purpose was that she belonged in that marriage, and she belonged to her husband, even if her love for him was fleeting; once he was gone, she felt duped. Without him, her identity was gone, and she had to go find it anew. As a young girl in parochial school, my mother had wanted to become a nun—I imagine she liked the order and hierarchy more than the dogma—but instead she had ended up going to secretarial school, where she learned to type sixty-five words per minute. After a couple years in her bedroom, grieving the end of the marriage, she decided to go back to work.

I know she was inspired, in some part, the same way I was inspired: by what we were seeing on the television. I remember her watching Jacqueline Onassis with absolute wonder and

amazement; she must have been thinking *That is one bad bitch*. She had overcome the most horrific thing imaginable—holding her husband's brains in her hands—only to bounce back, marry a billionaire, and keep on living her life. Jackie O, then, was perhaps the most famous woman in the world. My mother had the same proportions as her; she was modelesque, and she knew she could wear the same kinds of things that Jackie might wear and had the body to pull it off. So she resolved to go back out into the world and live her life again, just as Jackie had. Gone was the durable polyester caftan and in were tailored pantsuits, which she sewed herself out of taupe gabardine.

My sister Renetta, who was now a teenager, was working for Planned Parenthood as a nurse's assistant; she would go in alongside the women, just so they could have another body there to feel safe. My mother decided to get a job working at Planned Parenthood, too, in the office. It was part of a movement toward progressivism that represented values she took seriously, and perhaps as importantly, it made her feel like Mary Tyler Moore—a modern woman who was doing it for herself.

When my mom came home from work, I watched *The Flip Wilson Show* with her. Flip's signature character was a woman named Geraldine, which was just Flip in false eyelashes, maybe some lipstick, and a wig. Flip would play Geraldine as a flight attendant or meter maid, and the guest star, someone like Dean Martin, would fall for her. When they made advances, Geraldine would scream, "Don't you touch me! Don't you put your hands on me!" and we would howl with laughter.

I knew even then that this was a major cultural event. Certainly it was for Black people, to see a Black comedian host a successful prime-time variety show. My mother had always felt shut out of Black culture because she was light-skinned; here, in the

laughter, she felt free. But to me, it was even more significant that this character was popular even though it was transgressive—a man dressed as a woman. Flip was someone who was violating the pact and still winning, which meant that such a thing was possible.

History had shifted in such a way to create space for a character like Geraldine. It was the sexual revolution, in the midst of the civil rights movement. People were spreading their wings and experimenting in ways that had never been done before. Now, here was a person pushing the limits of gender on television. Milton Berle and Jonathan Winters had done drag, too, but Geraldine was a Black woman—the kind of Black woman we knew. She had a wink, too; she liked to have fun. She had a sense of humor, but only up until a point, and then she'd get fiercely indignant. In costume as a waitress, she'd announce, "Oh, and by the way—I'm *not* on the menu!" She wasn't gorgeous, but she made us believe that she was.

That's not to say I grasped what drag was, but it was a crack in my understanding of the world—this, the possibility that men could behave like women in certain ways. And seeing that it could make people laugh—even make my mother laugh. Not long after that, Renetta cut out a newspaper article about Christine Jorgensen, the first woman who became well-known in America for having gender confirmation surgery. I wasn't sure why she was giving it to me, but I had my suspicions. It felt like she was trying to be helpful. People had always mistaken me for a girl, because I had a big Afro and soft features. And like Jackie Onassis, and like my mother, I, too, was developing proportions that were modelesque.

—————

Many of us have a secret girl living within us. Mine awakened when I was twelve years old and the film *Cleopatra Jones* came out amid the blaxploitation film explosion. I could watch it on the drive-in movie screen that we could see from my front yard. There she was: fearless, powerful, strong. She wore bell-bottoms and a fur car coat and had a voluminous Afro, and she wouldn't hesitate to gun a motherfucker down. Cleopatra Jones didn't play by the rules. She couldn't be told what to do. I loved Cleopatra Jones so much that I wrote a letter to Warner Brothers and asked when the next movie was coming out.

It wasn't until I was an adult that I realized: That's how I see myself. Or rather, Cleopatra Jones was who I wanted to be. When you understand your secret girl, she can be useful to you. You can know her, this little avatar that lives within you, see what she's made of, what her characteristics are, and understand when she needs to be revealed to the world and how. But as powerful as your secret girl can be, she's equally dangerous when you refuse to acknowledge her—and what she needs.

There was also value, I understood, in realizing who your secret girl *wasn't* and what she *didn't* want. Around the same time, my mother and a friend of hers took us all to see a double feature: *Valley of the Dolls* and its unofficial sequel, *Beyond the Valley of the Dolls*, which was rated X. In that movie, there was a flamboyant gay man who was revealed to be a woman after he took off his binding and exposed his breasts. Later, that same character put a gun in a sleeping girl's mouth, and she began sucking it like it was a dick. Then he pulled the trigger.

I knew intuitively that this content was all too explicit for me. The cheekiness of Flip Wilson spoke to me, but the overt sexuality of these scenes I found traumatic. Humor was straightforward in its pleasure, but sex was confounding. I came from

parents who I couldn't really trust, who were trapped in their own vampire psychodrama that didn't have anything to do with my well-being. Within my own family, I felt like a eunuch; certainly, there was nobody to say, "Here's how you have sex." In that respect, I was on my own, and nothing I saw on-screen provided any further insight.

It seemed like there were just so many different ways to be a girl—more ways, perhaps, than there were to be a boy. My sister Renetta carried herself so graciously, in the Barbizon Modeling School style—a kind and gentle hostess, allowing everyone else to be comfortable no matter how much she might have to contort herself. Renae was so different, so combative with my mother. There were the women I saw on television, like the elegant, polished Diana Ross, or Cher, who my sisters told me never wore dresses, which I thought was so cool. And then there was my mother, who was tough and fearless, but held a brutal grudge.

Sometime after my parents split, my father's sister Bea came over to the house. My mother had just gotten home and was hanging up her coat when Bea knocked on the door. Bea wanted to discuss something related to my parents' separation, and my mother wasn't having it.

"What the fuck are you doing on my motherfucking porch?" she yelled. "Who the fuck do you think you are? Coming up to *my* house? Talking to me about *my* kids? You know what, bitch—get the fuck—"

She swiped the hanger at Bea like a knife, slashing open her nose. Blood ran everywhere. Bea had to get eighteen stitches, but she didn't press charges. If my mother's intention had been to teach Bea not to fuck with her, it worked. But the truth is, I don't know my mom's intention: if she had really wanted to hurt Bea, or if she had just lost control. Bea represented everything

that she hated about my father, and his sisters were like a chorus of witches who encouraged his philandering because they had never liked her in the first place. When Bea showed up at the door meddling, my mother lost her last shred of restraint.

———

My mother had been undone by the divorce, but none of us kids were reacting much better. It created so much upheaval. Renae, who my mother had sent away as a little girl, sided with my father. On their sixteenth birthday, Renetta and Renae went to dinner with our father, who brought Betty along. When they came home, and my mother learned that Betty had been there, she became furious. "Get your fucking shit and get out of my motherfucking house," she said. After she kicked them out, she turned them in as runaways, although they had never stopped going to school or work. Eventually, they would go to live with a counselor from their school, a woman named Alfrieda. She was very dark-skinned and very beautiful, with a cropped Afro, and she wore fashionable clothes—I remember a linen Mexican smock dress in tomato red, bright green, and cobalt blue. Alfrieda seemed very hip and understanding, which infuriated my mother. "That's one educated Black bitch," she said bitterly.

My mother had always privileged education. As a little boy, I told her I wanted her to call me RuPaul "Education" Charles. She laughed endlessly at that, because she could see how I was playing with her: It was the thing I knew she revered the most, sandwiched in the middle of her own son's name.

Unfortunately, I hated school. I didn't want to do my home-work; I wanted to run around the neighborhood with my friend Gary. He had an older brother, who we called Junebug. One night

Gary stole a joint out of Junebug's pants and we went to a construction site in the canyon just a block from our house. We sat up on a power box and lit the joint, coughing at the smoke. After a few minutes, I started laughing. And then both of us were laughing, rolling around on the ground, hugging ourselves, and in that moment, everything shifted.

It felt like freedom I'd never experienced before. The margins collapsed. The hilarity that I had always suspected was just beyond the perceptible realm came bubbling up to the surface. The illusion that I knew the world to be snapped into focus for the first time. It was confirmation of the thing that I had always, on some level, known: Life was just one big fucking joke. Anyone who was taking it seriously was missing the point.

Gary and I began getting high together any chance we could. Other times, we would stake out a market in the neighborhood called Big Bear when their liquor was being delivered. While the delivery man was hauling cases of liquor into the store on a dolly, leaving his truck door open, we would jump into the bed, each of us grabbing a pint of bourbon, and then run like hell to the canyon. We would sit and drink in a manzanita treehouse. One night I drank too much. Stumbling home, I beelined for the bathroom and vomited.

My mother knew exactly what had gone down. "See, motherfucker?" I remember her saying as I hugged the cold porcelain of the toilet. "That's what you get."

Another time, I smoked some weed sprinkled with angel dust—which wasn't hard to come by in those days—out in the canyon, then staggered home. But I couldn't make it past the retaining wall in our front yard to actually enter the house; instead, I started doing somersaults off the wall onto the sidewalk. She came outside, looking at me suspiciously.

"What's wrong with you?" she said.

"I'm just happy," I told her.

She didn't press it. But she must have known something was up.

I suppose that each of us was trying to escape our circumstances in our own way. Renae ended up moving in with my father in Cerritos for a time; not long after that, she joined the Air Force. Renetta fell in love with a fellow student named Gerald, who she met in school.

I liked Gerald. At the time, it felt like he was opening my eyes to the possibilities of what I could do. He was so ambitious; he had his mind set on being an entrepreneur, not an employee. He was leonine, intelligent, and—like me—I understood that he dreamed of a bigger life. On Sundays, my mother, Renetta, Rozy, and I would drive around with him in his car looking at the houses in affluent La Jolla. Gerald wanted to live in a fancy house someday and drive a gorgeous car.

"Wow—look at that," Renetta would say.

"I want that one."

"No—this is the one I want right here."

Wealthy people lived there: Dr. Seuss, Jonas Salk, Efrem Zimbalist Jr. We drove past their homes, even to Del Mar, where we looked at Desi Arnaz's house. All the houses were beautiful, but it was also the shared ritual of doing these things together—planting seeds for the future I wanted to build. Gerald, I felt, understood why doing this was so crucial. Like me, he dared to want more.

Gerald and Renetta got married when she was seventeen and he was eighteen. The wedding was at city hall, and the reception was at his parents' house. In the wedding photos, both of them have Afros, and she's wearing a white dress with a line of pearls

around the empire waist. My mother called Renae after the wedding. "I just wanted you to know, your sister got married today," she said casually. "And we're over at the Covingtons' house having cake." She was only using Renae to send a message to my father, probably to emasculate him: *Another man has taken your daughter, and you didn't even get to be present for it.*

The newlyweds moved to student housing in La Jolla while Gerald was attending UC San Diego. On the wall of their apartment was a picture of Sylvester, the disco singer. He was lying on a chaise longue, wearing satin. He looked luxurious, decadent, and feminine.

I pointed at the picture. "Who is that?" I asked Renetta one day when I was visiting.

"Oh," she said nonchalantly, "Sylvester is this transvestite in San Francisco who puts on shows." It was complete anarchy to do what he was doing; it was rock 'n' roll. And I knew, even as a teenager, that it was important.

———

Most queer people understand the experience of growing up feeling that you are at least a little bit different. But I was *really* different, enough so that everyone knew it. I had been codified in the neighborhood consciousness from a young age as a sissy, such that I couldn't even pretend to be like other boys. It wouldn't have worked for a second.

There was something intangible that set me apart that people could see. I knew other kids liked me, yet I felt as if I was held at a distance, understood to be above or beyond the fray of what the other boys were doing. When I was in junior high, a kid named Cliff moved into the neighborhood from Los Angeles. Cliff was

rough, rougher than anyone with whom I'd grown up. In me he saw an easy way to prove his dominance, and so he let it be known that he was going to beat me up. I dodged the situation for as long as I could, but eventually, I knew I had to face it. I thought it would be better if I got there first, so I met him outside his class and threw the first punch. He hit me back, and the ring that he was wearing slashed the skin below my left eyebrow, drawing blood. Quickly we were broken up. It remains the only event of childhood violence I can remember. I was protected, as if by some unseen force, but in that protection, too, I was often lonely.

Because I was so conscious of the ways in which I didn't belong, it felt significant when a boy at school named Lamar expressed more than polite kindness to me. He was so tall and handsome; to him, the interaction we were having probably felt completely normal, but to me, there was an electricity—as if he was oblivious to the distance I felt was there with other kids. The next morning, there was a knock at the front door. It was Lamar. My mother answered. "Who the fuck are you?" she said. I scrambled to get ready, embarrassed by her hostility, and slipped out the door to walk with him to school.

I was touched by this, beyond words. Why would he do that—go all the way out of his way to pick me up? I thought it was the absolute sweetest thing a boy could do. It was the first time a boy had acted as if he liked me in a way that to me was romantic, and I was overwhelmed.

Years later, I would understand that Lamar waiting for me on my front porch was the upside down of my father leaving me there waiting. That front porch represented a portal to love. My father was blocked; he had a canned, easy charm, but it was never sincere. In fact, it was so plastic that it would never even occur to him that I might be waiting for him at all. His thought-

lessness was the opposite of Lamar thinking of me enough to stop by. The waiting melted me; it moved me beyond my imagination. Immediately I fell in love with him.

There was a way that boys treated girls when they liked them, with a kind of affection that I'd always craved from my father but had never received, even as he doled it out to my sisters. That was what Lamar had done. He wasn't bothered by the way everyone saw me; he wasn't alienated by it. This was my Achilles' heel. From this moment on, I would be putty in his hands. Before this, I had walked to school with Shirley from across the street, listening to music on her Panasonic AM/FM radio, a tomato-red orb that played the hits of the day. But now I would walk with Lamar.

In our friendship, I know there was sexual tension, because I felt so tingly; the sight of him would make my heart flutter. And he was flirty with me, too, though nothing ever came of it. Looking back on it, I realize that I can't remember anything about how I was with him, only the way that he was with me. When I transport myself back into his living room, I see him in my memory—but I do not see myself. Now I understand that there's a certain type of man who is like my father—funny, charming—who makes me lose myself entirely. It is as if I, in all my self-consciousness, disappear, swept away by a man's charisma. To feel that with Lamar was intoxicating.

Isn't it strange the way those first early crushes take on this mythic dimension? My fantasy life with Lamar was just that, and in my heart I yearned for him, day after day that I spent at his house. I must have performed that it was just a normal friendship—I became friends with his younger brother Jimmy, too, and I remember us getting stoned and laughing together—but within me there was something snagged, an unresolved question I didn't yet know how to answer.

Outside of that friendship, I was depressed, trapped in provincial San Diego. School bored me endlessly—when I went to class at all, which wasn't often. After junior high, I went to a high school far away in the suburbs, only because Lamar went there and I wanted to be close to him. Lamar mostly distracted himself by flirting with girls. I never learned anything in school. Everything I learned was from reading books, watching television, and studying people. Renae subscribed to the *San Diego Union* for me from the age of eleven so I could keep up with what was happening in the world, and I loved that, much more so than anything that happened in school. It felt like I was standing at the crossroads of the matrix, knowing how hard it would be to fake playing along. I still hadn't found my community. I could see them on television, but I hadn't found them in my real life; I knew that they existed, but not anywhere close enough to touch.

I would stand on the retaining wall looking out on Hal Street, feeling the claustrophobia of the city. There was just one clear, unbearable thought: *I gotta get out of here.*

In the first quarter of tenth grade, I would take the bus to school, then not go to class, just sit in the quad smoking cigarettes all day until it was time to go home. Finally, at the end of that quarter, my report card arrived, and it was all Fs. I had flunked everything. Because I lived outside the school district, that school was not going to extend an invitation for me to return, which put me in a dilemma: The neighborhood school was tough—a ticket to nowhere. For Black boys, especially in a place like San Diego, there was a sense that many of us were doomed. The trajectory was limited. Most of the boys I grew up with fell through one of two trapdoors: They'd end up in prison or doing drugs.

Upon learning that I would have to enroll at the neighborhood school, Renetta intervened. "That's it," she said. "You're

coming to live with us." I understood what she was saying: *Ru, this is not the way your story goes.* She was trying to put me into an environment that could set me up for something better—something different. But I was a teenager, and so I experienced the decision as a way to restrict me, to choke my freedom.

I left the decision up to my mother, hoping she would fight for me to stay. Surely she wouldn't want to see her only son leave the house so soon—I was just fifteen. But she agreed with Renetta. "You should go," she said. She was sitting at her sewing machine, looking down at the fabric, refusing eye contact.

I was furious. "I hate you," I said. It was the only time I had ever said that to my mother, and instantly I regretted it. But instead of flinching, I could see her blocking it out—as if she had heard it and made the decision not to let it in, because she knew it wasn't real. And true to her word, she let me go.

———

I moved in with Renetta and Gerald across town, in Tierra Santa, and enrolled at another school. There, I went to a few more classes, but mostly I just hung out and smoked weed. I befriended a hippie girl named Belinda, a white girl with sandy brown hair with whom I would cut class. One day we were walking down an alley off campus, and one of us noticed that there were little remnants of marijuana all over the ground; clearly there had been a bust of some kind. We spent the next hour picking up little pieces and rolled a nice doobie out of it. "We are all witches," she said very seriously as we sat on the ground, getting high. "And the greatest spell we can cast is laughter." That was a lesson much more precious than anything I picked up in class.

The other great teacher for me turned out to be Gerald. It

wasn't anything he said; rather, I learned by watching him—the way his hunger moved through him and made him ambitious and fearless, unwilling to settle for life's first offer. Somehow, he'd gotten into University of California San Diego with a scholarship. Now he was working as a promoter in the nightlife industry as well as flipping cars, and he was making real money doing it—or so it seemed. Not long after I came to live with them, we moved into a big house in Mount Helix—a sprawling, beautiful estate overlooking the city, with a three-car garage. He always managed to pull that kind of thing off through sheer bluster and confidence. I knew him well enough to know that he was bluffing, but people believed it enough that they were game to invest in him. As much as there were many systems in place to stifle opportunities for Black people, there was also an energy of change in the air, such that it was cool to be in business with Black people—a sign that you were liberal and progressive enough to look past race. Gerald capitalized on that, and I watched him speak his self-assurance into reality. He understood that he wasn't just selling cars—he was selling himself.

After we moved into that house on Mount Helix, I transferred yet again—to a third school in the same year. Unsurprisingly, I ended up flunking the tenth grade altogether. It was an unimaginably depressing thought that I would have to do the entire year over again.

Renetta was still working at Planned Parenthood, going to satellite clinics and doing intakes. She had been struck by the reality, a painful one, that there were so many babies that nobody wanted. She and Gerald decided to adopt a little boy named Scott, who came to them when he was two months old.

I spent some time looking after Scott, who seemed to need a lot of attention. As soon as he could walk, I would take him

to the mall, and he would start walking in one direction, never looking back to say, "Where are the people I came here with?" He was always searching for something, something I was afraid that he would not find. I thought of him as my baby—it was as if, like me, he had come from outer space. Like me, it seemed, he was different. He had come to this world alone, without the allegiances to convention that bonded people to normality.

———

That spring, my father and Betty took my sister Rozy and me on a trip up to Sequoia so we could see the redwoods, packing up Betty's brand-new, green-on-green Ford Gran Torino with suitcases and snacks and heading north up I-5 from Cerritos. On the way, we stopped at Busch Gardens, which had a park in Van Nuys, to ride a tram and see the bird show. I hated it, the same way I had hated such trips when I was a little kid, feeling the wrongness of it all, the ways we didn't fit in as a family.

There was always a fake sincerity with my father; I couldn't quite feel him. We were meant to be having fun; it was clear from looking around at all the other families, sticky-mouthed and sunburned, that fun was on the menu. But all I saw was an opportunity for my father to get drunk and expect me to pretend. To pretend that I was a little kid again, as opposed to an angry teenager who was already drinking and getting high whenever he could. Here we were making up for all the family trips we hadn't taken in the years that he was absent, and it felt so suffocating, because I wasn't the person that he was asking me to be. But for the sake of his ego, I had to play along with the fantasy.

We never talked about what happened, this traumatic division within our family, nor did we talk about the fact that he never

paid child support or really engaged with me as a father. If any of it came up, he might allude to my mother being difficult, but it was always in broad strokes. There was so much that went unsaid.

On our way to Tahoe, we were speeding down the highway when out of nowhere a deer appeared in the road. It turned to stare at us, its eyes reflecting the headlights of the car. I was sitting in the front seat, close enough to see the placid look in its eyes. My father slammed on the brakes, and we screeched to a halt.

My heart pounded in the silence, all of us catching our breath as the deer scampered off. It was a miracle that we didn't hit it. None of us had seen it coming—least of all my father.

That moment—its thrilling, terrifying surge of adrenaline— was the only thing between me and my father that felt tangible enough to touch. It was the only thing that happened on the trip that felt real.

————

What do I mean when I say "real"? I mean that there are moments that snap you out of the illusion, the waking daydream that we all move through in this, the world that we have created. Everybody is born awake, sharp and conscious, and then as you get older, you go back to sleep. But those moments, those near-misses—the feeling of dodging a bullet, of circumventing a fate that seems so obvious—there is nothing realer than this. It wakes you right up. It jolts you out of your waking dream into something bracing and difficult. Because life can be bracing and difficult, even in all its magic, and when we taste its bitterness, we know that it is real, and so, too, are we.

This was the difference between my father and Gerald: My father couldn't distinguish his artifice from his true self, like a mask that had been grafted to his face. Gerald knew that he was

playing a game; his awareness of the game was something real. This was exactly what I was chasing: the feeling of breaking the wall, of grasping something sturdier than the theater that we were all being asked to participate in. I hated those roles, boring and predictable as they were. Me, nothing more than a sissy. School, something that mattered. Families, meant to act like they belonged together despite how poorly some had behaved. Why were we taking life so seriously, anyway, when so much of it was clearly bullshit? It felt as though I was on the operating table and the anesthesia wasn't working.

All I wanted was to feel something real, something beyond all these mistaken priorities that I was sure didn't matter. But the way it felt in the car as we all stared at that deer, our lives hanging in the balance—that was something that counted. That was real.

———

For a little while, as a teenager, I worked part-time for a man who sold cars, a white guy in his midthirties; I can't remember his name now. He had a little Cessna plane, and one day he was flying to Yuma, Arizona, for a meeting and he asked me if I wanted to come with him. Of course, I said yes—I always loved being up high in the clouds, feeling the dizzying sense of freedom that came with being on a plane.

The two of us were in the sky, flying east toward Yuma, when he tapped me on my knee. "Look forward," he said. There were two Air Force jets heading directly toward us. And with so much agility it astonished me, he swerved into a nosedive.

My stomach dropped. The air disappeared from my lungs. The jets passed over us.

And then we rose back up in flight.

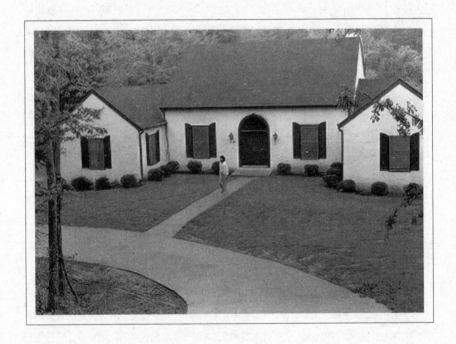

"*I was young and gorgeous, too—*

*I imagined the rush of having*

*that kind of freedom,*

# Details

*to drive to school and fuck*

*my hot boyfriend in the*

*parking lot all day long.*"

The key word in detailing a car is *detail*. You can't just gloss over things. You have to study every corner of the car. You have to make sure it's pristine.

I would start with some sort of dishwashing liquid. I'd put water in a bucket with a few rags, wet the whole car, and then go over it again with another rag and the sudsy water, washing it to take away the dirt and debris. I'd flick the windshield wipers up. I'd take my finger and wash through the tire rims. I would take my time, making sure it looked spotless. Then I'd rinse off all the suds with a hose.

After that, I would dry it off with a shammy. Once the car was completely dry, I would go in with the wax. There was a product called Diamond Shield, better than Turtle Wax, that I would use to coat the entire exterior of the car. After it was dry, I would go back in again with a rag and buff it out. And after it was buffed, I would go back in, with more detail now, to get any waxy residue out of the cracks and the seams of the car.

Then I would turn my focus to specific areas: I would vacuum the car first, of course. I'd use Windex to clean the windows from the inside. I'd put Armor All on the tires, then use it to wipe down the interior, whether the seats were leather or vinyl. I'd spotlessly clean the ashtrays, now emptied of their cigarette butts. I'd find the little detailed bits that everyone else would miss in a quick wash. And finally, if I needed to take a toothbrush to something, I would even do that.

I could do all of this in under ninety minutes. And I could get into it—because I loved cars.

I had fallen in love with cars as a little boy, but that love had deepened because of Gerald, who had made cars part of his business. He had started off working in concerts and promotions, then opened up a nightclub in downtown San Diego called

Mr. Covington's Club. He befriended a producer from *Soul Train* and made a deal to bring acts from their roster to town for performances. But San Diego was a tough market; the crowd was inconsistent. "All the work put into Mr. Covington's," he said. "All these tables—meeting all these people—it should be working." But it wasn't.

More than with the club, Gerald started making money buying exotic cars and flipping them. He had every major newspaper in the country delivered to him, and he would comb through the classified ads, looking for luxury vehicles in regions that undervalued them, knowing that he could pick them up, drive them to Southern California, and resell them there, where there was a healthier market. It was so much fun: Cars would come into our orbit for a month or two, just long enough to enjoy them, then move on to their next owner.

But even in that business, there was a ceiling to how much he could build his empire in San Diego, and over the course of the first few months that I was living with him and Renetta, a plan had begun to take shape. Gerald finishing college, which had previously been a priority? It wasn't that important after all. What was important now was that we all make our way to Atlanta.

Atlanta, as I understood it, represented the Black boom of the seventies. The city had elected its first Black mayor, Maynard Jackson, in 1974, and from there, it felt as if the possibilities were endless. There was money to be made in Atlanta, and people were making it; more specifically, Black people were making it. Since Reconstruction, the city had always been represented by the phoenix rising from the ashes, designating it as a place of endless reinvention. To us, then, it was a frontier of abundant potential. And for me, having been suffocated by so much about my home-

town, Atlanta was everything San Diego was not. San Diego was conservative, where Atlanta was progressive. San Diego was provincial, where Atlanta was cosmopolitan. San Diego was white, where Atlanta was Black. San Diego was the past, but Atlanta was the future.

I knew all this because I read about Atlanta in magazines like *Jet* and *Ebony*, which were the links to what was happening in the world for Black folks, and because people spoke of it often, mythologizing Atlanta as a wonderland in which more things were possible. We had witnessed firsthand how closed-off the culture was in San Diego. In Atlanta, I believed, things would be different.

I don't remember saying goodbye to my mother; that door, the door that led to my childhood, had already been closed when I had moved across town with Gerald and Renetta six months earlier. When I had come back to that house to visit, things had never been the same, and they would not be again. To the extent that I had been my mother's child, I had also never felt like I was her responsibility. My mother was too good at nourishing self-sufficiency within us for me to feel like I belonged to her.

So Renetta left baby Scott behind with my mother and Rozy until we all got settled, and the three of us—Renetta, Gerald, and me—packed up and drove to Atlanta, leaving the dry heat of a San Diego summer behind. It felt like an adventure—the beginning of something. One step closer, I hoped, to a place where I'd belong.

---

Summer in Atlanta was sticky: the drone of a window AC unit in a motel room, all of us just trying to stay cool. Gerald was a fast

talker and knew how to connect with people, and in short order we were moving in with a family in Southwest Atlanta, a preacher named W. J. Stafford and his wife, Hattie Ruth. They ran the Free For All Baptist Church in Decatur, and he'd just come out of some scandal—something to do with the IRS that had ended with him being incarcerated for fraud. The reverend would watch wrestling in the living room, which I found odd, considering how homoerotic it was. I also understood that he'd gotten in trouble with his congregation for opening a nightclub, not that he seemed to be bothered by the claims of hypocrisy. Gerald, Renetta, and I stayed downstairs, in the basement. I used to steal the church van and drive it to the gas station down the road to buy cigarettes, although I didn't have a license yet; somehow, I never got caught. But then, I was always a sneaky bitch: Even back in San Diego, I used to borrow Renetta's 1965 Ford Fairlane, which would be parked outside my mother's house, and drive it all over, never leaving any clues, returning the car to exactly where I'd found it.

Hattie Ruth called on a boy from the congregation to come show me around Atlanta; his name was Andre. He said I should come hang out with him and his cousin.

That cousin, Donny, picked us up in a 1970 Ford Mustang that was already full of church boys. Donny was wild and dark-skinned, a firecracker, like Taye Diggs but not as pretty. As soon as I shut the door, he pulled out of there in a shriek of rubber, speeding like he was in a car chase. We went to a gas station— Donny pumped the tank full of gas and then sped off without paying. Next, we stopped at somebody's cousin's house. We all got out of the car. I noticed that Donny had dropped his drawers and pulled out his giant dick. He was swinging it around. "Who gon' suck my dick?" he yelled. "Who gon' suck my dick?" I had the

feeling he was doing this for my benefit; I looked like a girl back then, and perhaps he found me exotic.

"You crazy, Donny," one of the other boys said. Donny cackled. I could see that he was the leader of whatever debauchery these church boys were up to. After a minute or two of dick-swinging, we got back in the car.

"I'm gonna get my dick sucked," Donny said determinedly.

Donny drove us to an apartment complex near the Greenbriar Mall, where we screeched to a halt in the parking lot. Me and the church boys followed him up the stairs into a second-floor apartment, and as the door opened, I went slack-jawed with surprise.

The apartment was full of trans women. That language didn't exist at the time, so they probably would have called themselves drag queens, but they weren't performing; rather, they were living in drag. They were wearing summertime women's clothes. Their makeup was a little rough, foundation covering their razor bumps. Three of them were very dark-skinned; one was lighter, a woman named Simone, who I would later see in the scene. They were all in their early twenties, which to me then seemed very old.

"Who wants to suck my dick?" Donny announced. They fell into what appeared to be a familiar choreography: The boys and girls formed couples and went into separate rooms, where presumably dicks were sucked.

I sat in that living room gobsmacked. An older queen who had stayed in the living room chatted with me for a while, exchanging pleasantries as the boys did their business. She must have been able to tell that I was an innocent in that respect. Eventually, they all rematerialized, and we followed Donny back into the Ford Mustang, speeding away again.

When he finally dropped me off back at the reverend's house, I couldn't believe what I had just experienced. This was something

very unique to Southern preachers' kids. It was my introduction to a certain kind of Black Southern morality, and the inherent dichotomy. The super-religious Black people I encountered in the South all led double lives, especially that particular group in Atlanta: As pious as they were perceived to be, there was a secret, second self roiling under the surface. And the fiercer their devotion appeared externally, the wilder that repressed self really was.

There are ideological precepts that people will fight or even kill for. But those things are never really what they seem to be. As much as people will claim a hard moral line, that line becomes very blurry depending on what their needs are at any given moment—like the conservative politician who's opposed to abortion, unless it's for his mistress.

Donny had taken his dick out for my benefit, because I was a novelty—new in town from California. I could tell that he was trying to impress and shock me with his wildness, and he had. These church boys appeared to be a paragon of Baptist morality. How interesting, then, that the sight of men dressed as women, as they were considered then, didn't cause them to recoil in moralistic horror. Instead, to them, these women were sexy, they were different, they were objects of desire to be used for pleasure. I didn't know what any of this meant yet, this realization, but I knew it was important to take note.

———

Gerald's philosophy on cars was simple: Buy low, sell high. Make cosmetic improvements, not mechanical adjustments. He was a middleman who could deliver cars in pristine condition: Rolls-Royces, Cadillacs, Jaguars, Corvettes, and most of all Mercedes. A few months after we arrived in Atlanta, on my sixteenth birth-

day, I got my driver's license at the DMV in a Porsche Targa stick shift.

The driver's license was my most treasured possession: It meant freedom, adulthood, and the ability to go to all the places I always wanted to go, of my own volition, with nobody granting permission. Never mind that I had been driving since I was eleven—and that it was obnoxious to take your driver's test in a stick shift, since it showed that you really already knew how to drive. I passed easily.

Gerald connected with a real estate agent named Royale, a white lady who drove us all over Buckhead looking at houses. She must have loved how well-spoken he was, to say nothing of the Mercedes he drove. "There's a great school for the performing arts right around here," she said. "It's actually where I went to school. It's called the Northside School of Performing Arts."

"Ru wants to be a performer," Gerald said.

"Yes, I do," I said. I had been writing songs since I was nine and had taken classes in the theater department at my school back in San Diego, although getting high was my top extracurricular activity.

In that moment, I decided, I would go to Northside. The house Gerald ended up finding wasn't in Buckhead at all. It was in Southwest Atlanta, on Greentree Trail, twenty-two miles from school. But if that was the place where stars were made, that's where I would go.

The head honcho of the performing arts department at Northside was named Billy G. Densmore, and he was a Southern queen who gave shades of Nathan Lane. I found him to be a prickly pear—forceful and opinionated—though many students loved him. I was surprised he wasn't impressed by my talent in my first months at Northside when I joined the chorus, but then, I

was more irreverent, and he was more of a traditionalist. The next quarter, in January, I began taking classes with a drama teacher named Bill Panell, who had himself graduated from Northside. He had gone to LA ten years prior, he told me, to become an actor. He had been met with little fanfare. Now he was back in Atlanta, teaching drama at his alma mater. He butted heads with Densmore, so much so that he ended up teaching at that school only one year. But his impact on me was inestimable.

Bill wanted to put up a Tennessee Williams play called *Camino Real*. I knew Williams from seeing movies like *Cat on a Hot Tin Roof* and *Suddenly, Last Summer*, and I'd seen him do interviews on Dick Cavett, who had all the intellectuals of the day on his PBS show. The play was a mess, but it was a Tennessee Williams mess: a Gothic, surrealist daydream. "This is not Tennessee Williams's greatest work," Bill said dryly. "This is a deeply flawed text. But it's a great piece to give us the space to get messy." I played a drag queen called Queenie.

The fact that I was going to be in drag didn't faze me all that much. I was primarily anxious because I was going to be onstage, in front of an audience, and I had to learn so much dialogue; that I would be wearing women's clothes was secondary. It was an extension of me performing for my mother in the living room: I was just playing dress-up, playing a role. To me, it had no political or sociological import. But to Densmore, Bill Panell's insistence that the school put up this controversial show was the final nail in his coffin.

In acting class, I became friends with a girl named Lynn Crank, with whom I rehearsed scenes from the William Saroyan play *Hello Out There!* She and I became close, and through her I became friends with her brothers, Charlie and Paul Crank. They lived in a condo in Buckhead, not far from school, and after act-

ing class I'd go over to their place, get high, and listen to the Beatles and Fleetwood Mac. Sometimes I'd just stay there at their apartment in the Cross Creek condominiums instead of finding my way back to Greentree Trail.

The Crank family matriarch, Metta Crank, had divorced their father, Dr. Paul Crank, a few years earlier. Dr. Paul Crank had married his nurse, Barbara, about which Metta was endlessly bitter. It was a classic *Alice Doesn't Live Here Anymore* scenario: She was a seventies woman who had been domesticated to be a housewife and then had been left with kids, emotionally shattered by the dissolution of her marriage, with no other skills or purpose. In my memory, she looks like Ellen Burstyn, pounding hefty pours of Blue Nun wine. The condo was always a mess, with cats mewling and crawling everywhere and the accompanying smell of cat piss. The Crank kids and I would get stoned, and once we were high enough, we would console Metta, then clean out the ashtrays and take the empty wine bottles down to the curb. I'd never seen a drunk like that—a Judy Garland drunk, who could get on the edge of cruel.

Metta was always furious that Paul hadn't sent a check yet, still bruised by the fact that this bitch Barbara had stolen him. He was such a bastard! In no time, she became like a surrogate mother for me in Atlanta, someone who could re-create the tension of my mother's home in a way that felt as familiar as a warm hug. And she knew that she could count on me to do things for her, whether that was pick up a bottle of wine or get her a pack of Merits.

All the Crank kids were bad, which was obviously thrilling to me. Lynn had recently been released from jail, where she'd been because she had done something illegal in Milledgeville; she

jumped bail, or did something stupid with her boyfriend, who was older and lived in Detroit. Whatever it was, it had gotten her in trouble. Paul was in my grade, and Charlie was one year younger. Charlie was the most beautiful of the Crank kids—he had piercing eyes, shaggy hair, and a sharp jawline—but there was something so gorgeously wounded about him, something I found tragic. It was so evident that like their mother, the kids were traumatized by the divorce, which must have been why I felt so at home there: They actually exhibited the signs of trauma that I never allowed myself to manifest. You could see their bruises in a way that my mother had raised us all to hide.

I befriended another boy from school named Charlie Meyers. He lived in the neighborhood, and his father was a preacher, so of course he was a rebel. He fancied himself a James Dean and he looked a bit like him, too: white T-shirt, 501 jeans, cigarette hanging out of his mouth. He was so brooding and angsty that it was inevitable I would fall in love with him.

We all hung out—Charlie Meyers, the Cranks, and some of the other bad kids from drama class—smoking weed and listening to music, playing Steely Dan after school. One night, Charlie drove his black Volkswagen Beetle over to the house on Greentree Trail to spend the night. We got smashed and found a bag of flour, which we started throwing all over the yard, making it snow. In the morning, the flour had gotten into the engine of his car, and it wouldn't start.

I was hopelessly infatuated with Charlie, but he was in love with an unremarkable blond girl named Melanie. One day, I saw Charlie's car parked on the street outside school. I went over to say hi, but as I got closer to the car, I could see that the windows were all fogged up. He was in there hooking up with Melanie. I

was heartbroken. Not only because I could never have him, but because I knew this was a part of the high school storyline that would never be mine, for a hundred reasons that had to do with who I was, things about myself that I couldn't change if I tried.

Deep down, I knew that the entire teenage romance narrative was bullshit: It was built on a foundation of fantasies and delusion. Yet being shut out of it was still devastating, and I craved it anyway. I was young and gorgeous, too—I imagined the rush of having that kind of freedom, to drive to school and fuck my hot boyfriend in the parking lot all day long. That's exactly what teenagers should be doing.

But as much as I lusted after boys like that, I had also resigned myself, in the same breath, to a life that would never run on the engine of those clichés. Instead, my life would be magical, set apart, different. Charlie would have girls in the back seats of cars. But I knew that I was lucky. It was never going to be me in the back seat. Being in the back seat was too easy. I'd been chosen, anointed—the universe saying: *You, over there!* I just had to be patient and wait for my bar mitzvah from the cosmos.

My grades were still terrible, of course, and Gerald had begun threatening to pull me out of school. I was mooning about it to Bill Panell one day during theater practice and he looked at me sideways. "RuPaul," he said, "don't take life too fucking seriously."

Not long after that, I stopped going to school. But I never forgot that lesson. It was of a piece with what had been revealed to me the first time I got high—that everything was a joke, an illusion, a big show. Over the years, Mr. Panell's words would become something more than that. Something like a mantra—a lucky rabbit's foot that I could always carry in my pocket.

———

When you have an eye for detail, you notice things that other people don't. Cars offer all kinds of small details. Most people are looking at the overall shape of something—checking it to see whether there are obvious signs of damage. But from Gerald, I learned how to study the seams, where different pieces of the body lined up, to know exactly whether the car had ever collided with something. I became a scholar of the little things, those minute details that tell you everything about someone or something, the little peeling corner that pulls away to reveal something underneath you might never suspect.

Gerald had become friendly with a woman named Lenore Adams, who was connected to Black society in Atlanta; she was upwardly mobile and social. After school some days I would hang out at the office she shared with her husband, who was a successful attorney, and wait for Gerald to pick me up on the way home. I didn't have much to say to Lenore, who was churchy and sanctimonious like a lot of the women in Atlanta.

But one day, when I was waiting for Gerald, I heard her voice. "See those two guys?" she said, trying to get my attention. I looked up as two men entered her husband's law office. They were dressed in a style that I would later come to associate with Tom of Finland: Levi's, a black T-shirt, and a black leather vest. They had bristly mustaches and soft eyes.

"They were arrested at a raid," Lenore said conspiratorially. "At a bookstore called the Underground." She leaned in even closer. "For sucking each other's dicks!"

"What are they doing here?" I asked.

"My husband's defending them," she said.

These men belonged to a subversive world, one that I equated with sex, with pornography, with transgression. Now I knew that there was a place in Atlanta that might be the nexus

of that world. It took me nearly a year to summon the courage to go there myself, but eventually I did. I borrowed Gerald's latest car—a beige Mercury Montego with a brown top, a company vehicle for the job he'd gotten working at American Express—and I drove it into midtown, to Cypress and Fifth Street. I circled the block for a while until I saw a man who also looked like he was cruising. He was Black, with an Afro, and I thought he was sexy; I would have guessed that he was twenty-one. Finally, after circling a few times, I parked and went into the Underground. As I opened the door, I looked behind me to see the same guy running across the street to follow me inside.

It was called the Underground because it felt like it was underground, as if it were built into the side of a hill; part of the roof was covered by the ground. Entering, I found that it smelled musty, too—of mildew, poppers, and leather. There were recessed lights with long beams tracking down the hallway. I paid twenty-five cents to pass through a turnstile at the front door; they didn't card me. I was so nervous. When I turned the corner, there was a long hallway of doors lined with men. A man with a mustache stood at every single doorway—white guys with thick, bristly mustaches like the construction worker in the Village People.

Panic rose within me, but I was hell-bent on saving face. *Nothing is wrong.* But I didn't want anyone to touch me. I didn't even want anyone to see me. *I'm just doing research. This is an anthropological experiment.*

As I passed through the gauntlet of Village People, I saw an open doorway. I paused at it. As I did, the man who I had seen on the street signaled for me to follow him into the room. Inside there was a projector that emitted a low hum. I stared at it like I wasn't sure what to do with it.

"You just have to put a couple quarters in," he said softly. He slipped them into the machine, one after the other. He must have felt how nervous I was, that I was trying to act unbothered. He moved closer to me. Then his hand grazed my elbow.

I jumped out of my skin. As fast as I could, I slipped past him and back into the hallway, where I ran past the turnstile and out to safety.

As much as it had intrigued me, that place was also the epitome of everything that I had been taught to fear in the world. And this—the simultaneous existence of this alternate world that was adult and powered by sex and taboo and pleasure and transgression, with the moralistic world that took place right on the surface—for the moment, that duality was too much to bear. I felt caught between both dimensions. I didn't belong with the church boys and their compartmentalized debauchery, nor did I belong with Charlie in his car, and now I had found that even here, in this place of fully realized sexuality, I did not belong. So if not in any of these places, then where?

I had learned from my parents that intimacy was dangerous. That to give yourself over to a man was dangerous—that it could only lead to ruin.

I would learn from my mother's mistakes. I would be smarter. I would not be undone by the stupid, primal desire to be held by a boy in the back seat of a car.

———

Jogging out to the car, I twisted the key in the door, unlocking it, then slammed it behind me. I sat there for a minute. The lingering, medicinal smell of Armor All was still in the air. I took a deep breath. The supple leather, the spit-slick dash.

That car was clean as a whistle.

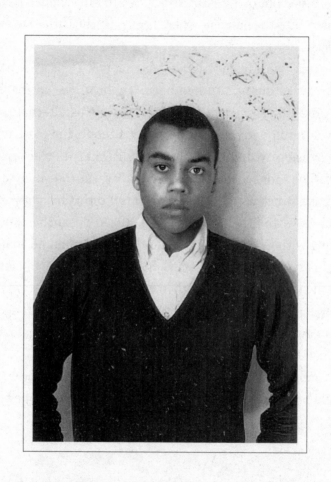

*"Much as we seek power in*

*every corner of our lives,*

*it's always already in us;*

# Power

*it's impossible to be powerless*

*if you recognize that you*

*yourself are power.*

*Life is power."*

The first winter I spent in Atlanta, Renetta went back to San Diego to give birth to her first daughter, Morgan, and to pick up Scott, who she had left in the care of my mother. That meant leaving me and Gerald behind in Atlanta for a time. Renetta had never tried to mother me, but she was responsible in ways that Gerald wasn't. With her away, we were free to turn the house on Greentree Trail into a bachelor pad. It wasn't much of a challenge: Gerald had gotten the house on a dime because it was only half-finished and certainly not up to code. The house wasn't fully heated, but there was a big, grand library downstairs with a fireplace. As the nights got colder, we slept in that one room with the fire lit to keep us warm. One evening I came back to the house and there were a few people, friends of Gerald's, gathered in the library with a glass pipe—not the kind you'd use to smoke weed, but thin with a long glass stem and a spherical bowl at the end.

"Ru," Gerald said. "Come sit with us."

I joined the group as we sat round-robin and freebased cocaine. There were no flashing alarm bells, no caution signs on the side of the road; the crack epidemic was years away, and the counterculture of the sixties was still the spirit of the time. Using drugs represented participating in the social enlightenment—a rite of passage that ushered you into the next frontier of human experience. It didn't mean you were self-destructive; rather, it meant that you were progressive. But this felt different. The ritual of chopping the cocaine and cooking it down with a propane lighter had a possessive, hungry energy that was dark, whereas smoking weed had always felt goofy, fun, easy. As my buzz waned, I watched the person next to me fumble with the pipe, luxuriating in their hit. I felt a sudden pinch of urgency. *Why were they taking so long with it? What kind of games were*

*they playing at?* It was startling, the greed I felt, forceful and foreign, and I understood quickly there was something evil in this. Smoking cocaine, I concluded, was not for me.

Gerald seemed to like it, though. He'd always had a free-wheeling streak, but now it felt tinged with danger. One day in late winter, Gerald and I drove down to Forest Park, south of Atlanta, watching as the suburban mansions turned to fields. It was raining, which gave the late afternoon sky the feeling of a horror film—gloomy and gray. We slowed down as we arrived at a wide field that had been cleared of trees and watched two guys, white guys, walk through the dale toward our car.

As they got closer, I could see they were rednecks, and there were guns slung around their torsos. But when we got out of the car to greet them, they flashed warm, gap-toothed smiles. One of them produced a brick of marijuana, and Gerald paid him for it.

After the transaction was done, the one carrying an Uzi fired a few rounds into the empty field. The bullets sprayed rapidly. There was an effortlessness to it, as if he was doing nothing more than letting off steam. "It's a semiautomatic," he said to us. Then he looked at me. I must have been eyeing it with some mix of apprehension and curiosity. "Do you want to try it?"

I nodded.

"Just make sure that you brace yourself," he said. "It's got some kick to it." He showed me how to wedge the butt of it into my side so it wouldn't knock me off my feet.

I felt its weight in my hands, cold and powerful. I braced myself into the ground and fired, scattering bullets across the field. It was the best feeling I had ever felt; it was so easy, so compact. It held so much force. The smell of gunpowder lingered in the air. On this rainy, dusky evening, the bullets were like a fine mist spraying the ground.

"That was amazing," I said.

Having been raised by television and the movies, I knew that every hero and villain has a gun. To hold that in my possession, next to my body, and pull that trigger—you could feel, viscerally, the strength and the damage that this weapon could cause. I felt omnipotent in a way I'd never experienced before. I had imagined it, the way it might feel. But this exceeded the limits of my imagination.

It was intoxicating, this feeling, but it was also frightening. And dangerous. Why? Because the power was temporary, and ultimately illusory; you can only feel it when you're holding the gun in your hands. It's not enduring. It disappears as soon as it's been taken from you.

The big lie of our lives is that we are powerless—that we need something else, like a job, or a partner, or fame, or the dopamine hijack of a hit of cocaine, or the chilly metallic weight of a gun—to grant us power. We mistake easy pleasure, or a rush of adrenaline, for power. But real power isn't a high: It's something else, grounded and secure.

Much as we seek power in every corner of our lives, it's always already in us; it's impossible to be powerless if you recognize that you yourself are power. Life is power.

Finding that power within yourself—that's the hard part.

———

Now that I had a driver's license, Gerald put me to work. Collecting newspapers from all over the country, he would circle the advertisements for luxury vehicles that he knew he could flip: in Kansas City, DC, Chicago. Then he would book me a one-way plane ticket to that city, which I was happy to take—I had plenty of time on my hands since dropping out of school.

I would go check out the car, confirming that it was in good condition—ensuring that the seams hadn't been tampered with, and the odometer hadn't been turned back to make it seem as if fewer miles had been driven on it, and that there weren't cracks in the windshield that would diminish the value of the car. If everything checked out, I would hand the seller a bank draft—a promissory note that they could take in and cash. Then I would leave with the title to the car.

I would drive these cars back to Atlanta, where Gerald would have them detailed—polished to gleaming perfection. Then he would sell the cars in the area. His mission, as he put it, was to put the Falcons, Deacons, and Braves in foreign cars. From there, it trickled down through the culture—airline pilots, megachurch pastors, business executives. He made imported cars a hot commodity all over Georgia.

Sometimes he would sell the cars to buyers in San Diego, so I was tasked with driving them back. After first moving to Atlanta, I drove across the United States perhaps fifty times, staying in San Diego for a few days each time. Sometimes I would fly back from San Diego to Atlanta. But more often I would wait for a car there, which I would then drive back across the country.

I loved it—oh, I loved driving! There was a CB radio craze in the midseventies; pop culture had become enamored with them, even though they had been around forever. A novelty song about CB radio, C. W. McCall's "Convoy," became the number one song in the country. There was a renewed romanticism over highway travel. Driving cross-country made you feel like you were a part of something beautiful—joining in a storied American tradition.

Back then, there was a code of the highway. Slow cars stayed in the slow lane. You used the fast lane sparingly, just so you could pass, then moved back into the slow lane. To me, it was

the perfect distillation of how a system should work: It was an acknowledgment of the established roles of the universe, like the impala and the cheetah. The person holding the gun, and the person standing before its barrel.

These power structures didn't feel oppressive; instead, they were organizing principles. A culture of civility undergirded the experience of being on the road. Letting someone pass you, sharing a friendly look of acknowledgment across lanes as they did—this made you feel proud to be an American, to participate in a system that was ruled by mutual respect.

Americans have always been frontiersmen, people who are open to a new adventure, and I felt this as I drove cars alone, back and forth, across the United States. From San Diego to Dallas was desert, but the desert was not monotonous. In New Mexico and Arizona, you'd see majestic mountains, far vistas, jagged cliffs. Then farther east, cutting through the South, the landscape lit up with green forests, crowded with kudzu.

I'd stop at a truck stop or a gas station, collect a speeding ticket from a good-natured highway patrolman, eat a fast-food burger, look up at the sky. Most of the cars had sunroofs, which I'd leave open all night. In the middle of the desert, with no other cars around, no other people around, looking toward the stars—that was a rare kind of magic. And there I was, sailing ahead, down a dark highway, knowing that I would find my way home.

———

Because I now had family in both San Diego and Atlanta, I moved fluidly between the two cities. Back at my mother's house, things were much the same—but also, in subtle ways, different. My mother's confidence had returned after the hibernation years that followed her divorce from my father. She had gotten a job,

become more dependable—had even, at the age of fifty-two, finally learned how to drive, gotten a driver's license, and bought a car of her own, a Volvo. By the way, I still own that Volvo. Growing up, she had been dependent on Rozy and me to take care of basic things around the house. Now, with me out of the house and Rozy set to graduate, she had become more self-sufficient.

In a family where everyone is traumatized, there's a kind of uneasy solidarity in the trauma—the shared, silent look of understanding between passengers who survive the same plane crash. But then you slough away the scabs from whatever you've been through and start to heal, and in that health, people become tougher. So it had been with my mother, who needed us less for the practical things as her hatred toward my father waned.

In the same breath, it was easier for her to champion me in little ways. I was interested in punk rock, disco, and dancing. On one brief move back to San Diego, I decided I wanted to start my own band, so I put out an ad in an independent newspaper, then auditioned those who responded. I found these two white boys from El Cajon who didn't know each other. We rehearsed a few times until I decided that we should cover the song "Because the Night" by Patti Smith, from her album *Easter*. I had no money—not a dime—so I begged my mother to buy it for me. "I don't have that kind of money," she said. "I can't be buying that shit."

"Mama," I said. "This is something I need. It's my future. If I'm going to become a star, I need a band. I know this song will suit my voice." Eventually, I wore her down, and she gave me the seven dollars I needed. It was a sign that she believed in my destiny.

Not long after that, she got me a gold chain that I still have, a series of interlocking rectangular links. "Keep this," she said. Then she added, a bit grimly, "If you ever get in real trouble, you can always hock this for money." I understood from these small

gestures that she wasn't as distracted by her personal, singular pain as she had been before. Now she had softened within herself, which allowed her to soften a bit toward the world.

Rozy and I, having been close in age, had always spent a lot of time together, but we were also different in some elemental ways. When I was nine, I remember asking her, almost as an accusation, "Don't you want to be a pop star?"

"No," she said. In her voice was a note of bewilderment: *Why would anyone want that?* I couldn't imagine why anyone *wouldn't*. Sky-high wigs? Private jets? Hordes of adoring fans? What could be better?

Now that we were older, we ran with the same group of friends whenever I was back in San Diego: Lamar and Jimmy Kendall. The same brothers I had hung around with all those years ago—and all these years later, I was still hopelessly in love with Lamar. The Kendall boys' mother would be out all day, leaving us to get high at their house, splash around in their swimming pool, and play records. They had Sylvester's album *Stars*, the title track of which was eight minutes long, and it was killer—a soaring electrofunk number. I could listen to it all day.

I had recently gotten into photography after inheriting Renetta's old camera, a Nikon, and taking a class at the South Fulton County Vocational School my first fall in Atlanta. The teacher was named Mr. Barnes, and I had a crush on him; he was a white dude with a mop of brown curls, sweet and soft-spoken. He taught me about light and composition, how to frame a picture.

Now I would take pictures of Lamar, who was happy to be my model. And I, in turn, was happy to photograph him. The process of it was so intimate, which lent it an erotic charge. He was tall and athletic, and he had a full mouth and pinched nose; his skin was a rich caramel. The sweetness he'd had as a boy, that had made me

fall in love with him when he waited on my porch to walk me to school, hadn't evaporated, as it sometimes does when boys turn into men. There was a kindness to him—a sense of justice. He wasn't trying to express his masculinity through bravado.

I had always kept a poker face with Lamar. To be a gay kid, especially around Black folks, was to be in a continual state of secret-keeping, of pretending. Trying not to feed that coiled snake of yearning within me, even though it was breaking my heart, was an exercise in stoicism.

I can't remember when I found out that Lamar and Rozy were dating. Maybe I've blocked it out, the slap of that realization. Fate had brought me the cruelest hand: This person that I'd fallen in love with at twelve years old and could never have, and had never gotten over, was now dating my sister. The only upside was that I got to be around him a lot because of it. Yet having a deep feeling and suppressing it was familiar to me. Growing up in my family, I'd always had to be politic—to be diplomatic with my mother when she would ask after my father, and vice versa. It had taught me to tuck away my emotions, such that I never showed my hand.

My mother liked Lamar, and she hardly liked anyone. She thought Lamar was very real. But one night I fell asleep at the Kendalls' place and woke up with a boiling heat in my mouth; Lamar had put hot sauce on my tongue while I slept. My eyes watered as I ran to the sink to wash it out. It surprised me—he had always been so sweet—and the memory stuck with me, because it was the first time I'd experienced cruelty from him, for him to allow me to be the butt of a practical joke.

I began spending more and more time back in San Diego on those cross-country road trips. I volunteered at the college radio station, cataloging crates of albums that the DJ had played. One day a guy came into the office. He looked Mediterranean, tanned

with curly black hair, and he was wearing shorts so tiny you could see the crease of his ass. His legs were hairy and muscular. He flirted with me, and again, I froze; I was allergic to his desire, still too closed in life to activate on it.

Other times, at night, I would drive to the areas where I knew gay people hung out, but I wouldn't get out, or walk into a cruising area. My brush with sex at the Underground in Atlanta had been more than enough. I was trapped in a liminal place: craving intimacy, but terrified of it. But I also knew I needed someone to help me decode who and what I was, which wasn't something anyone in my social world was equipped to do.

So I went to the gay center on Golden Hill. It was located in a turn-of-the-century Victorian house with creaky wooden floors and a musty smell, like dry wood and old paper, as if the house had been insulated with newsprint. Every step you took, the floors creaked; the whole house just groaned. I told the receptionist I wanted to talk to a counselor, and she directed me to a man named Andrew.

Andrew had long hair and fine features—the kind of man who you could tell, just by looking at him, was intelligent. He was thirty-six at the time, he told me, and he had come out as gay six years earlier. He asked me how I felt about being gay, and I told him that I felt alienated from the world. I didn't know many gay people, if any at all, and I knew I needed community. Later, I would find out that I didn't have as much in common with other gay people as I assumed I would. The only thing we really had in common was that we preferred dick. My tribe was bohemian people, some of whom were gay and others of whom were not. The point was, we had an ideological alignment that superseded our sexuality. But I couldn't know any of that at the time.

Andrew was reassuring. There was an even-keeled quality

to him, something solid and grounded that made me feel imme-diately safe. I went back to see him week after week, telling him about my life, my family, my friends, the way I felt. During one of those sessions, as we were saying goodbye, he asked if he could kiss me—a real kiss. The question caught me off guard, but as ever, I kept my poker face.

"Sure," I said.

His face was very close to mine. He was clean-shaven, and I could smell his Old Spice deodorant. I realized that he was tall, nearly as tall as I was. And when he kissed me, deeply, my knees buckled. Isn't that funny? I had kissed a girl before, I suddenly remembered, a girl named Tina in my neighborhood. I kissed her in the garage of my mother's house on Hal Street. I was sit-ting on a chair, and she was sitting on my lap, and we kissed, while a circle of neighborhood kids gathered around us, watch-ing, not because there was any lust or intimacy between us, but because it was something to do. But kissing Andrew felt like a breakthrough for me. I had officially crossed over. I had kissed a man. And I knew, from the way my body reacted to the kiss, that it was right. That it was what I had always wanted.

Not long after, Andrew and I talked about having sex. "We have to wait until you're eighteen," he said. To me, the distinction felt arbitrary, but it was clear that it was important to him. After my eighteenth birthday, I met him at his apartment, which was a few blocks away from the center. He was sweet, and slow, but the entire thing felt more like a ritual than like the consumma-tion of desire. I remember wondering: *Is this all there is?* I wasn't connected enough to my body to experience anything beyond physical sensation. We hooked up a few more times.

The last time we had sex, at his apartment, he had friends coming to pick him up to go somewhere. He asked if I wanted to

meet them. "I would love to, but I have to go," I lied. I had a sense of these men, and I knew that I would never fit in with them, and that knowledge made me sad, in an odd sort of way—the knowledge that I could share this experience with this man, be so desired by him, and yet I would never belong to the world in the way that he did with his friends, these white San Diego gay guys who replicated normative straight culture in their own little territory, with their codes of masculine presentation. I understood, even in a nascent way, that there was a divide between who is acceptable to society and who is not. The men who could pass for straight if they wanted had a form of privilege that people like me, people who could never pass, never would. Later, when my career had blossomed, I would cross paths with masculine white gay men who looked at me with a kind of seething hatred, a self-loathing turned outward, their internalized homophobia like a sneer of contempt. To them I would always be a flamenco dancer, interrupting the well-rehearsed choreography of their line dance.

It wasn't just white gay men, of course, who had bought into that cult of masculinity. When I was nineteen, I was in Balboa Park when I walked past a guy—he was Black, handsome, and about my age, maybe a few years older. I heard him say, "Hey, good-looking."

I turned around. "What?" I laughed. I hadn't been catcalled before.

He told me he was in the navy, stationed in San Diego. He was from Pine Bluff, Arkansas. "My name is John Wayne," he said. He smiled. "Yeah, I know. It's a lot to live up to." His very name recalled a tradition of masculinity—the ultimate man's man.

We spent the rest of the day together, and soon we were sneaking off to my mother's house when nobody else was there

to hook up. We had sex in the back of her Volvo in Balboa Park. I picked him up at the navy base, and once, I remember, I met up with him in Los Angeles at a pink church on Vermont Avenue where he was getting out of some kind of service. We had sex there, too, in the parking lot, in the back of the car.

After a few weeks, he called me from the hospital, where he'd been ill with appendicitis. I went to visit him at the veterans' hospital in Balboa Park, the same place where we'd met.

"After going through this whole ordeal . . ." he began. I wondered what was coming next. "I've been thinking a lot about Jesus. And I've realized that what we're doing just isn't right."

"Really?" I said. "Honestly?" He looked at me. "There's nothing wrong with what we're doing," I told him. "We're just having fun." He looked down at his hospital gown, as if he were embarrassed.

"Are you sure?" I asked.

"I am sure," he said.

I never saw John Wayne again. The ultimate man's man didn't fuck other men.

————

The only thing left to do was to keep driving, and so I did. Back and forth, across the country, in one car after another: a Jaguar XJ6, a BMW 2002, a Mercedes 450SL. Car culture was an important symbol for America; these vehicles represented unbridled style and power, and you felt that when you were driving them. On one trip, driving a Mercedes cross-country, I picked up a hitchhiker— a good-looking Black guy—somewhere in Arizona, driving west. The car broke down in the middle of the night. This happened from time to time, and this was a temperamental vintage European car, so I found myself in the position of having to think on my feet. Having been raised in a household that privileged

self-sufficiency, I sprang into action; the hitchhiker, not being particularly resourceful, had no skills to offer. I resented him for that—the luxury of his ineptitude, the fact that he could sit back, helpless, while I solved the problem for us both.

On another trip, I drove with my cousin Welby, who was the glue that held our extended family together: Everyone loved Welby, even my mother, who hated everyone on my father's side. He was quick to laugh, easy to be around, and like me, he loved cars. When I was thirteen, he had picked me up in San Diego in a Pantera, a beautiful Italian sports car that had just begun to be sold in the States, and I couldn't believe how glamorous it was.

Welby and I had stopped to see another cousin in Fort Worth and were heading west on I-20 on our way to San Diego, passing through Weatherford, when we saw flashing lights behind us. "License and registration?" the officer said. But because we were flipping the car, we didn't have the registration.

When this had happened before, I could usually explain it to the cop and they'd cut me some slack. But not in Weatherford, Texas. They had us follow them to the police station, where they placed Welby in custody. I called the cousin we'd seen in Fort Worth on a pay phone—how did I even have the number?—and she agreed to drive to Weatherford and bail him out.

The sheriff's station was on a town square so picturesque it looked like a studio backlot. I remember thinking to myself, *This seems like a nice place to live*. It was late at night, maybe eleven o'clock, and I paced around wearing a pair of cutoff denim shorts, a tank top, a tiny jacket, a cowboy hat, and cowboy boots—as was my wont. I truly could not have looked gayer. The cops had to wake up the judge, who had already gone to bed, to sign off on Welby's release. But once bail had been posted, we were back on our way—the whole detour taking only a few hours.

The real offense, of course, was that we were two Black guys driving a nice car; I knew that. But our luck prevailed that night.

When Welby and I got back on the road, we wanted to get as far away from Weatherford as we could. We drove through the night, all the way to Phoenix, laughing the entire time.

Some of my solitary memories on the road are strangely fond. I was a devotee of David Bowie, whose album *Scary Monsters* I played constantly while I was driving. I was excited when he was going to be interviewed on *20/20* about his Broadway debut in *The Elephant Man*, but the interview was airing in the dead middle of my road trip. I checked into a motel in Wilcox, Arizona, just in time to watch the special. The room cost eleven dollars, and it remains, to this day, one of the loveliest hotels I've ever been in—clean and dimly lit, with a soft chenille bedspread and a heater attached to the wall that kept the room warm and cozy. I sat, contented, happy to be with only myself for company, and watched Bowie on television. I had everything I needed.

---

Lamar and my sister had broken up, but I was still spending time with the Kendall boys whenever I was back in San Diego. I had cooked up a plan: I was going back to Atlanta, and this time, Lamar was coming with me. It didn't take much to sell him on the vision of Atlanta, the same vision that had sold me: It was common knowledge among Black people that this was the place to be, more so even than DC, or Houston, or New York. Atlanta was the place where Black culture was being shaped. Gerald didn't have a car he needed me to transit, so my plan with Lamar was to take the Greyhound across the country; it would be two and a half days on a bus.

The day before, Lamar bailed. He offered some excuse: *I'm not*

*ready. I don't have my finances together.* Something like that. But I knew that it was really about fear—that he wasn't ready to take that kind of chance. I was undeterred. I would make the journey by myself, and I told him so.

But inside, I was shattered. His canceling on the plan solidified the awareness I'd had for a long time that these figures who were just like my father—these charmers who made empty commitments, writing checks they knew would bounce—would always disappoint me. Eventually, I knew, I would have to stop expecting that the outcome would ever be any different.

I was used to being let down by them because I'd felt that from my father so many times. I genuinely believed that I would do something important in my life, and I knew this belief would bear fruit. I had moments of doubt, certainly, but I never lost my faith. So many of the people I knew, particularly the men, were bullshit artists. They overpromised and underdelivered.

Being on that bus all alone, when I'd thought I would be with Lamar, was like passing through a psychic birth canal. As the bus drove through El Paso, the sun was going down amid a dust storm. Everything turned orange, like in a Scorsese film—a hypnotic surrealist dreamscape. I couldn't believe my eyes. I knew, from that moment, that my life would never be the same. That I was letting go of something important, much as it hurt.

In Monroe, Louisiana, a couple got on—a Black dude and a white girl. At night, everything was quiet as the passengers slept, but I was awake, gazing out the window. I could hear him trying to convince her to give him a blowjob.

"No," she said. "I don't want to."

"Baby, come on," he said. He coerced her, wearing her down until finally she said yes. Then I heard the unzipping of his pants, the smacking of her lips, wet and noisy.

Life was just like this, sometimes. You think you're going to sail off into the sunset with Prince Charming, and instead you end up listening to a stranger getting his dick sucked on a Greyhound bus. I knew that this was the end of Lamar Kendall, and that was just fine.

There was something else out there waiting for me—something, someone better.

———

Atlanta remained a waystation for me. I had left school, and my little community—the Crank kids, the friends I'd made in theater—had dispersed. I would take trips for Gerald, then find myself bored, killing time at Greentree Trail.

Over Thanksgiving, Renetta and Gerald took the kids to the Dominican Republic on vacation. I stayed behind, with an empty house and a banana-yellow Ferrari that I drove to a club called Numbers, an enormous disco on Cheshire Bridge Road.

There, I watched a woman named Crystal LaBeija perform. She emerged onstage in a camisole, panties, and a garter; she looked so convincing that at first, I asked myself, "Is that Donna Summer?" But by the end of the number, I knew it wasn't, because she was so much more dynamic onstage than Donna ever was, lip-syncing "Bad Girls." My jaw was on the floor.

Driving home on the freeway, listening to Donna Summer's "Our Love"—it really felt like nothing could get better than this, this music, this fast car. This was the only sensation in my little life that activated me. I watched the speedometer tick up. I felt the pedal underneath my feet. The bass throbbed through the speakers. I belonged to no one but myself, this moment, and this beat, and that was enough.

———

Back in San Diego not long after, Renae and I were sitting in the living room of my mother's house on Hal Street one afternoon when she got a funny look in her eye. "Daddy wants to talk to you," she said. I had the immediate sense that she had practiced saying this; she didn't want to hurt my feelings, nor did she want to put me on the spot. She was trying to warn me. She wanted to prepare me for what was coming.

"About what?" I asked. I had barely spoken with my father in years.

"Somebody saw you in Balboa Park," she said slowly, "with some people that they know are gay."

My stomach dropped. Not so much because of the possibility that my sexuality would be revealed, but because I knew I was going to have a real, substantive conversation with him, which I had avoided doing for so long—maybe for my entire life. His interest in me had always been so superficial, so noncommittal, that my first thought wasn't concern for the revealing of this secret, if you could call it that. It was, instead, how fucking *dare* you have any concern about *that*?

He'd found it so easy to talk to my sisters, saying, "Hey, puddin'! Hey, princess! C'mere!" in his slick, charming way. But for me, he had nothing—not even a scrap. As for my being gay, I'd been informed of it by the kids in my neighborhood years before; this could hardly be breaking news to my dad. A resentment inside me was roiling, bilious—I hated that he was putting me in this position in the first place.

On a Sunday, he came and picked me up. And I was prepared. I knew exactly what I was going to say to him. We drove to Golden Hill Park in silence, parked the car, then walked to a bench and sat down.

When he finally spoke, the tone was heavy, and he said it just

the same way Renae had. "Some people told me that they had seen you in the park," he said, "with people that they knew were gay. Is that true?"

When I replied, it was slow and deliberate. I didn't let my anger overtake me. I was cool. "How dare you have the nerve to ask me about my personal life, when you have never had any interest in me?" I began. "We haven't received a dime of child support from you. I haven't received an ounce of emotional support from you. So it's none of your business."

He stammered something back at me. I could tell he was surprised by my reaction. But there was nothing more for him to say. I wasn't even certain the scenario he'd described was real. I wished I'd been hanging out with a bunch of gay people in Balboa Park, but I didn't have enough gay friends for that to be true. The whole thing may have been a setup by some friend of his who suspected I was gay and wanted to have it confirmed.

But what really broke me was to understand, as clearly as I'd ever seen it, just how small and selfish my father's worldview truly was. It would never have occurred to him to wonder if I was happy, if my friends loved me for who I was, if I was loved at all. The only time I landed on his radar was when there was a chance I might reflect poorly on him—that there was a possibility he might be embarrassed by having a son who was gay.

———

My father had been so involved with my sisters. He loved the ladies. Fawned over them. Praised their beauty. Adored them.

This was how the world worked, after all.

What would it be like for me to become the prettiest girl of all?

Now that—that would be real power.

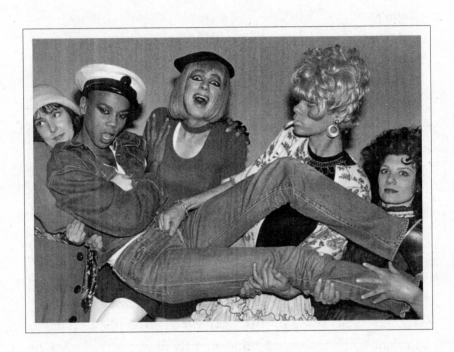

*"I can't explain the magic that*

*enlivens those performances,*

*other than a sense of play—*

# Belonging

*a spirit of goofy, childlike fun,*

*an unwillingness to step into the*

*quicksand of life's self-seriousness."*

I was driving on the highway one day in Atlanta, listening to the college radio station, when I heard an interview. A man named Tom Zarilli was talking to a woman named Elouise Montague about a television program they both appeared on called *The American Music Show*. I could tell from the rhythm of their conversation that they were both oddballs. I liked the way they spoke to one another, with a goofy, musical cadence; a spirit of play animated them. I resolved to watch their show.

And so I looked for it when it came on public access television. Public access was a relatively new creation. Television providers had been digging up the streets to install cables, and as part of their agreements with the local government, they'd allocated channels on their systems for anyone to air their own programming. Broadcast was available first come, first served to anyone in the community. It was through this medium that *The American Music Show* was shared with the public, prerecorded on VHS tapes and delivered to the cable provider. A year earlier, in 1981, Sony had made the first mass-market video recorder available, a handheld device with a battery pack you carried on your waist. It had democratized the medium completely.

The aesthetic of *The American Music Show* was unorthodox and raw; there was none of the slick production that you found on other channels. The show was shot on a shaky handheld camera and opened with two people, the hosts—James Bond and Dick Richards. They sat in front of a bookcase in a room crowded with stuff—irreverent knickknacks, memorabilia, old television sets, yellowed paperback books. It immediately established the world of the show as one of intellectual irreverence. James and Dick would talk about current events, then invite guests on, as casually as if it were *The Johnny Carson Show*. The guests would sing a song while playing guitar or perform a dance number or just sit and chat.

In one of the first episodes I watched, Elouise, the woman I'd heard on the radio, sang a Bessie Smith song accompanied by a guitarist. She had a childlike innocence and beautiful doe eyes. She looked as if she had just stepped out of a thirties MGM talkie, wearing thrift store clothes and a flapper bob. In the bridge of the song, she tap-danced.

There was something about it all that felt fresh to me. It wasn't trying to be slick, or polished, and the scruffiness of it made it inherently punk rock. The do-it-yourself energy of the production told me immediately that they were all in on the joke of life—that they had a willingness to explode the absurd self-seriousness of performance, that they wouldn't take themselves too seriously. That sensibility was now like a religion for me, and had been ever since I'd first heard it crystallized by Bill Panell.

I had grown up watching Monty Python, which I loved because of their willingness to poke fun at gender, politics, and religion—everything that was sacred in the American consciousness. *The American Music Show* was less slapstick, but like Monty Python it wasn't careful, safe, or precious. Its ethos was rooted in underlining the absurdity of life. I knew I had been looking for a tribe; it was something that I had longed for all my life. Watching this show was the first time I'd ever had a sense that my tribe existed. I just needed to connect.

At the end of every episode, the hosts included a post office box where you could send mail to them, and so I wrote them a letter. I told them I was a big fan of the show, that I was someone who was a future star and that I'd like to come on and perform. Then I crossed my fingers for a reply. About a week and a half later, I got a call from a man named Paul. "We got your letter!" he said enthusiastically. "We'd love for you to be on the show!"

"Really?" I said.

"Yeah!" he said. I couldn't believe it. I was so honored that they were willing to put me on television. Later I'd find out they were the ones who were over the moon with excitement: I was the first person who'd ever written in and asked to be on the show.

———

Disco had dominated the charts for my whole adolescence, which had been just fine by me. I can still remember, with perfect clarity, exactly where I was the first time I heard Donna Summer's "I Feel Love" playing on the radio: in a navy blue four-door Lincoln Continental with my mother and Rozy, on an off-ramp on a San Diego freeway. All the hairs on my neck stood up on end. Every time I heard disco, anywhere, I was transported by the groove.

But in the late seventies, disco ceded the floor to punk as an anarchist streak had taken hold in the culture. Then, in the summer of 1979, a radio station in Chicago incited a ritual burning of disco records that ended in a riot. White men clocked disco as the domain of Blacks and gays. They'd let it have a good run, but now, they decided, enough was enough.

In place of disco and after the angry rush of punk came new wave, which borrowed from punk's DIY sensibility while incorporating the synth-driven sounds that got you to the dancefloor. New wave wasn't just a sound. It was a visual style and an attitude that was rooted in irreverence—a wink at the establishment, or even an elbow to its ribs. I embraced the punk ethos but saw myself as a new wave artist, and I knew I wanted to bring that energy to what would be my first televised performance on *The American Music Show.* The title of the show itself was a nod to the ridiculous, a way to sneak past detection with a name that was both anodyne and authoritative: Not just an American

music show, but *the* American music show! It was positively undeniable!

I had moved with Gerald and Renetta to their newest house on River Overlook Drive out in Sandy Springs. They didn't have much of a reaction to my announcement that I was going to be on television. Like everyone else in my family, they understood that I had a destiny, and it *would* be fulfilled. They never knew how, or through what avenue; they never understood my dalliances with punk and now new wave. Rather, it was understood that I was operating in the tradition of rock 'n' roll, conceptually if not sonically—that there was a spirit of rebellion that suffused everything I was doing.

I was still working for Gerald, going down to the Atlanta public library and scanning the newspapers for used car listings. Gerald was tough but fair: "If you can't come back with what I want," he would say, "come back with something better." Leaving the library a few days after the call from Paul, I found twenty dollars on the ground. It felt like serendipity; I never had any money. I went to the lounge at a nearby hotel to treat myself to a cocktail, where I struck up a conversation with a waitress. Her name was Robin, and she was a hoot—a white girl, a few years older than I was, who had a two-year-old baby. She lived with a roommate named Josette, who needed help moving. I agreed to help her.

Driving the truck across town, it suddenly occurred to me: My group should be called RuPaul and the U-Hauls. I knew a girl who performed under the name Patty O. Furniture, which was peak new wave—a goofy undermining of this tentpole of postwar consumer culture. I, too, liked the idea of taking a brand name and flipping it. Robin and Josette, I thought, could be my U-Hauls.

We were a group, not a band—we wouldn't be playing instruments. We were just going to be fabulous, in a Warholian way. We

worked out a routine to Junior Walker & the All Stars's "Shotgun" that was mostly recycled steps from a dance number I'd done years earlier with Rozy. It didn't take too long to rehearse; the song was only two minutes and thirty seconds long. And we fashioned costumes—tasteful ones, of course, like leopard-print catsuits with fringe down the side.

The studio where the show was shot didn't look like much of a studio, because it wasn't one—it was the apartment building where James, one of the producers, lived with his mother. She had the upstairs unit, while James lived in the basement. Walking in, the first thing I saw were stacks of newspapers piled on cheap linoleum, giving the immediate sense that someone was collecting something. There were harsh fluorescent lights overhead, magazines and boxes half-obstructing the door to the "studio." The stale aroma of cannabis wafted from the space. It wasn't what I'd imagined it to be, some epicenter of cultural awakening. It was far more basic. But even that was an object lesson in something that I had suspected, but needed confirmed: that somehow, through the lens of a television camera, everything becomes magical.

We had to adjust our choreography because the space was so cramped, but in the end, the show creators were happy with what we did. We were welcome back any time. And so I went back within a week or two, and I would keep going back for the next eight years.

———

James, I learned quickly, was an oddball—a stoner and a slacker, but a sweetheart. He had caramel skin and curly, salt-and-pepper hair, and he guffawed after everything he said, like a tic.

The first time I watched the show, I gathered that James was the brother of the civil rights activist and politician Julian Bond, who was a confidante of Martin Luther King Jr. and had become something of a celebrity in his own right. Julian was a state senator and the first Black politician to host *Saturday Night Live*, which made him a rock star not just within the movement but also to the wider public. The opening credits of *The American Music Show* panned around the room, where you could see JULIAN BOND FOR SENATE campaign buttons, bumper stickers, matchbooks, and a picture of MLK. The whole civil rights movement of Atlanta was coded into the first few minutes of each episode.

The fact that there was overlap between the civil rights movement and the birth of this scene wasn't lost on me. The torch that had been lit by the fight for racial equality, the nucleus of which was in Atlanta, would be passed on here in another form: an unwillingness to accept the status quo or to acquiesce to the terms that had been laid out by society. In fact, the folks behind *The American Music Show* had met volunteering on the campaign for George McGovern, the progressive candidate who ran opposite Richard Nixon in the 1972 presidential election. Although many of the other players in the group were white, I felt wholly welcome—maybe even more so because I was Black. Everyone was socially progressive and conscious of race, and that spirit of inclusion was in the DNA of the show.

The other host of the show was Dick Richards, a charismatic personality who was the heartbeat of the whole operation. Dick had grown up in South Carolina, and he had a thick Southern accent and a generous laugh, like he was whistling through his teeth, and a twinkle in his eye—the look of someone who could see through and beyond you. Sometimes he would walk around the house doing curls with a tiny pair of barbells, talking in his

genteel Southern way. He parted his hair on his left side, a little too low, such that he was always fixing it. With James frequently by his side, Dick had made it his mission to document the scene of the day in Atlanta, with one guiding creed: "If it ain't fun, don't do it!"

James's ex-girlfriend Potsy operated the camera and did the visuals for the show. She'd write the names of the guests in curlicue letters and create a collage that would be shown in the opening credits. Potsy had a low, singsong voice and a curly perm. While she recorded the shows, she also had a camera pointed at her, and that camera fed a livestream of herself to a television placed on set that the first camera, which she was operating, was filming—a Russian nesting doll of cameras and televisions, like a perpetually looping joke.

The show taped on Tuesday nights. Everyone would come over with weed and food, dishes shared potluck-style; we'd all get high and eat fried chicken, mashed potatoes, macaroni and cheese, green beans, and sweet potato pie. There would be guests, members of the broader Atlanta scene, who would drop by, some of them the younger crew who would leave the studio for the clubs in costumes to dance until the sun came up, and others were older and more intellectually minded, members of the counterculture and literati. Many of them had grown up in the South, and I came to understand that in this part of our country there was a tradition of producing characters entirely eccentric and flamboyant, the kind that Tennessee Williams wrote about, and nobody questioned them. In San Diego, which felt so constraining, they would have been picked apart constantly. Here it seemed that wild flamingos coexisted with everyday people. You never knew exactly who would show up, some mix of perfor-

mance artists and sex workers, straight people and gay people, often donning wigs, goofy costumes, or face paint and putting on absurdist acts of play.

I performed with Robin and Josette a few more times, but it quickly became clear that show business wasn't quite as much a priority for them as it was for me. I already had replacements lined up. I'd met a girl on a plane named Susie, who was coming back from going to school at Howard; she had left early, she said, because she couldn't tolerate being away from home. I could tell that she was a fragile creature, a Black Blanche DuBois, but I liked her anyway.

Susie was working as a server at the café at Davison's department store at the Lenox Square Mall, and her friend Gina was the hostess; they helped me get a job there as a short order cook. But more importantly, they stepped in as the U-Hauls, and we began performing weekly on *The American Music Show*, doing dance numbers to Fern Kinney's "Groove Me," or "Murphy's Law" by Chéri. I made all our costumes, which were inspired by the contemporary ethos of jungle chic that was being imported from London: Groups like Bow Wow Wow and Bananarama were all the rage in shredded denim and animal prints. I'd buy cheap fabric and fashion a dress or a top from it, tie bands of fabric around my arms, make a headband.

Susie had feelings for me, although it should have been obvious that she was barking up the wrong tree. I understood that there was a type of woman who would fall for a gay man to insulate herself from how hurtful straight men could be; pining after me was a way to ensure her own safety. But she couldn't accept that I would not be her boyfriend. One time after we argued about this, she left dog shit on the hood of my car. But we made

up in time to perform on Tuesday's show, doing high kicks to "In the Name of Love" by the Thompson Twins.

————

How do you put into words the way it feels to find your people, to belong, to finally be understood, to know the connective tissue that binds you invisibly to others? Dogs can hear a frequency that can't be discerned by the human ear; insects can see ultraviolet colors that are imperceptible to us. So it was for me those first months on *The American Music Show*, when I was twenty-one in Atlanta. Even when I watch those tapes back, I can't explain the magic that enlivens those performances, other than a sense of play—a spirit of goofy, childlike fun, an unwillingness to step into the quicksand of life's self-seriousness. It's impossible to put into words, but I know exactly what it is when I see it.

It was as if these people had pressed pause on the stage-play we call life—or, even more so, that they had awakened to the great, idiotic theater of everything society held dear. They had left the forest of everyday living and summited the mountain-top of consciousness such that they might survey the vast panorama, and up there they realized that there was more to living than they could possibly see from inside the thicket. And then, once you return to the quotidian business of being a person in the world, you carry with you the knowledge of what you witnessed up there. What was seen can never be unseen. You can't take the little things in life so seriously anymore. It all becomes a big joke.

Of course, you would never bother climbing if you were comfortable in the forest. What united us in that scene was that we were all outsiders, and the pain of not fitting in to the daytime nightmare of the ordinary world was a powerful motivating

factor. But once I found this little community, things began to click into place for me. With the U-Hauls, I started performing at frat parties, then at the 40 Watt Club in Athens, and then at the 688 Club in midtown Atlanta. There I met Kathy, a serious-minded lesbian who was very into Bowie, and who was tired of living with her nine brothers and sisters out in the suburb of Marietta, and we decided to get an apartment together in mid-town on Charles Allen Drive. In short order I had moved out of Renetta and Gerald's house and was in the earliest stages of making a name for myself as a performer. All thanks to that public access television show.

Everyone was taking a lot of substances, some of which were more anesthetizing and others of which were more consciousness-expanding, but all of which were inexpensive and widely available. Freebasing cocaine, as I had done with Gerald, was the exception—a costly habit that wouldn't really become popular until crack hit the streets a few years later. But marijuana was cheap and ubiquitous, a forty of Ballantine Ale was two dollars and forty cents, and even LSD was only five bucks a hit.

Not long after I started performing on *The American Music Show*, I got my first hit of acid from a friend of mine, a girl named Cassie Banks. She was model-skinny, like she'd come off a Paris runway, and she was ubiquitous around town. Later on, I'd see her dancing in a crowd on a public access show called *Dance-O-Rama USA*. At that point, my knowledge of acid only went as far as what was in the popular culture. I'd heard of Timothy Leary, and I understood that LSD had played an important role in the birth of the counterculture. But I didn't really know what I was in for.

I took the acid at my apartment on Charles Allen Drive. The tab had a star on it. Cassie told me I would start to feel it in about forty minutes. At first, there was a tingly feeling that started in

my groin and then spread through my entire body, like a grin. I held my hand up and waved it around, and there were trails, the ones I'd heard about. *Here we go*, I thought.

The feeling was marvelous. I understood it as a rebirth, as though I was being reborn into the life I thought I would always have. There was a life that had been kept from me by the constraints of normal society and the myth of reality, and now I was seeing the other side. I thanked God that I was finally being delivered out of life's hypocrisy, into the teeming ridiculousness of the world that was intended for me. I understood, deeply, that everything I had done in my life up until that point was preparing me for this, my first acid trip. Now I saw what was *really* happening, the molecules that comprised matter itself vibrating and spinning. This was the real world; the other thing, all that I'd been living in for the last twenty-one years, was just an illusion. It was overwhelming but not frightening, because the anesthesia had never worked on me in the first place. That made it less a revelation than a confirmation.

Instantaneously, I knew that I had to leave the house and be outside. I wanted to go out into the world, to experience it fully. A childlike curiosity was restored in me; I remembered the child I used to be, the child I'd been before my parents interrupted it with their vampiric drama, hurling lamps at each other from across the room. Now I wanted to go out and discover. I wanted to play!

So I walked out of that apartment and down Charles Allen Drive. The way the leaves diffused the light through the branches, creating shadows on the sidewalk, was beautiful beyond words. Everything was electric. I let the acid guide me to where I needed to go. I could see each individual blade of grass growing in the ground—how remarkable!

I went down to the entrance of the park and made a sharp left. I walked up Tenth Street, listening to the music of the passing cars. Then, suddenly, I remembered: *the water!* I made a sharp right and walked down to a bench at the edge of the pond. There were two people standing by the water's edge—a boy and a girl—and another boy sitting on the bench.

The young woman was breathtaking—a rare beauty, like Lauren Bacall. She was wearing a sixties-era thrift store dress underneath a light blue denim jacket. Next to her was a wiry boy with ginger hair and freckles; he was animated, a little jangly.

I sat down on the bench next to the other boy. He was tall, nearly as tall as I was, with blond hair and genteel good looks. His knee brushed up against mine and I nearly gasped. The charge that passed between us was unbearable.

The trees breathed.

I looked at him and thought:

*I've been looking for you everywhere.*

———

"Hey, what's your name?" I glanced up to see the wiry ginger boy staring at me.

"RuPaul," I said. "What's yours?"

"Floyd," he said. He smiled at me. He looked as if he had just discovered an exotic new creature, and that creature was me.

The boy next to me, whose knee I touched, was named Mark. And the girl was named Anna. She was a Welsh foreign exchange student who had been sent to study at the University of Georgia; Floyd and Mark were childhood friends. As soon as we began talking, I knew immediately that these were also my people, and I

could tell they felt the same way. I told them I was on acid. "We've got pot back at our place," Anna said. "You should come with us."

I followed them back to their apartment, which was a few blocks away in midtown. We lay on beanbags and listened to Nina Hagen's "African Reggae," then put on David Bowie's *Low*. There was a breeze, and the curtains were billowing in the wind. All four of us were dancing—Floyd as animated as a cartoon character, Anna soft and fluid—when it suddenly occurred to me: *I've got a car.*

"I've got a car!" I exclaimed. "A convertible!" I had been driving a 1964 Plymouth Valiant, white on white on white. "We should go for a drive!"

We walked down to my apartment, had a brief exchange with my roommate Kathy—who eyed the luminous Anna like she was a faerie, which, in fairness, she was—and went to the convenience store to get some forties.

As we pulled up, a tall guy approached the car. "Police department," he said. "I'm gonna need to take a look at your license." We eyed one another in absolute panic. I was still tripping on acid, and they were all stoned. Then the man laughed. "I'm just fucking with you," he said. "Can you guys get me high?"

We told him no, and the stranger left. As he walked away, we looked at one another in slack-jawed amazement: *Can you imagine how bad that would have been?* And instead, we felt incredulity at our good fortune, to have dodged that bullet. We drove around—drinking, high, buzzing on the perfect weather, that buttery feel of the Atlanta air, the perfect nowness of being young and unencumbered. This is just how it would work: We had been anointed. We were the chosen ones. No bad vibes would befall us.

Or me, it seemed. A few days later, my new friends and I went out to see a band, the Now Explosion, play in Marietta. I was driving—wearing a halter top embellished with silver Christmas tree tinsel, white Daisy Dukes, and a naval commander's hat—while everyone else drank in the back seat. Mark tossed an empty beer can from the open car window, and a few seconds later I saw flashing red and blue lights as a police car pulled up behind us.

They made me walk in a straight line and touch my nose, but I passed the field sobriety test well enough that they let me go. Mark, who had thrown the can, got hauled off to jail. We drove back to Renetta's house and called Mark's mother, who managed to bail him out.

Mark didn't have as strong a force field of protection around him as I did me—whatever guardian angel had kept me insulated from bullying, from violence, from the brutality of the world. That thing that had carried me to the cafeteria at Horton Elementary School all those years earlier, the day I went home for lunch and thought I'd been abandoned by my mother. There was something impulsive and a little dangerous about Mark, even though he was very sweet. His laugh, open and easy, gave his secrets away; it revealed that there was a joy that was growing within him. But he was in the shadow, I understood, of a restrictive father who might never let him be who he was. He had grown up at the foot of Stone Mountain, Georgia, and I could feel within him a push-and-pull between his softer, more feminine side and that staunch maleness that had been instilled in him by his father.

Floyd had a kind of bratty charm, and Anna was an earth angel, lovely and glowing. But of my new friends, I was taken

most with Mark, who was blossoming in a way that grabbed my heart in its fist. I can picture us now, taking Renetta's Honda— which I must have been driving for some reason that was important at the time—to Peachtree Battle, at the edge of a little park where we had stopped to get high. It was almost midnight, and we were making out as furiously as I had ever kissed anyone before. I wanted him desperately. It felt as if the whole world had stopped around us, like we were living in a freeze-frame and the only thing that was in motion was our bodies.

Mark and I waited another week, to when Renetta and Gerald would be out of town and I would be housesitting for them at their nice house in the suburbs with a swimming pool. Before leaving midtown, we took acid, knowing that it would come on just as we arrived at the house.

But not long after we pulled onto the on-ramp, we ground to a halt. There was a traffic jam—not the normal kind, but the apocalyptic road-closure kind, where everyone parks their cars and starts getting out in the middle of the freeway, looking ahead, murmuring to each other, trying to figure out exactly what happened. The acid hit while we were still waiting there, trapped in this jam, as dense as if everyone was trying to flee the city from an alien attack. The trails set in, and the cars were wheezing their exhaust, and the night sky was brimming with stars, and there were hundreds of us, gathered under this luminescent sky, waiting for the road to clear.

———

We need one another; we do. I had seen my mother's mistrust of others, the way the vagaries of life had turned her cold, and maybe some piece of that had taken hold in me already. But I was young

enough to believe in the goodness of people, and so here was what I wanted: to belong, to be felt, to be known, the satisfying click of one piece into another, when you find the people who just get it. I had gone looking for belonging, and in the span of an instant, it seemed, I had found it.

When we finally got to the house, we couldn't keep our hands off each other. His shoulders were broad, and his skin was milky and soft, and the hair on his body was fine as down. It was so different from the way it had been with Richard or Jack, which had been about satisfying an impulse. This was about knowing, real knowing, the way I had known the moment I took that tab of acid that I needed to be outside in nature.

Mark was blooming in his beauty, the same way flowers bloomed in spring. He was those shadows on the sidewalk, diffused by the sunlight. And in that psychedelic twilight, I understood.

I hadn't just come back with what I wanted.

I had come back with something better.

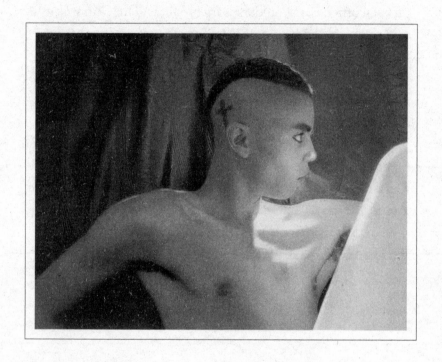

"Life is full of dualities:

night and day, black and white,

yin and yang, good and evil,

# Duality

birth and death, love and fear.

You can't have one

without the other."

Mark had moved into my apartment by the end of that summer. Part of it was that he and Floyd had been evicted from the apartment where I'd listened to Bowie on acid that first day, after the park. Part of it was that Kathy was moving out, to some warehouse downtown. But the most important thing was the way we felt about each other. He didn't have much in the way of stuff, but I made him feel right at home. As soon as he was settled in, I did his makeup and took some glamour shots of him with the Minolta that Renetta had given to me.

Neither of us had any money. We lived on Coca-Cola, chips, Snickers bars, and cigarettes. We slept on a mattress and box spring on the floor, covered with plain white sheets. When Kathy had lived there, I had taken bedsheets and stapled them to the ceiling to form a kind of makeshift hallway, cutting the living room in half to make a room within a room, since Kathy had taken the bedroom. Now that she was gone, we turned that bedroom into an art studio. In the bathroom, I'd cut out enormous Dior and Clinique ads from old copies of *Women's Wear Daily* and taped them to the walls.

By September, I had been fired from Davison's, once they got a new manager who didn't seem to like me much. Instead I got a job as a janitor at a conference center, in a hotel that had been converted for this use out on North Druid Hills Road. People who worked in business would come from all over the southeast for conferences there, and I'd sweep and mop and clean up after they left, clearing the chalkboards, clapping the erasers, wiping down the desks, and making sure there were pencils in the pencil cups and fresh pads of paper. I hated that job. My true calling was getting high and going to clubs. And yet I needed the

little money it made me. The Valiant I'd been driving all summer broke down, and in its place I was driving a 1976 Ford Granada, creamy yellow with a Landau top, that I'd gotten from Gerald. I was still transporting cars for him but less frequently than I had before, now that I'd found more of a purpose for my own life.

Mark and I didn't have much. But we had each other. One night, he told me about a time he'd been out at the Sweet Gum Head, a drag bar on Cheshire Bridge Road. "I saw this drag queen there named Lakesha Lucky," he said. "She was up there onstage, and she said, 'You're born naked, and the rest is drag.'" I looked at him as if he'd just unlocked the secret of the universe. Maybe he had.

————

Life is full of dualities: night and day, black and white, yin and yang, good and evil, birth and death, love and fear. You can't have one without the other. It takes two to create the magnetic pull to generate energy in the first place. This is the natural order: that everything, in contrast, hangs in perfect balance. I always felt both male and female. Counterintuitively, I felt more masculine in drag than I did out of drag, because I knew that I could command more power that way—power being a currency that was typically conferred to men. As a feminine Black man, in violation of society's norms by virtue of just existing, drag was a way to reclaim the power I had always been denied.

Back then, my drag wasn't polished. It was a middle finger to society, a way to say: *How's this for fitting into your box?* It had nothing to do with identity; in an elemental way, it defied the binary, the built-in either-or that was intrinsic to so much of life.

In this, my style was inherently provocative, because it dared to subvert the duality of all things, to poke fun at the ridiculousness of choosing a gender at all. Drag provided a type of permission, to be something in the middle, or neither, or both.

All the boys and all the girls in the scene in Atlanta did some form of drag, but it wasn't glamorous. It was thrift store rags, combat boots, lipstick smeared across the cheek. We painted on mustaches and eyebrows, glued plastic bits to our faces, scribbled on our arms—anything, *anything* other than putting ourselves into a box. Drag made a mockery of the sacred cow of identity and all the societal expectations that came along with it. This act of rebellion was an unspoken alliance that united us. In a system where things insisted on being one or the other, drag was everything. That made it magic.

The opposing forces that I felt most palpably were my optimism and my cynicism, two wolves that coexisted within me. I could feel darkness at times, creeping in from the margins, spilling out from the box where I stored it, and I knew it was the same thing that had consumed my mother after my father left. It was her world-weariness and negativity that had made her notorious in the neighborhood. Surely if I showed that face to anyone, they would leave. The only option was to shove it down and choose fun, and so that's what I did. Just as I had when I was a little boy, I would put on a show if it would lighten the mood. I would perform until it wore me down if it could get someone to crack a smile. I wanted to do that for the whole world, to make them laugh and keep them entertained, but I wanted it most of all for the people I loved, as I had for my mother.

And I did love Mark, although I couldn't say why. I had felt it instantaneously, the moment my knee touched his that day at

the park, that there was a symbiotic energy between us, a cur-
rent that was my own that was transmitting from me to him and
back again. It felt good, and right. Why had it been him sitting on
that bench and not Floyd or Anna? I couldn't say, but I believed
that he had been calling to me when I left my apartment that
day on acid—that our frequencies had been seeking each other
in the airwaves, a call so clear it had beckoned me down to the
water to sit next to him.

I understood tacitly that Mark was fighting an inner battle,
between the part of him that was his father—staunch, stoic,
masculine—and this other side of him, the woman that lived
within him, which was his mother: a traditional, sweet Southern
woman, a fixer, a kind person, even if in all of this she was a
collaborator in the toxic dynamic that Mark told me played
out between his parents. I would see her when he would laugh
unself-consciously, even girlishly, or sometimes when he was
smoking a cigarette, looking so feminine—*There's a woman in
there!* And then she would disappear, replaced by the man he
was—the other half of the binary. To watch him modulate in that
way, from man to woman, was a reminder that we are all mul-
titudinous, that we all contain everything. I had that, too—my
father's easy charisma and my mother's chilly bitterness—but
when Mark went cold, I found that I was not my mother. Instead,
I was a little boy back in my mother's living room trying to make
her laugh.

If the most fundamental duality of all is love and fear, that
was at the heart of it: I loved him, but I was also afraid he would
leave.

———

In the fall, Mark and I drove up to New York to see our friends perform in their band the Now Explosion, which was comprised of Larry Tee, Lahoma, Elouise Montague, Clare Parker, and Russ Trent, who went by the name Lisette. They were in the tradition of the B-52s, which meant they were new wave, but rudimentary in their approach. Larry knew how to play the guitar, but the keyboards were rough, such that the sound was more garage band than polished. They wore thrifted clothes and messy wigs. Boys dressed as girls, and vice versa. Sometimes Lahoma dressed as Jesus Christ, carrying an enormous cross on his back.

I'd also seen Larry perform in a band called the Fans when they played at the 688 Club. I noticed him because I thought he was good-looking, and also because I could see him keeping time with his mouth, working his jaw to the rhythm while he played the guitar. Lahoma, whose real name was Jon, I'd met that spring. I was at Dick Richards's house, which was on the edge of Inman Park. If James's apartment, the makeshift studio, represented straight kitsch, with the basketball jerseys to prove it, Dick's house, a thirties Craftsman with a screened porch and wooden stairs and rooms crowded with tchotchkes, was peak gay kitsch, and we'd all hang out there from time to time, getting high and listening to records.

I'd seen Lahoma before a festival we were all set to attend and introduced myself. At first, he seemed closed off, but eventually he would open up to me. After the festival, I went back to Dick's house and DJed, playing Motown records and getting everyone up on the floor, playing the Supremes' "When the Lovelight Starts Shining Through His Eyes."

Larry, Lahoma, and I had become friendly, and when they invited me and the U-Hauls up to New York to share the stage with them during a performance, I jumped at the chance.

The surging counterculture in downtown New York in the sixties had led to a grimmer period in the seventies; by the end of that decade, the city of New York was on the verge of bankruptcy. There were blackouts, garbage strikes, rats everywhere, and muggings. But in that, there was an unspoken camaraderie shared by New Yorkers, the understanding that everyone was in it together—a mob mentality not to burn the world down, but to lift everyone up. To be a survivor in the midst of all this destruction and decay, as resilient as the roaches in tenement housing, was a badge of honor.

Out of that darkness came roaring to life one of the most vibrant and exciting creative periods in the history of New York City. As disco waned and the new wave took hold, the Warhol experience was still felt in the bars and clubs that crowded downtown Manhattan. Even from the vantage point of Atlanta, we all knew that New York represented a dangerous bacchanal of cultural convergence—so many people and ideas and influences intersecting on this one tiny island where anything and everything was possible.

I had only been once, in 1980, when Renetta and I had picked up a car for Gerald in New Jersey and taken it to meet up with Renetta's old friend Simone in Manhattan. We ate at a restaurant called Nirvana, and then, walking down the street, I stepped in dog shit—that juxtaposition, a perfect encapsulation of New York. Going now with my friends and my boyfriend felt different. Gina rented a tiny tomato-red compact car with her credit card, and Chrissy, Mark, and I started up I-85. It was a grueling drive, and by the time we arrived, we were all exhausted as we made our way to the venue.

The Pyramid Club was on Avenue A in the East Village, in a storefront that was very narrow but very deep. There was only

one way in and one way out. A long bar ran parallel with the entryway; at the end of the bar was an ice machine, next to which was a door leading to a little basement lounge. Just past the ice machine was a dancefloor, the same size as the front bar, with a DJ booth in the corner. And beyond the dancefloor was a tiny stage with a spiral staircase through stage right, which led down to a dressing room that was painted gold.

The Pyramid had been a rundown dive bar before a group of drag queens discovered it and made it the nucleus of the New York scene, the place where bohemian, punk, queer, and new wave cultures all intersected now in the early eighties. Everything was cramped, with a distinctive smell of mildew, cheap beer, and cigarette smoke. We went out alongside the Now Explosion, shimmying and shaking tambourines, doing high kicks, looking out at the crowded dancefloor. Everyone there was of the same cut—the children of Warhol and Bowie. Their body language and wardrobes gave them away.

Avenue A had been colonized, but that was as far as you could go; anything farther east than that was considered too dangerous. These kids, in their black leather jackets, black jeans, and chains, were on the front lines of rock 'n' roll by the sheer fact that they were here on Avenue A. Even if it was a posture, they were still unmistakably the cool kids.

To be out onstage in a grungy New York City nightclub didn't feel exhilarating, exactly; it felt more preordained. I understood that it was the beginning of something, a new chapter in the journey of my destiny. Walking out of the club that night, I noticed that there were posters for different musical artists everywhere—on abandoned buildings, on scaffolding, on walls. I'd find out later that these are called snipes, but I'd never seen

them in Atlanta. It struck me as a missed opportunity. After all, any working girl could tell you: It pays to advertise.

———————

In October, Mark and I took a job transporting cars from Atlanta to Phoenix. A friend of Renetta's, who had lived across the street on Greentree Trail, was moving to Scottsdale and needed her two cars—a Ford Bronco and a Mercedes—transported there. We drove separately and stayed in a motel along the way. Mark had run out of underwear and was wearing a black spandex bathing suit instead.

Lying alongside him in that motel bed, I could feel that something had shifted, although I couldn't articulate what it was. The coldness, the thing that was in his father and my mother, had taken hold. The fun kid he'd been, who would go to *The Rocky Horror Picture Show* and put on makeup and dance, was no longer within him.

"Come on!" I would say. "Let's put on high heels and wigs and go through the drive-through at Crystal's and order eighteen hamburgers in Mexican accents!" He would push me away, and that would make me angry, because how could he not want to do that? Why wouldn't he want to play with me? I had just suggested the most fun thing in the world.

Years later, I would understand that my response was all about the dynamic with my father. There was nothing I could have done to make my father see me; likewise, there was nothing I could have done to make Mark reactivate that spirit of play I knew was in him. I had so much resentment about not being the kind of person that a man would be willing to risk everything

for, to try for, to meet me where I was. Most men and women proved their power in basic ways that revealed the binary underneath everything: For men it was shows of domination, strength, and virility; for women it was sexuality, pleasure, and femininity. I had neither. I had known it as a little boy when the neighborhood kids called me a sissy, just like I did when my father kept me waiting on that front porch, that I had neither form of power.

———

That trip to Phoenix was the beginning of the end. By December, we were fighting all the time, that terrible push-and-pull between my desire for play and his irritation with it. I could always get riled up by disloyalty, real or perceived, and that had become a focal point for our conflict: I would accuse him of giving someone else the eye, then put him through tests to prove his devotion to me, and he would refuse. Or I would concoct some plan to create a good time, and he would ignore me. He wasn't fun anymore, and every time I asked him why, he shut me down.

We descended into conflict so quickly, becoming my parents—or maybe his, because I knew they fought, too. It felt as if there was a beast within me that was clawing for release, a mysterious and malignant force—this obsession, this anger, this jealousy. Watching my parents do it all those years had gotten trapped in my body, absorbed by osmosis.

We had been drinking, taking forties up to the parking lot outside the church at the top of our block, the tree-lined street where I'd walked that first day to meet him. It was cold outside, enough that his cheeks were pink, and I was angry at him again, for being my father and not being my father and a hundred other reasons. "You son of a bitch," I said.

And he slapped me, so hard I saw stars, with an open palm across my face. I looked at him in shock. Instantly, I heard my mother's words, running around in my head like a track: *If a man hits you once, he will do it again. Leave. Don't walk. Run.*

She was right. She had been right about everything.

———

All these years later, looking back on that moment, I hear her voice. *How could you be so stupid?* My mother didn't suffer fools, and she couldn't abide weakness. It was that same human frailty within herself that had allowed her to succumb to my father's charms, and she hated it so much that she had tried to smother it when she saw it blooming in me as a little boy—that sentimentality, that tendency toward the romantic. "You're too goddamn sensitive, and you reminisce too much." She had told me that. She had witnessed it in me and called it dangerous. I remembered.

For a long time, I believed her. I saw that part of me—the part of me that allowed me to fall for Mark, to buy into the fantasy that he was good when his knee touched mine that day in the park—and I hated myself for allowing that part to run the show. It was fear that had made me cling to him, fear that I would be alone, fear that no one else would ever see me as lovable or deserving, fear that my father had been right to leave me waiting on that porch all those years earlier. I despised that fear, that human vulnerability that made me want to belong to someone else. It made me weak, and for that I was ashamed. I hated that part of myself. I thought I needed to reject it, to be more like my mother, who belonged to no one but herself.

———

But then, I turn. I soften. I return to the house of hidden meanings, and I look for something new. I ask myself different questions.

What if it wasn't?

What if I had it wrong all along?

What if it was love, the other side of that duality, not fear, that made me reach for him in the night in a motel room in New Mexico, across a dancefloor in the East Village, on a sunny day in Piedmont Park with a disco song on the wind and his knee brushing against mine?

What if it had never been stupid of me to wait on that porch at all, believing that the next car to come down the block would be my father's?

What if it wasn't my worst instinct, but my highest one?

What if that—that need to love—was the best thing about me?

There are things, mysterious things, that exist beyond dualities, caught in an in-between place, in some transcendent everything. So it was here. I had drunk from the chalice of my mother's sadness. But she had only been trying to protect me, and that, her protection, was born from the crosshairs of that most fundamental duality: the gravest fear, and the deepest love.

It wasn't one or the other.

It was both.

————

The next day, Mark moved out. But I kept the first photograph I'd taken of him. In the picture, he is eighteen and beautiful, a boy and a girl, and the makeup I drew him in is fierce as war paint.

I took the lessons from New York back to Atlanta with me. I designed a poster with a photograph of myself and came up with a slogan I liked. I had a friend, a boy named Nick, who worked at an office where he had access to a Xerox machine that he said he would let me use. I went there and made hundreds of copies of these signs. Then I pasted them up all over town.

The signs said: RUPAUL IS EVERYTHING.

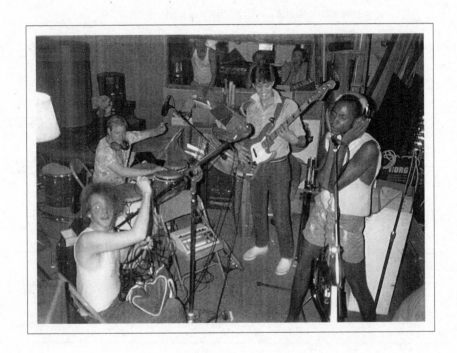

"To be purely objectified

in the sexual hierarchy,

perceived as genuinely sexy,

# Snipe

as opposed to set apart from

the world—it felt new, after

being shut out of that for so long."

The story in my family went like this: When my mother was pregnant with me, she went to see a psychic, who told her that the baby she was carrying was a boy and that he was bound to be famous. With that in mind, she gave me the name RuPaul because, as she put it, "Ain't another motherfucker alive with a name like that." Fame, for me, was less a dream than a predestination.

I had grown up loving the stars I'd seen on television. But it was clear to me from an early age that there were plenty of people out there who were talented as singers or actors or dancers, or even at all three, and not all of them made it in the entertainment industry. The ones who stuck around, it seemed, had an added element that people could rally around. They weren't just talents. They were something else. Consumers are always looking for something proprietary in a product that offers more than the thing itself, whatever its utility. They want a vocabulary, a lifestyle, an aesthetic that goes along with whatever they're buying. Nowadays, we call that a brand.

Diana Ross had this figured out. She just had that "It" factor. It was difficult to take your eyes off her. Of course, she is an extraordinary singer, a charismatic performer, and a brilliant actress. But she is about something more than that. At the height of her fame, she meant so much to me, as she did to many Black people, because she represented everything we wanted to project into pop culture at that time, and that was: *You don't have to be afraid of us, white people. We can be everything that you can be and more.* It was never said, but always understood: Diana Ross represented the release of centuries-old baggage associated with

Black. You could invite Diana Ross, I felt, to any home in America and she would be welcome—that's how beloved she was.

Then there was Cher, who was unapologetically rebellious. Her talent is legion, but her personality was what made me love her. I could see that she didn't act the way other women acted, fawning and flirting at the carrot of male attention. She was stone-faced. She seemed disaffected in a way that I admired.

At around thirteen, I became a student of David Bowie. Likewise, no matter how exceptional his talents, it was his personal presentation that was revolutionary. He never seemed to make an event of the fact that everything he did was weird and transgressive; it was tossed-off, casual, rendered with a sense of ease that spoke to every kid who was drawing outside the lines.

Two bands born in the Atlanta scene had made it big, too: The B-52s, who made scruffy garage-party songs, a kind of postmodern, Warholian commentary on pop music. The sound captured the energy of Motown without the pristine musicality of it. The other band was R.E.M. I thought R.E.M. made music that was the equivalent of a human sob, songs that gave voice to the angst of suburban white boys. Nevertheless, these artists proved, unquestionably, that this environment in Atlanta could produce global stars. All it took was a little self-belief.

Mark had broken my heart, and I would remain devastated by it for the next four years. In time, I would see the end of the relationship as the gift that it was, but I experienced it then as a sort of denial of my fundamental worth. Had I been enough for Mark, the full object of his desire, I could have gotten distracted, and it would have upended my ambition. I could have languished or self-destructed in a relationship. I could have let

the obsessive call of my heart's longing take me off my course. But this didn't happen.

That isn't to say that after Mark left, I didn't indulge a few moments of regression. He had gone back to Athens, about fifty miles northeast of Atlanta, to be with his best friend, who was attending the University of Georgia. I drove out to Athens once to pick him up, and we went back to midtown, had something to eat, and discussed reconciling. We were on our way back to Athens, maybe ten miles outside of Atlanta, when I asked him, in the car, if he wanted to fool around.

"Yes," he said.

I made a U-turn on the highway in my yellow Ford Granada and sped back to the apartment in the direction we'd came. And yet I knew that what we had was over, and even sleeping together one last time only cemented that feeling.

My friend Clare from the Now Explosion was forlorn, too— over Michael Stipe, the front man of R.E.M. We drove to Athens again one day with half a plan to spy on both him and Mark, the objects of our affection, or maybe it was just to commiserate with each other. But even to Clare, who was in a similar position, I couldn't reveal the depth of my heartache. If the world was a casting director, I was seen as an alien, a jester, an asexual oddball—not a romantic lead capable of being wounded as deeply as I had been.

Instead, I was perceived as exotic and unique, unlike anyone else, even in our band of misfits. When Mark and I had started seeing each other, everyone in our little group understood what was happening and why, but I don't think anyone was surprised by the eventual outcome. Underneath it was a shameful inevitability. How could something like *that* ever work out between

two people like *us*? I was just too different to figure into conventional romantic dynamics—not because nobody desired me, but because there seemed to be that force field around me, where I was perceived as other, standing outside the sexual hierarchy in which everyone else seemed to be able to situate themselves.

It would take a lifetime to unravel the pain of not being seen as someone who was deserving of that sort of romantic attention. At the time, I knew only that I could use it as jet fuel to propel me forward into my destiny—which was, of course, fame. And so, until the world reorganized itself to recognize that, I would do the only rational thing I could do: I would act as if I was already famous.

After all, it was self-evident that I was a star—the psychic had predicted it. And what did stars do? They created projects for themselves. Hollywood isn't calling? Do it yourself. Start a band. Produce films you can star in. Design your own clothes. Write your own books. Create your own merchandise. Build your own empire. Become your own icon.

———————

On New Year's Eve, I was at a club when a boy came over to me. He introduced himself as Robert, and he was handsome, like a young Matt Dillon, with dark hair and commanding energy. "I go to Northside," he said. "I've been following you for a while." Obviously, I was flattered by this, which validated that my plan of making a name for myself was working. "I actually saw you perform a year and a half ago, at this comedy club called the Punchline."

"Oh my God," I said, cringing. "I was terrible!" I really had been. It was before I'd discovered *The American Music Show.*

I'd read about an open mic night in a local alt-weekly and had performed a comedy set, if you could call it that—mostly I just rambled. I'd been terrified, and I'd known going in that I would bomb, but it was part of my philosophy: *Just get the damn thing over with.*

"We should start a band," he said. "I play bass and my friend Timothy plays guitar."

A week later, he invited me over to Timothy's house near Peachtree Battle to mess around and write. Timothy was fair-skinned and strawberry blond; he had been chubby and now was scrupulously watching his weight. He was so soft-spoken he could barely raise his voice above a whisper, but I liked him. We were all fans of the Now Explosion, and we rehearsed in their informal, messy tradition. There was what felt like chemistry between us, and so the band was born. Robert was casual about it. "If a band doesn't work after a year, you've gotta split up and try something new," he said with a shrug.

There was a long, cylindrical cushion on Timothy's mother's couch; it looked like a pole. Inspired by this, I suggested the name Wee Wee Pole for our band. It sounded similar in the mouth to Bow Wow Wow, my favorite act at the time, who also did a kind of tribal rock; like the name RuPaul and the U-Hauls, it was goofy. But unlike RuPaul and the U-Hauls, which was more of a performance act that would emerge onstage to enliven the Now Explosion's sets and do lip-sync choreography on *The American Music Show*, this, I decided, would be a *real* band. With Wee Wee Pole, I would be formally introduced to the world of rock 'n' roll.

Not long after, that January, there was a knock on my door early one morning. It was Floyd, who had his arm around Jon,

a boy we'd met at the Bistro Nightclub about a month earlier, although I probably would have called Jon "she"—less because she insisted on it and more out of gay irreverence.

I had met her right before Christmas. We were crossing the street, a little group of us, and Jon said something so clever and funny it made me laugh out loud and look at her again in surprise. She was nineteen and pale with a mop of blond hair; even her eyelashes were white-blond. She had just moved to Atlanta from Chattanooga, and she was an old friend of Cheryl's, another girl I knew in the scene. She would be going back to Chattanooga for Christmas, she said, and I remember thinking: *I hate that she has to leave, because I actually like this bitch.*

Now here she was, just a few weeks later, arm in arm with Floyd.

"We're dating," Floyd said.

I looked at them in surprise. "You two?"

They nodded confidently. I suspected that they'd fooled around the night before and had decided to extend their goodwill tour by paying me a visit. The relationship would last no longer than a week. But it cemented my friendship with Jon, who would come to assume a more formal name: Bunny Hickory Dickory Dock, or Lady Bunny for short. Soon we were inseparable.

We'd walk up and down Peachtree Street, always in search of some kind of good time—whatever might be available to us. Back then, midtown was like the Tennessee Williams play *Camino Real* that I'd appeared in at Northside: a parade of hookers, hustlers, gay men, and anyone else who didn't fit into mainstream Atlanta society. Up and down the street we would walk, singing our favorite songs: Geraldine Hunt's "Can't Fake the

Feeling," or "I Don't Wanna Lose Your Love" by the Emotions. We'd sashay up the street, asking the guys who passed us by to show us their dicks. Rarely did it work.

Late one night, at a gas station on the corner of Eighth and Peachtree, we saw a 1954 Cadillac that had been left open by the mechanic who'd abandoned it mid-repair. We corralled some Black guy into the front seat and took turns groping him. I'd quickly learn that Bunny had a thing for Black men; in fact, Floyd may have been the last white guy she ever dated. But like me, she also loved Black female singers: Patti LaBelle, Chaka Khan, and Stephanie Mills. And she was whip-smart. Her father had been a Fulbright scholar, and she'd lived all over the world. There was a slight bitterness to her, the isolation that results from being bright and struggling to find people who could keep up with you, but nevertheless she was in on the joke. She understood the hilarity of the world we were inhabiting. Bunny was a soul sister.

A rich girl we knew named Carla had a prescription for a sleeping pill called Placidyl that could sedate an elephant. We'd get them from her at a club called Weekends, pop them, and enter a hazy waking dream state that would take days to wear off. Once we took Placidyl and woke up days later in the home of Dolores French, a renowned sex worker who had rallied to unionize prostitution by holding protests at city hall. *How did we even get here?* we wondered. *What happened last night?* We stumbled outside into the afternoon in time to run up to the Starvin Marvin convenience store and get a Coca-Cola for breakfast. Those were our shenanigans, day in and day out, living for the day each week when we could get into a drag bar called Illusions for two dollars to see their show called Monday Madness.

You have to understand that in the southeast of America, Atlanta was drag Mecca. There were queens in Florida and as far west as Houston, but all the traditional drag queens played Atlanta. Many though not all of them were trans women, and the objective was to give you the look and feel of real—to perform womanhood, with full-throated sincerity. Most of them were pageant girls, with beaded gowns and prom-queen updos. We punk kids, who now belonged to the new wave, were of another sensibility; our goal was to poke fun at all that. Now, they might call what we were doing "genderfuck," since it was born from a desire to deliberately explode expectations of gendered style. The drag establishment, a generation above us, would have looked at us and thought: *Those kids are cute.* But we were never taken seriously—nor would we have wanted to be.

At Illusions, there were revues, anchored by an emcee who would introduce the act, and then each act would lip-sync a song that was part of their repertoire, typically one that was unique to them, and for which they were known. I can still remember the names of the girls who we'd go see at the time. Chena Black, Dina Jacobs, Tina Devore, Yetiva Antoinette, Erica Adams, Lily White. Some of the younger girls would just perform the hits of the day, but the biggest star was Charlie Brown, a white girl who always did Millie Jackson, specifically her version of "(If Loving You Is Wrong) I Don't Want to Be Right." The live version of the song led to a hilarious spoken-word breakdown, which Charlie had down pat. Bunny loved a queen from Chattanooga, her hometown, named Tasha Khan. I put Bunny herself into drag for the first time at the 688 Club, for a Boy George costume contest that she ended up winning. In drag, she looked a little bit like Dusty Springfield, who she idolized from her years living in the UK.

We'd go see the drag show, shrieking with laughter. We'd find somebody who could get us high. We'd parade up and down Peachtree. That was it. That was how we lived. And we'd do anything for a joke. As spring approached, Robert, my bandmate in Wee Wee Pole, told me that there was a girl in his grade at Northside named Deborah Kampmeier who wanted me to go to prom with her. She thought all the guys at school were boring. A recent dropout who was making waves in the Atlanta scene, on the other hand? That was cool. I said yes in a second—I'd left school before I'd had a chance to attend my own prom at the very same school. I had recently met some strippers who'd given me what I thought was a truly fabulous outfit—tails and striped satin pants. So that's what I wore to prom, with steel-tipped work boots (black with a yellow rubberized sole) and an enormous safety pin on my lapel.

There were a lot of kids around doing the mopey, gothic thing, which I found contrived and very self-serious. I wasn't looking to wallow—I was looking for fun. I wanted laughter, colors, music. I didn't need or want to work overtime to look moody like the goths, who believed it made them interesting. I had no doubt I was already interesting.

And the crowds who started showing up to see Wee Wee Pole live were only affirming that. We opened for the Now Explosion, then added a percussionist to the mix, a guy named David Klimchak. We soon were playing all the clubs in Atlanta, then Birmingham, then Athens, and even a club in South Carolina. But I had my sights set on bigger prizes—not just becoming a rock star. I wanted to follow in the tradition of Warhol, who had created an entire world—that was my goal.

———

Though the whole of the Atlanta alternative scene was centered around *The American Music Show*, there was a phenomenal amount of creativity swirling outside those tapings, too. Lahoma and I loved a television movie called *Trilogy of Terror* starring Karen Black, in which she is terrorized by a Zuni fetish doll, so we decided to shoot our own version. In ours, I was to be terrorized by a statue of the Blue Boy, from the famous painting by Thomas Gainsborough. That film was the first time I'd worn my own wig—although in fact it was two wigs, gifted to me by Clare Parker of the Now Explosion. She had a treasure trove of thrift store wigs, and I piled them on top of my head to create what I considered my own signature style. It meant something to me that they weren't on loan, that I got to take them home once we were done—that they were mine.

Off this star-making turn, Tom Zarilli asked me to star in his movie *The Wild Thing*, a version of the François Truffaut film *The Wild Child*, in which I'd appear opposite Lady Bunny. We used Gerald's VHR to do it, with the same waist-pack battery system that was used to record *The American Music Show*, editing in real time while filming. Once we were finished, we'd play our movies on *The American Music Show* or we'd take them down to the 688 Club or the Bistro, announce our "world premiere," and—because all the bars back then had AV systems since the advent of MTV—play them from the VCR.

Outside of my budding "film career," I continued to appear on *The American Music Show*, as well as on the public access spin-off *Dance-O-Rama USA*, which was like a new wave *American Bandstand*. I'd teach a dance like the cha-cha wearing a ruffled blouse and basketball sneakers. All of this gave me a testing ground in which to experiment with the skills I would eventu-

ally need for my career in the entertainment industry: doing bits and sketches, developing an on-screen persona, getting comfortable being in front of a camera.

Obviously, I needed to fast-track my future work in publishing, too, so Nick, who I'd met at South Fulton Vocational School where I took the photography class—the same one who'd let me use his Xerox to print posters to hang up all over town—allowed me use of the copier again to print little books I'd write. Mostly they were magazine clippings and photographs collaged together with little sayings. Each one was about twenty-two pages, front and back. The first one was called *If You Love Me, Give It to Me!* Then I added an appendix and did a second print run—a revised edition, if you will. That one was titled *If You Love Me, Give It to Me—One More Time!*

But the real sign of making it would be to play in a bigger market than Atlanta, the way the Now Explosion had done when they played in New York. In the late seventies, the band Joy Division had emerged as a favorite of the new wave. Their lead singer, Ian Curtis, had died by suicide in 1980, and the remaining members had formed the group New Order. On their tour, they stopped in Atlanta. Larry Tee, who was very connected, had a party for them in the backyard of his house. There I was introduced to a woman named Ruth Polsky. She had a distinctive mop of tight curls and downtown style, and I liked her instantly. She was the booker for Danceteria, another club in New York that, like the Pyramid, played host to all the important acts of the day. Ruth was already a legend—she helped cement Duran Duran, the Smiths, and R.E.M. as stars. Even though we only chatted for a minute, I could tell that she liked me, too. "If you make your way up to New York," she said, "I'll book you."

Robert and Timothy and I had been rehearsing twice a week, writing songs, and plotting the course of our career. The next time I saw them, I told them about Ruth's offer, and we agreed we had to make our move. This was too good to let slip away. So a few weeks later, we drove up to New York in a rented van.

When I'd come up the year before, with Mark and the U-Hauls to appear at the Pyramid, we'd just caught a few hours of sleep in the car. This time we stayed at a friend of a friend of Robert's who agreed to let us crash at his place for one night. We stopped at the apartment, on Seventh Avenue and Thirty-Third Street in the Garment District, and then we headed to the club, which was on Twenty-First Street between Fifth and Sixth.

Danceteria was a multilevel experience, a full building that had four stories of dance club. An elevator would take you to every floor, each of which had its own DJ, as if it were four separate clubs in one. Walking in, it had that same smell of beer and mildew that I'd come to associate with New York nightlife. I'd read about the club in magazines like *Details* and *Interview*; it was world-famous. Arriving in the afternoon for sound check, I felt as if I was seeing a star without her makeup on.

Our set went well, playing the songs we'd been writing to a packed house, full of more colorful people than I had seen at the Pyramid a year earlier. There was a lighter, warmer energy to this crowd; the farther east you went in the Village, the darker things became. At Danceteria there was brightly colored hair and Siouxsie Sioux makeup, girls dressed like Cyndi Lauper and boys dressed like Duran Duran. They danced joyfully, exuberantly—like they were having a great time. Unlike the self-conscious hipsters at the Pyramid, this was a commercial crowd, and they loved us even more. As we were packing up,

Ruth said to us, "Whenever you guys want to come back, you're welcome."

After our set, triumphant from having conquered New York and high on our success, we drove the van onto the Staten Island Ferry and rode it across the channel. I was still in my costume from the club—who knows what I was wearing, although at the time I could often be found in a jock strap and football pads—and some knuckleheads on the boat said something to me in an effort to prove their masculinity: "Faggot." Normally, I tuned that kind of thing out, but Robert didn't. He turned to them and got in their faces. "Who the fuck do you think you are?" He was a commanding enough presence that the losers shrunk from him. It was nice to be protected by my tribe, even away from home.

The apartment where we were staying, back in Manhattan, was on the second floor across from a pizza place. Timothy slept, while Robert was on the phone to his girlfriend, wearing only white underwear. His body was beautiful, and so was New York. I looked out the window, at the grim cityscape buzzing with neon lights, and thought: *Never forget where this is.*

———

By summer, I'd gotten evicted from the place on Charles Allen Drive, which came as no surprise. I hadn't paid rent in months—since Mark had left that December, in fact. Dick Richards assured me that I'd always be welcome at his place, and I knew that I could couch-surf around midtown. But often I'd end up back at Renetta and Gerald's house, at least one night a week.

The mood there was deteriorating. Gerald had such an entre-preneurial spirit, but he had always been a tad short on follow-

through; he loved the plan more than the execution. Now I could see that he had lost his way. I would come home to find him passed-out on the couch, or he would fall asleep with his underwear on, lying on the floor, with his tongue hanging out of his mouth. It reminded me of a child who didn't want to go sleep in their bed, but rather wanted to stay in the room with everyone else. His life force was being drained, whether from drugs or his other struggles I don't know. He could no longer convince himself of his promise, let alone any of us.

Renetta would never have confided in me about the problems in her marriage. But I would hear them arguing. "Why the fuck would you put my name on it, Gerald?" I'd listen to my sister say about some document or contract as they fought in the kitchen. Within the next year, they would decide to separate.

The energy created from my rising star was enough to distract me from the fact that my own heart was, in many ways, still broken. I'd fool around with a guy named Nate, who was so Black he almost looked blue; he was tall, beautiful, and real country, and sweet enough I didn't mind that he was a hustler—and not the kind that swindles you, but the kind who sells sex. I brought him to a party at Clare's house, where a bunch of folks from the scene were in attendance, and realized immediately that I'd made a mistake. He was out of place among all these artsy people and seemed instantly uncomfortable.

Friends of mine like Floyd would talk about going cruising in the trails at Piedmont Park, which would have scared me to death. I wasn't interested in an anonymous, faceless sexual workout. It would require too much imagination to project intimacy onto a body that was performing nothing more than a biological function. I was only interested in experiencing another person in a real way.

For reasons I couldn't entirely explain, I was afraid. It wasn't just the threat of AIDS, which had appeared on the news beginning in 1981 and created a culture of anxiety—a specter that could turn up at any moment. It was understood that by having unprotected sex, you could catch it, and soon it was common to see condoms and literature passed out in clubs. It was terrifying, and yet it was a looming threat for which there was no cure, so what were we to do? We went to protests, talked about it constantly, and partied as if Rome was burning. I knew that I was fiercely lucky that I didn't lose more friends to the epidemic, to say nothing of my own life, given how much it was ravaging our community. But my fears of sex ran deeper than that. It was a fear of what would happen if I really let myself go and allowed myself to be submerged into the realm of total abandon. I was so different, so not of this world. Very tall, Black, artistic, feminine. I believed I was too many kinds of other to be seen as sexually desirable in the hierarchy of gay men, and it was safer for me to keep my walls up. So it became a self-fulfilling prophecy: In refusing to allow myself to be desired, I never was. It was a loop—my self-negation, and the negation by the world. I needed a power shift.

My drag had always been the Boy George–influenced, mohawk-and-extensions, tribal apocalyptic Thunderdome look. But once I went out in high-femme drag, something turned.

The Now Explosion was doing a wedding-themed show, and Wee Wee Pole was opening, so I went on-stage in a white lacy strapless party dress in the cinched-waist style of Dior's "New Look." I was wearing heels that were about three sizes too small for me, a wig, and makeup. The silhouette signaled to the surrounding human animal that I was a woman. In my mind, I was

being contrary and punk; I was a six-foot-four Black dude with a hairy chest and hairy legs in this party dress. But even backstage, I felt some energy shift. The way the men were looking at me was feral, aggressive. It was the first time I could remember that feeling from men. The closest I'd ever come before was when John Wayne picked me up in that park in San Diego, seeing me as an object of desire. To be purely objectified in the sexual hierarchy, perceived as genuinely sexy, as opposed to set apart from the world—it felt new, after being shut out of that for so long.

I was finally getting sexual attention, but it was by disguising myself. I was only doing drag as a joke. But suddenly it seemed like the joke was on me.

This is true of gay men who are sexually invisible until they get into drag, when their role is established: They're something that can be fetishized. For the first time, they have a place in the sexual hierarchy.

Back then, my drag wasn't yet refined in the way it would become. It was still rough-and-tumble, punk rock, defiant enough that it mostly reinforced my sense of being an outsider. But I could see that the sexier I appeared, the more the men watching granted me power.

On one level, it was disappointing—to understand just how superficial people were and how easily they could be manipulated. On another, it was newfound influence. I wanted to get into high-femme drag again as soon as I could and terrorize the whole neighborhood.

So many gay men seek out sexual partners who are surrogates for their fathers, or a replica for themselves. I was never going to be anybody's daddy, nor could I be their twin. Drag was

the first clue that there was a place where I would be granted a currency I could actually spend.

———

In September, Wee Wee Pole went into the studio to record our first singles. One of them was called "Ernestine's Rap," which consisted of me reciting some of my mother's most memorable sayings while Robert slapped the bass. The second was "In My Neighborhood," which I considered our hit song, and then there was "Tarzan," in keeping with our larger aesthetic.

By November, the band had broken up. It had been nearly a year, and we hadn't landed a record deal, so per Robert's original plan, we would go our separate ways and try something new.

Not long after, I was standing outside an apartment building in midtown Atlanta on Tenth and Juniper, the building where Floyd and Bunny lived, smoking a cigarette, when a car passed by. I could see a guy inside checking me out. "Hey!" I said. He circled back around one more time, and then parked the car on the street. He was hot, Greek, with ombre hair, wearing tight white jeans. Things moved quickly from there. First we were on the front porch, then in the stairway in the lobby, making out. The next thing I remember, I was out at the club with him, dancing. And then in an instant, it seemed, he had ingratiated himself into our scene. He was sweet and handsome. It was nice to have him around, so I didn't mind.

The next time I saw him out, he was hand in hand with Cheryl—the girl from Chattanooga who was a childhood friend of Bunny's. She lived in that same apartment building where we'd met. *What?* I thought. *Cheryl?*

Once he came by to see Cheryl while I was hanging out there waiting for Floyd and Bunny, but she wasn't home. Cheryl never locked her door, so we went into her apartment to wait for her. One thing led to another, and we ended up having sex in her bed.

Afterward, I looked at him. "What the fuck are you doing with her?"

He shrugged, looking a little guilty.

"You can rape me if you want," he said.

In that moment, I felt like I understood everything there is to know about men and sex: how deeply, stubbornly stupid and impulsive they are in their carnal motivations—present company included. How basic it all was, this life of earthly, lusty concerns.

*Pathetic*, I thought.

Cheryl could keep him.

The fortune teller had been right.

Stardom beckoned.

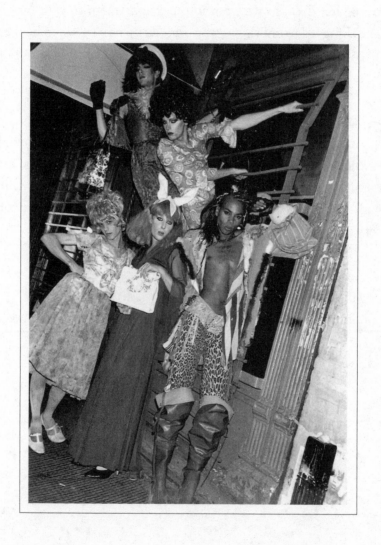

"I'd had a feeling our show
would be a hit—it was fun,
optimistic, and glamorous.

# Pyramid

But the reception felt rapturous
in a way it hadn't in my earlier
performances in the city."

I n January, Floyd let me crash on the floor of his room for a week in the apartment on Tenth and Juniper. It was freezing outside, and Floyd didn't have a bed, so we slept on towels and a blanket on the floor. Although we'd known each other for a year and a half, this was the first time that we'd ever spent concentrated time together alone, and that week cemented the bond between us. I had always known that Floyd had bite—that he could be territorial and a little bratty— but it was then that I experienced the other side. He was, in his way, very sweet—even tender. I was always looking for that in people, the vulnerable spot that allowed me to say: *Ah! There you are.*

Not long after, Floyd and Bunny's roommate left, opening up the third bedroom, a corner room with a balcony. I moved in, scraping together the money for rent. And now the three of us traveled as a unit.

In this season of life, the first order of business was this: *Get high.* Just that one simple, clear directive would start the process. It typically began with cannabis, but if somebody had coke, or acid, or something to sip on, we were all for it. But weed was the accelerant and the thing that could activate us. Somebody's got weed at their house? *Let's go!*

Once stoned, the events of the day's remaining hours unfurled with a kind of lazy ease. On the corner, we'd run into somebody who would say, "They're giving away T-shirts down at 96 Rock for Bob Seger!" *What? What are we waiting for?* Or we would go to a lesbian bar on Cheshire Bridge Road called the Sports Page, where they had a Sunday tea dance and a buffet where you could eat for free. There was some kind of performance happening every night; if nobody was performing, it was

taking acid and making a trek through midtown to get in free at the 688 Club or the Bistro or Weekends and dance.

There were girls working the streets, some of them trans, others assigned female at birth. We knew them all by name. A trans girl named Cornisha was very suspicious of our little posse as we rolled up and down the street, but we were so ubiquitous as to be unavoidable. Her pimp had just gotten out of prison, and I thought he was hot, like a young Smokey Robinson. He'd say hello as we sashayed along night after night.

Is it the rose-colored glasses of nostalgia that makes me yearn for how fun and free that time was? I had always felt like a solo agent. I knew, even from my earliest moments, that I would have to leave the nest of my family and trudge the road alone. The sense of being a part of something, of belonging, that had once felt so elusive now felt vital. We had been anointed with fun, and maybe even as it was happening, we knew how special that was—and that it wouldn't last forever. And it was different from how it had been with Bunny alone. She was fun, smart, and a master at turning a phrase, but she was very staunch in her convictions. Floyd, on the other hand, was just down to play.

As we all fancied ourselves entertainers, the other main focus, besides getting high, was to plan some type of show, whether it was an art opening at Metroplex or an upcoming performance at the Celebrity Club, which Larry Tee oversaw. Everybody we knew had a band, or at least some type of act. To build a career in show business—that was the expressed goal, even if most folks were just following the crowd, because every-one had a creative outlet of some kind. We had seen other peo-ple from the scene become millionaires from having nothing more than a garage band—what was stopping us from doing the

same? In the interim we were just trying to get enough money to survive, waiting tables or working at the arthouse theater down at Ainsley Mall, which is what I did for a time, tearing tickets for gays and intellectuals who came to see French New Wave films or avant-garde American features. Some aspiring politician who had his campaign headquarters at the Biltmore Hotel hired Floyd and Bunny to stuff envelopes in exchange for swag; they were desperate and bored enough that they actually did it.

Throughout the day, if we weren't asleep at one another's houses, we would be out walking around. We listened to music and talked about music. Bunny wasn't into Bowie or Cher, but she went hard for a soulful disco moment. The bigger and Blacker the singer, the better. Floyd went for David Bowie, like me, but he also loved the Cocteau Twins and Elton John. When the building across the street from us burned down, we went rooting around in the wreckage for anything we could find that was salvageable. There, in the charred remains of somebody's home, was a copy of Cyndi Lauper's *She's So Unusual*, only slightly warped from the fire damage. We played her cover of Prince's song "When You Were Mine" over and over and danced on the balcony outside of my bedroom.

Not long after I moved in, a handsome boy named Danny Morton pulled into the parking lot of the building in a candy apple metallic-green Chevy Malibu with a white top. He and his friends had moved down to Atlanta from Illinois and were moving in. They formed a band called the Cocktail Girls. Danny was the lead singer, although I wasn't entirely convinced he had the star wattage to front a band. They moved in on the second floor across the hall from Cheryl.

Like Mark, and Lamar before him, there was something so sweet about Danny; even though he claimed to be straight, he was very touchy-feely. I could sense he had no barriers. We went driving around, the whole gang, and he had me sit in the front seat next to him like we were in a fifties movie. We would sometimes fool around and grope each other in the apartment. I got inspired enough by Danny Morton to put him in a movie that I directed starring my friend Lori Nevada called *Disco Isis*. Lori played the titular role, a warrior for justice who is spurred to action when an evil crime boss, played by my friend Cherry Snow, kidnaps the Cocktail Girls. Disco Isis rescues them with a few choice dance moves and saves the day. Back then, I would shoot with a crumpled-up cigarette wrapper over the lens, to smooth out everyone's edges and give the film a particularly gauzy look.

But it was really music that drove us, music that kept us nourished. In the spring, Prince released "When Doves Cry," which was playing on repeat—along with its B-side, "17 Days"— from at least one of our apartments at any given time. And each weekend, somebody we knew would be playing a show, often at the Celebrity Club. One night I went to see a group called Eastern Stars who just banged on pots and pans. Leading the group was my old roommate Kathy who I'd lived with on Charles Allen Drive, although by then she was calling herself either Cabbage or Carson—it was hard to keep up.

Get high. Have adventures. Get ready for the weekend's gig. That was the life.

I had worn out my slogan RUPAUL IS EVERYTHING, so had moved on to a new one: RUPAUL IS RED HOT. I pasted posters with that one over every telephone pole in town. I knew the mes-

sage was spreading because when Floyd, Bunny, and I were out on the balcony of my room, getting stoned or dancing around, people passing in cars below would stick their heads out of windows and scream: "RuPaul is red hot!"

Eventually, someone launched a counter-campaign, crossing out my name and writing WHO-PAUL. Around the same time, a piece of graffiti in the dressing room at the 688 Club was pointed out to me. It read IN THE BLINK OF AN EYE, RUPAUL WILL FADE INTO OBSCURITY. I took it as a compliment. You're nobody until somebody hates you.

———

The first concert I ever went to was in 1969, to see James Brown and the Famous Flames Revue at the San Diego Sports Arena. I understood that a revue was a show centered around one star that also incorporated supporting cast members. After Wee Wee Pole split up, I needed a new act, and the answer was obvious: I had so many friends who were entertainers, too. They could help me round out the show. I would open, bring on two or three additional acts while I changed costumes, then close the show and invite everyone back on for a grand finale. And I knew that I could get booked, because I had built a name that was now recognizable. I was self-aware enough to know that this was marketing 101—the only thing I didn't know is why other people weren't forging ahead with the same kind of brand-building.

The revue would include Floyd, Bunny, and two others. First there was Lady Pecan, a roommate of Clare Parker's whose real name was Jance. He was a good-looking Southern boy, terribly

gay and terribly sweet—not a bitchy bone in his body. He was like the opposite of Bunny, who was all bitch but so funny that you forgave it. And then there was Opal Foxx, a real country white boy from the deep South whose humor was dry as chardonnay. He worked at IHOP, so he would dress up in a waitress's outfit but without a makeup or wig, and take your order with a cigarette hanging out of his mouth.

The show didn't need to be overly complicated. Lady Pecan wasn't much of a dancer, but she could do a trick with a balloon, or some paper, or she would just recite how to make biscuits onstage. I made cardboard boxes that I painted to look like huge Instamatic cameras and put them on two of the boys who had come down from Illinois with Danny, along with striped pants with fringe down the side. They'd dance around me, and I'd sing a song and pose as if they were taking my picture. I called it the RuPaul Is Red Hot Revue.

We previewed the show in Atlanta before we got ready to take it up to New York in July. We all knew, even if we didn't say it to one another, that New York had the toughest crowds in the world. I had learned this from experience. At clubs like the Pyramid—which was at that moment probably the coolest club in America—the audiences were jaded and precious. This was not so much the case at Danceteria, which was more commercial in its sensibility but still intimidating. The Pyramid would never willingly court the bridge-and-tunnel crowd. People in New York were dead-set on holding on to their identities as downtown dissidents—and that's where we'd be going, in an attempt to charm them into laughing along with us.

The owners of the Pyramid arranged for us to stay in an apartment right above the club, with the two waitresses who

also lived there. They had a boyfriend, an Israeli guy named Ayel, who flirted with me shamelessly. Two women sharing one bisexual beau? It couldn't have been more cosmopolitan.

I'd had a feeling our show would be a hit—it was fun, optimistic, and glamorous. But the reception felt rapturous in a way it hadn't in my earlier performances in the city. New York was still recuperating from its dreary, bankrupt darkness, and here we'd come from Atlanta—gorgeous and dripping in fringe, showcasing a low-rent Vegas morality, luminous in our fake Bob Mackie best. To win them over with love and kindness, the message I'd always wanted to spread in my work, felt like conquering Goliath—as if we had vanquished the darkest, most cynical monster imaginable. On my arc to stardom, this was a triumph—a local one, but a triumph nevertheless.

We stayed in New York for a few days, eventually crashing with Nelson Sullivan, a childhood friend of Dick Richards's. They had been next-door neighbors growing up. Like Dick, Nelson was obsessed with capturing everything. He was from an old-money Southern family and had come to New York to write a novel, but had gotten so caught up in the downtown scene that instead he'd bought a video camera and started filming everything, everywhere. He lived in a three-story Federalist house that, he told us, had been built when the Dutch came over and colonized that part of the city. The house was in the Meatpacking District on the old cow roads that weren't on the grid system like the rest of Manhattan. Even the floors were made of the wood from the boat that had brought the colonists here. We were standing on the shoulders of all that history.

After we had been in New York for about a week, Bunny stomped her feet. "I'm staying!" she said.

I looked at her like she was crazy. "What are you talking about?" I laughed.

"I'm not going back to Atlanta!" she said. "Throw all my shit in the trash!"

Floyd and I decided that we wanted to stay in New York, too. But we wanted to go back and get some things organized before moving, so we drove back down that day, leaving Bunny behind. Back in Atlanta, I cleaned out my room in my apartment and liquidated what little I had. Then we returned to New York by car a few days later. I brought just one tiny suitcase back with me, packed with underwear, a few pairs of homemade pants and tops, a coat for when it got cold, and some makeup. Those elements could be combined to create perhaps three different costumes, interchangeable pieces that could be mixed-and-matched. For shoes, all I needed were a pair of thigh-high rubber boots I could dance in. It didn't matter—the promise of New York was irresistible. Never mind that we didn't have a place to live. We would figure it all out.

And we did. Floyd and I met a pair of girls, Suzie and Jennifer, with an apartment on Sixth Street east of Avenue B, who would let us crash on their couch. We slept in parks, on benches, and on the pier, but only during the day. We showered wherever we could, but that wasn't a high priority; after all, we were bohemian scallywags.

Floyd and I were inseparable through this period. We needed each other, not just for practical reasons, to ensure each other's safety, but emotionally, too. It was clear that we were in this crazy adventure together.

The owners of the Pyramid Club let us store our luggage there, which was a mercy—that way we always knew where to

find our meager belongings, no matter how chaotic things got. Sometimes we'd end up somewhere because the guy who was hosting us wanted to sleep with Floyd. I was never the object of sexual desire, which was just as well for me—I'd get a better night's sleep. Sometimes we crashed at the apartment of Ruth Polsky, the booker at Danceteria who had been so sweet to me. Most of the New Yorkers I encountered had a rough, hard exterior. Ruth knew how to handle herself, but she was soft—I knew instinctively that she was kind and always would be.

———

I have always believed that kindness is the highest form of intellect. From my earliest memories, I had been called names—sissy or faggot—but they never stuck to me. In Atlanta, in the first apartment where I was living, someone spraypainted the word "faggot" on my wall while I was out. I genuinely forgot about the whole incident until years later, when an old roommate reminded me. I could feel that these boring, mundane forms of cruelty were just the tics of those who had no imagination, like the kids in my neighborhood who gathered to see me exiting the bus as a little boy, aghast that I had gone to see the beach by myself. It wasn't that I was any of the things they said I was. It was only by daring to step outside the bounds of what I was expected to be that I was ostracized.

Part of the security I had found in Atlanta with the gang of oddballs I'd met was the certainty that I'd be understood—perhaps not fully, but enough to feel a sense of community. I expected the same in New York, given how scrappy and bohemian that vibe was. But I was surprised to discover that the kids

in the East Village, the same ones who had cheered our revue at the Pyramid, were colder than in Atlanta, even to the point of cruelty. One piece of it was that New York was inherently harder. Taxi drivers were on edge; passersby on the street seemed defensive instead of open. We all knew that pickpockets roamed the streets, that anyone could be trying to scam you or mug you. People we saw in the clubs held a posture of disenchantment. When we showed up in our bright colors, skipping down the sidewalk, we must have looked like naive aliens.

I came to see that kindness, my religion, wasn't practiced universally. Even if I was capable of going cold, too, I knew that I couldn't allow my own pain to become radioactive, to spill out and infect anyone else.

I began dancing on the bar at the Pyramid Club, earning maybe fifty dollars a night to spend on cigarettes or food or whatever else I needed. I could see that I was better at working the patrons than the other dancers, pointing at people and imploring them to come over, then asking them for a dollar. "For good luck," I would say. On a good night, I could clear a hundred and twenty dollars in tips just by engaging with the clients, locking eyes and working the crowd. And yet among the cool kids of the downtown scene, I was treated with disdain, and while we found pockets of kindness here and there, there was something frostbitten about East Village people. Late one night, we were closing down the club, and it had started pouring down rain. I hadn't made arrangements to stay anywhere, so I asked one of the guys who ran the club if I could crash at his place for a couple hours.

In a very straight-faced way, he just looked at me and shook his head. "No," he said. Not: *I'm so sorry, but that would put me*

*out.* Or a lie: *Unfortunately, I already have a houseguest.* Just no. What could I say? That was how it went in New York.

I had first learned of Madonna back when she was working the coat check at Danceteria; by now, she had become a star. Not long after we arrived in New York, Floyd and I volunteered as helpers at the New Music Seminar in 1984, which was put on by Tommy Boy Records—one of the leading hip-hop labels—and the owner of Danceteria. It was a weekend where unsigned bands, music executives, and fans from the public would gather for a three-day convention with panels about the music industry, explaining how to get signed or how to advance your independent label. People would come hear speakers at the Marriott Marquis in midtown during the day, then later go to showcases featuring unsigned artists at the Peppermint Lounge, Danceteria, or the Pyramid. By day we'd mostly be at Danceteria, stuffing bags or envelopes with packets for the paid attendees of the conference, but eventually, we got to go to the seminar, and Madonna was on a panel.

We listened to her speak about her struggle to make her way in the city. She had been trying to get a record deal for a while, she said, and she talked about being relentless about getting signed. Somehow, she got to Seymour Stein, the head of Sire Records, when he was in the hospital with a heart infection; it was then that he signed her. I loved hearing about her tenacity, and it was thrilling to know that a girl who came from a similar scene with the same hustle could have rocketed to stardom in the way that she had. As we were leaving, we saw her standing outside with her publicist, Liz Rosenberg. They hailed a taxi and disappeared into the stream of yellow cabs heading down Forty-Seventh Street.

Sometime later, I went down into the break room of the Pyramid and she was there, holding court with a small group of people assembled around her. She looked at me with an expression I'll never forget—a snarl of contempt at the sight of me, cold fury that I would deign to enter while she was in the room. Of course, it was our break room, and I was on a break—it's not as if I'd done anything wrong. But her look said: *What are you doing in here? Why are you here right now? How dare you take up oxygen in my world?* She made no attempt to veil her derision for me. The fact that I saw it so nakedly was the whole point.

I felt intuitively that, in an instant, she had sized me up and seen that I had nothing of value to provide her. The world ran on a system where sex conferred power; she had become such a big star by seizing control of her sexuality. But that also meant she sized up everyone she encountered, determining whether they'd add anything to that equation. In clocking me as a eunuch, I became worthless to her. It was a microcosm for the rest of the world, but I saw it most clearly in her.

She reminded me in that moment of my mother. Both were Leos. Both were cold to a fault. All the social niceties that people conduct ultimately serve as signaling devices, communicating this: *I know how cold this world is. And I know that being kind is a choice I could make to soften the anguish of being alive for you.* But not everyone was willing to play by those rules.

————

Just like Madonna, New York saw no need to be nice to me. Sometimes I'd sleep at the house of Renetta's friend Simone, who lived out in Queens. One day, she brought me over to the home of a friend

who had an apartment in Tribeca. He was a coke dealer, but he was nice; he gave us a few lines and we sat on the floor, chatting in a neighborly way. At one point while he was in another room, I needed to use the phone to call Floyd, who was working delivering takeout at a Chinese restaurant in the East Village.

"There's a phone right there," Simone said, pointing to the landline.

I made my call, and as I was hanging up, the coke dealer walked back into the room.

"Did you just use my phone?" he said. He was furious. A vein in his forehead throbbed. "Did you just fucking use my phone?" he yelled.

All the pressure of being in New York—and being so disconnected, and being homeless—in that moment, I just burst into tears. It had been so long since I had allowed myself to crack like that. As a rule, I never broke down. But my Pollyannaish belief that by presenting kindness and sweetness you'll get that in return had been challenged too many times.

"It's cool, dude," he said as I cried. "Relax."

I pulled myself together. Coldness was tolerable, but only if it was backed by love. When my mother was unkind to me, I could abide it, because I knew she loved me. New York, on the other hand, didn't care if I lived or died.

———

Winter was coming, and Floyd and I both knew that being homeless in New York in the winter wasn't an option. As harsh as the city could be, it would only be more so in the bitter cold. We decided to go back down to Atlanta for the season. So we packed up

what little we had and made our way back down South. We hadn't been defeated by New York, but we hadn't quite bested it, either—we would put a pin in it and make another attempt later. Surely, we thought, the goodwill we'd accrued in that year would be waiting for us when we were ready to come back.

When I returned to Atlanta, Renetta had finally left Gerald. Now she was living in a townhouse over near Piedmont Plaza, midway between Lenox Square and midtown, with both of her kids. I crashed there for a while, coming home at all hours with a mohawk, a high-top ponytail, and a long extension that came down to my waist, plus a white long-sleeved shirt cropped above my ribs and yellow drawstring sweats tucked into my wading boots—an understated look.

My mother had continued to soften, at least toward her grand-children. She would call the house and Renetta would pick up.

"Hello?"

"Are Scott and Morgan up?"

"No," Renetta answered. "They're asleep."

And my mother would hang up the phone without so much as another word.

One night I came home from the club and there was a man in the living room. It was the Greek guy who I'd dated who had gone on to date Cheryl. I looked at him, stunned, then over to Renetta. I remembered that they'd crossed paths briefly when he was hanging around. Renetta wasn't close enough to the scene to have known that he and I were dating.

"Hello," I said. *The things you drag in from the street*, I thought.

The next day, I told her. "No, you did not sleep with that man before me," she said.

"Renetta," I said. "I did."

"You did not!"

"Do you want me to describe his dick to you?" I asked.

She shook her head no.

I knew she was looking for something in the wake of what had collapsed with Gerald. We had both been soldiers in the dream life he had created—the fantasy that he would break this world right open. That somehow, through his luck and charisma and ability to weave in and out of different circles and smooth-talk people into a yes, he would crack the code.

But the world had changed. The optimism of the late sixties and seventies had only carried so far, and by now, in the Reagan era, the future was no longer for the making for men like Gerald. His shine had worn off, and he was a wunderkind no more. So he had begun drinking more and using more drugs. He was medicating something, instead of expanding something. And the distance between him and his wife had widened into a chasm. Renetta leaving him had been a long time coming.

I started go-go dancing again at Weekends in midtown and got a new apartment by myself. Not long after, Renetta came to say goodbye. She was taking the kids and going back to San Diego—she had only ever come to Atlanta for Gerald, anyway, and now that the marriage was over, there was nothing really keeping her there.

"Bye, Ru," she said. Her eyes were wet. I understood we would not see each other again for a while, and that this—this last connection to my nuclear family in Atlanta, to the safety net of home I'd felt with my sister all those years—was going away. Yet if this was the ending of the story for Renetta in this chapter of her life, it was the beginning of one for me.

———

I had learned self-sufficiency from my mother and practiced it always. I always knew that I could survive, that I would be all right on my own. But kindness was another matter. There was no guarantee anyone else would be sweet to me. Not boyfriends. Not the people I met in clubs. And certainly not New York City.

The only option was to be kind to myself.

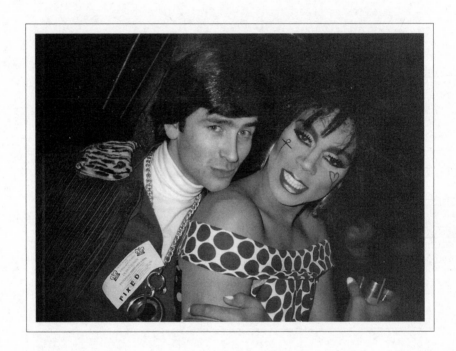

"I can't explain why it

was so clear that we all

had to leave the nest,

# Saturn

but it was:

One era had to close

for this next one to open."

The year I came back to Atlanta from New York, the band that had been the glue that held our scene together—the Now Explosion, fronted by Larry Tee—broke up. Larry was devastated. That band had been his universe, and it was his only claim to fame so far. The implosion of his act left him lost, and his ego bruised. In this, he became vulnerable for the first time, at least with me. Although we had been friends for years, I had never seen this side of him, a soft underbelly born of pain.

I was go-go dancing at Weekends, and now Larry began working as a DJ there. After work, we'd get high and hang out until morning came. But our friendship was about more than partying. Larry was obsessed with hidden meanings, with the invisible undercarriage of things beyond immediate perception. Larry was convinced there was a secret message on Prince's *Sign o' the Times* album; Prince's lyrics were so evocative and thought-provoking, surely there had to be another layer. The cover artwork of Sheila E.'s single "Koo Koo," Larry thought, was actually Prince's body, shaved and in drag. He saw things that seemed, at first glance, not to be there. Or were they, and only certain people in the world could see them? Was Larry projecting meaning where it didn't exist, or was much of humanity just blind? These were things we pondered, usually high out of our minds.

I danced from eleven-thirty at night until four in the morning, then Larry and I would take acid and run around with a friend of his, a beautiful lesbian named Lisa who always had coke. We would drive out to the river or grab food at a greasy spoon twenty-four-hour diner. He still drove the Now Explosion van, this vestige of his former life. Once we drove two hours to

Augusta to take his mother to the doctor. Larry was heartbroken that his mother was in pain, and, accordingly, he was as well.

Here is what I told myself in these months: My planned ascent to stardom in New York hadn't failed, exactly—it was just going to take a bit longer than I'd anticipated to get that train moving. The best thing to do was to keep myself occupied with projects in Atlanta that could grow my star power. So that's what I did. I was cast as Riff Raff in a local theater company's production of *The Rocky Horror Show,* and it made me feel like a real professional actor for the first time, because I was paid an actual salary. Moreover, my costar who played Magenta was local theater legend Megan McFarland. It felt as if I had legitimized myself as an actor, not just as a nightclub performer.

I put out an EP called *Sex Freak* on Dick Richards's label Funtone featuring the three songs I'd recorded previously with Wee Wee Pole, plus three others. When I went on *Dance-O-Rama USA* to promote it, the host, Spencer Thornton, asked me what he should call me. Reflexively, I said, "Starbooty." Later, I'd remember that I'd heard the word before; Roy Ayers had a group called Ubiquity who'd released an album by that name. But now, suddenly, it was rolling around in my head: *Starbooty.*

I told Lahoma that I thought our next vehicle should be called just that: *Starbooty.* I would play a crime-fighter in the tradition of Cleopatra Jones and Foxy Brown—the characters I'd so idolized growing up as a little boy, watching them on the screen of the drive-in movie theater. Starbooty was a former supermodel turned secret agent. I outlined a story, which I shared with Lahoma, who would be directing. The film opened with the kidnapping of Ronald Reagan's son by the primary antagonists, the Evil Twins; Starbooty then discovers that the Twins plan to

put AIDS in the water supply. Floyd and Larry Tee would costar. We shot the film in my apartment for a budget of exactly zero dollars. When we were done, we immediately began work on the sequel, *Starbooty II: The Mack.*

The films were cheap, goofy, and outrageous. They were meant to be a tribute to the blaxploitation era and to John Waters, whose movies I adored for their absurdist commentary on American life. We made copies on VHS tapes and sent them out to friends in New York and Los Angeles, and quickly the films developed a cult following; people started showing them at bars and in clubs. Someone in LA wrote me to ask if they could fly me out to host a viewing party. Not long after, I got the same offer from someone in San Francisco. It was a contained form of stardom, but it felt like the beginning of something.

Even if I was currently bound to Atlanta, it seemed my star was starting to shine in other places. I was still taking frequent trips back up to New York. On one such trip, I went with Dick Richards for the New Music Seminar, and while crossing the lobby of the Marriot Marquis, Dick saw someone he knew—a man named Randy Barbato, who was in a music duo called the Fabulous Pop Tarts. Dick called him over and introduced us.

Randy was good-looking and a bit shorter than me; I remember looking down at him, although I would have been towering in my high heels. When I looked into his eyes, something extraordinary happened. I saw my own future. It was as if he was seeing in me all of my true potential. His eyes were a mirror, illuminating to me what was possible for my life. I had never felt anything like it. There had been people who had believed in me along the way—people like Dick, and Ruth from Danceteria—but Randy instantly was different. There was an electricity between us—a charge. In that moment of looking at him, I knew that

my dreams would come true. It would be another week before I met Randy's partner, Fenton Bailey, a beautiful English man with sweet features that belied his shrewd business acumen. Quickly it was agreed that Randy and Fenton would collaborate with me on music. We met at a studio across from Madison Square Garden, the recordings from which ended up becoming an album I released on Dick Richards's label called *RuPaul Is Starbooty*. It felt as if we were all cousins: Randy and Fenton were acolytes of Nelson Sullivan, who was a den mother to them in New York the way that Dick was to me in Atlanta.

I toured on that album, including an appearance in New York at Danceteria, courtesy of Ruth, who was by now a true friend. She had been such a fierce ally—not only in booking me whenever I came to New York but also in giving me a place to crash anytime I showed up at her door.

Just a few weeks later, an out-of-control taxi plowed into a crowd waiting to get into another club, the Limelight, and Ruth was killed in the melee. I was shocked and devastated; we all were. She had been someone who I knew always had my back and who was invested in my dreams. I thought she'd always be there. Ruth's death felt like the end of something. The only beacon of kindness I knew in New York, a place that was so often hostile to me, was now gone, as it was for the battery of other artists she'd helped introduce.

But the pull of the city was irresistible, no matter how challenging living there could be. Not long after Ruth's passing, Larry Tee, Lahoma, and I decided it was time to take another run at living in New York—a real one, not the driving back and forth we'd all been doing. Larry had built a following for a group he had formed in the wake of the Now Explosion called La Palace de Beauté; it featured him as the front man backed by Lahoma

and Judy La Grange. When Judy was unavailable I would fill in, so we were used to traveling as a triad.

We drove a GMC work van with no windows in the back—just two seats up front and a funky middle seat, where I sat—up from Atlanta. We were on Highway 85, right outside Greenville, South Carolina, maybe two hours north of Atlanta, just past midnight. We had each taken a few bumps of cocaine and then lit a joint to keep us focused on the road, when all of a sudden, we heard a sickening *thwack* as one of the back tires blew out. We screamed. The van fishtailed, lurching to-and-fro, and then we flipped. I felt the force of it all as we landed upside down. Then we flipped again and landed right side up.

I looked out the window. I could see that we had landed on the side of the road—a miracle, given that we easily could have landed in the middle, or in the way of oncoming traffic. Lahoma's photographs and keepsakes were sailing in the air, raining down over the highway. Passing cars rolled over them, leaving tire tracks across them. We ran out and tried to collect our possessions that were now scattered along the highway as quickly as possible. Then we got a tow to a gas station, where we stayed until the tire was replaced.

Now we had to spend the night in South Carolina, and the most obvious place for us to stay was Heritage USA—the religious theme park that Jim and Tammy Faye Bakker had developed in Fort Mill. It had once been a major tourist attraction, like a Christian version of Disneyland, but Jim Bakker's sex and financial scandals had had a chilling effect on business. It was eventually taken over by Jerry Falwell, and the park was a whisper of its former self—barren as a ghost town. We wandered around its ruins, looking at the facades of the old-timey buildings, high

and still shaking from the bizarre trauma of our accident—and the fact that we'd been so lucky.

It felt as if we had traveled through a portal to the next phase of our lives, and things would never be the same again. The age of innocence had shit us out. Things in Atlanta had been so easy. Now that we were on our way to New York, barreling down the highway in a cartwheeling van, there was no guarantee things would be so charmed again. I can't explain why it was so clear that we all had to leave the nest, but it was: One era had to close for this next one to open.

———

Things felt different in my friendships with both Larry and Lahoma once we got to New York. With Larry, to whom I'd felt so connected in Atlanta, I suddenly felt distant. On previous trips, he had befriended a guy named Michael Alig, a promoter who had a night at the Tunnel, a club at Twenty-Eighth Street and the West Side Highway. When we got back to New York, they became even closer. Michael gave Larry a space at the Tunnel called the Celebrity Club. One night I was hired as a dancer; it was there that I met Michael for the first time. I immediately disliked him—there was something about his energy I didn't trust.

Later in the evening, he suggested we go over to a competing club to see how their crowd looked—it must have been the Limelight—so I got in a cab with Lahoma and Michael to scope out the crowd. Then we took a taxi back to Tunnel. As we pulled up at the door, Michael jumped out and ran into the club without paying the driver. It was understood that we all had to run out of the cab as quickly as possible after him to avoid being stuck with

the bill. I then knew for sure that Michael Alig was not my kind of person. He'd showed me everything I needed to know about who he was in that moment. I avoided him socially, but we had so much overlap in our circles that seeing him was inevitable.

Sometime later, he booked me to go-go dance for him at Tunnel. I didn't want to be associated with him, but I would do it for the money. When I approached him at the end of the night, it was only to collect my payment.

"I'm ready for my fee," I said.

"Only if you kiss me," he said.

"Don't fuck with me, Michael," I said. "Pay me."

"Just one kiss," he said softly.

I looked at him. "Fine," I said. As I leaned in to kiss him, he stuck his tongue in my mouth. Then he spat directly into it. It was shocking and disgusting. I recoiled. He just laughed. That was the last time I worked for him.

It was unsettling to me that Larry was spending so much time with this man. But being in New York only brought me closer with Lahoma, who became a drinking buddy after years of making movies together. I knew that Lahoma had come from an alcoholic household; his mother, a gregarious former drunk, had great stories to tell of her adventures as a drinker, but was now fierce in her sobriety. Lahoma had always been a moderate drinker in Atlanta, but once we got to New York, the pace changed, and so did the tone. It should have been concerning, but I was in the same boat: For us to be working the scene every night, we needed to be lubricated.

I also spent time with Bunny and Floyd, both of whom had stayed in New York. On Thanksgiving that year, Bunny, Floyd, and I went to Boy Bar on St. Mark's Place. It was empty. We were the only people there—drunk, rowdy, gallivanting. Finally, the DJ

approached me. "I'll pay you five dollars right now if you leave." I took it, and we went elsewhere. Another night, I performed at the Chameleon and made a grand total of eighteen dollars. Times were tough. It was a darker chapter than it had been two years prior, and all the inroads we had made to lightening up the mood seemed to have closed, as if New York's coldness was winning. My bright-eyed optimism was starting to wane, dimming as a result of my struggle. Randy and Fenton, who had seen something in me, had gone back to England to record an album; I didn't have them to lift me up.

As chilled as I could be by the climate of New York, there were new people I encountered that year, too, who I saw as kindred spirits. In the spring, I got an offer to do a play called *The Shaggy Dog Animation* back in Atlanta, at the same theater where I had done *Rocky Horror* a few years earlier. The play was smart, and I liked the music director, whose name was Jimmy Harry. He had a fun personality, he was quick to a laugh, and I thought he was super talented—one song in that show was a beautiful ballad sung by a Black woman with an enormous voice. I thought the song was good, and I told him so.

But as excited as I was to be in that show, I was only a hired hand—it didn't feel like it was mine. One Saturday night after a performance, I stayed out all night long doing coke with friends, forgetting that I had an afternoon matinee the next day. I was awakened by a banging on the front door of my apartment by the stage manager. I had twenty minutes to get to the theater, put on my makeup and get onstage. I was acting out by partying harder than ever to distract myself from the feeling of being stuck.

When I got back to New York, I got a job go-go dancing at a club called Savage, booked by Kenny Kenny, a club kid who became a legendary door guy. I was on the box dancing one

night, and in walked the promoter and host of the evening. I'd heard about her, but I'd never seen her before. Her name was Susanne Bartsch. She appeared as a fairy godmother hovering over the crowd, as if she was floating on wires. She was lovely, energetically—not the harsh, jaded New York type I had come to expect. She was a sprite. I watched as she worked the room, and then she came over to me. She studied me for a moment.

"You are a pop star," she said simply. She didn't know anything about me—not that I'd had some small-time success in Atlanta, or that I'd been in bands. She just saw me.

"Thank you," I said.

I didn't understand why I couldn't seem to translate the star power that other people saw in me into a kind of meaningful public reception. My whole life, there had been people like this: from my mother, who had considered my stardom a predestination; to Ruth Polsky, who had given me space and confidence in New York; to Randy, who had reflected my future back to me in his eyes; and now Susanne, who knew I was special and told me so. And yet audiences weren't catching up.

A friend had a plane ticket to London that he said he wasn't going to use, and it was nonrefundable, so he offered it to me instead. *Maybe,* I thought, *I should just go to London.* I didn't have any money to get around, but New York didn't seem to be working all that well. Perhaps something would happen in London.

When I landed at Gatwick and attempted to clear customs, they stopped me upon discovering that I had no return ticket. And, of course, I had no money with which to buy a return ticket. The security officer, a Black guy with a West Indies accent wearing a Jheri curl wig, pulled me into a room and strip-searched me thoroughly wearing a pair of rubber gloves. He was cruel to me; I could tell he was taking pleasure in my humiliation. Instead of

letting me through, I was sent unceremoniously on a plane right back to New York. It felt like a strange and terrible dream.

I was floundering, and I knew it. There was only one place I knew I could take a time-out with no expectations: my mother's house. Where was it that I always felt safest, the place I conjured before going out onstage? *It's just Mama's living room.*

Sadly, I didn't have enough money to buy a ticket all the way to San Diego. Back then, there were many flights that made stops where passengers stayed on the plane if they were continuing to the next destination. I knew that Continental flew to San Diego via Dallas. If I bought a ticket to Dallas with what little money I had left, I thought, and there was enough room on the flight, I could just stay on the plane and fly to San Diego as a stowaway.

But as we were landing, it was just my luck—I'd messed up the flights, and it was actually headed to Atlanta after Dallas. That was the last place I wanted to go back to. Going back to Atlanta seemed like some kind of cruel joke.

I got off in Dallas, deflated, and called my mother.

"You're where?" she said.

"I'm in Dallas, Mama."

"Oh, Ru," she said. "You know what? Renae and her husband are driving from San Diego right now to go visit your father in Mansfield."

"They're going to Louisiana?"

"Yes," she said. "Why don't you see if they can pick you up in Dallas, you can go with them, and then you can get a ride with them back to California after that?"

I had performed before at a venue called the Starck Club in Dallas, right behind the grassy knoll where John F. Kennedy was shot. I went there looking for anyone I knew who might be able to help with a place to stay, but there was nobody familiar there.

Instead I slept on a park bench in downtown Dallas and waited for Renae to come pick me up, and then we drove several hours east to Mansfield.

Mansfield was thirty miles south of Shreveport, way out in the country. There was a main street with a few businesses—an auto supply store, maybe some branch of a bank, and a place to get ribs—and then farther away from Main Street was my father's homestead, where he had grown up and where my grandfather had kept a general store and raised all fourteen of his children. The house that they grew up in still stood, but my father lived in a newer house across the property.

I had always felt safe in Georgia, even in its more backwoods corners, but other parts of the South scared me. Mansfield did, too. It had a different energy—as if it was haunted. The fact that I had just been to London and then slept on a bench in Dallas made me feel lost and out of my body. It was as if some unseen force was whirling around me, taunting me. I was swirling, so quickly that I was getting nauseous.

It had been seven years since I'd seen my father, and I dreaded the reunion because I was determined not to do what I had always done before, which was morph into a version of myself that I thought would make him feel comfortable. If anything, I felt only pity for him—that he would have escaped this small town only to move back because of some twisted connection to it. I wanted to say: *You made it all the way out to California! And you wanted to come back to this?* I knew that he had gone back because of some nostalgic, romantic ideal of what the place represented, but that belied the fact that this was no place for Black people.

I had one of my movies with me—*Starbooty III*. Once we arrived at my father's house, I put it on and watched it with him. I wanted to show him who I really was. The whole first act

was me running—in fact, the first shot was of my legs dashing through Times Square.

"Are those your legs?" my father said. "Are those yours?" He was incredulous. I had only learned that I had good legs a few years before that, when someone at the Pyramid saw me in a miniskirt. "Your legs are gorgeous!" they'd said. In his awe, I felt that I had fulfilled the prophecy: I had become the most beautiful of all the girls in my family.

"You know, Ru," my father said. "You were such a good little baby. You never cried. You never complained. You were always a good boy." I understood what he was saying. I had done the best thing that I could do: I had made him feel comfortable and minimized the extent to which he would have to worry about me or care for me. It was true that I never cried; when I was six months old, Renetta accidentally broke my arm while trying to give me a bath, and my parents only knew something was wrong because I was crying, uncharacteristically. My father would always tell that story, because it exemplified what he thought was a good thing. I had never needed anything from anyone, least of all him.

But the truth was I did need something now, even if it wasn't something that my father could give me. I was lost. And I wasn't sure how I was going to get found. My father had gone home to this dead end, which was the exact same thing I was trying to do by going back to the house on Hal Street. What if the fortune teller had been wrong about the glory that was waiting for me?

What if instead I ended up just like him?

———

From Mansfield, I rode back out to San Diego with Renae, then made my way up to Los Angeles. In LA, I thought, I would be able to get

something going—I wasn't sure what—with the people who had flown me out to host a *Starbooty* screening. I made my way on to *The Gong Show*, an amateur TV talent contest, where I came in second place—but no opportunities materialized out of that, either. Rozy was living in mid-Wilshire, so I asked her if I could sleep on her couch while I figured things out. But she and I weren't getting along; I was too old to be crashing with her, and the whole thing felt embarrassing. I would stay in her house all day until after *Oprah*, then I'd leave before she got home from work so we wouldn't have to see each other. I'd wander the streets of LA until I knew she'd gone to bed, when I would sneak back into the house. I was RuPaul—superstar extraordinaire, destined for fame—sleeping on my baby sister's couch without a dime to my name. The very same name I'd always believed, since the prophecy was shared with my mother, would buoy me to the top of the world. What had happened? How had I fallen so far? Was this the end? I had never felt lower. The humiliation was beyond anything I'd ever felt.

Late one night, I saw Jackée Harry filming a commercial for ARCO gas in a driveway in front of the Century Plaza Towers. I was dumbfounded by the sight of her standing there all lit up in a red satin evening dress; she represented everything that I wanted to be doing. I was supposed to be in her shoes—a spokesperson for a company that would pay me a huge check to be in hair and makeup, cameras rolling. I was so deeply depressed. Being the only pedestrian in Los Angeles will do that to you.

In October, I went up to San Francisco for a Pride event. Sylvester—the singer whose picture Renetta had up on her wall, the first man I'd ever seen dress up in women's clothing as an act of rock 'n' roll defiance—was dying of AIDS. Someone from the parade arranged to have him address the crowd by phone;

they ran his voice through a loudspeaker. "I love you all," he said, his voice sailing out over the crowd. "Thank you for my life!" I thought about the lyrics to Otis Redding's "(Sittin' On) The Dock of the Bay": *'Cause I've had nothin' to live for / It look like nothin's gonna come my way.* Hearing Sylvester's strained voice felt like the literal death of disco. A joyous era of my life was dying, too.

––––––

With the holidays approaching, it felt like as good a time as any to hide out back at my mother's house in San Diego. I never felt like I was imposing on her by being there. She liked having me around, and we had fun together, teasing each other and cracking jokes. My mother was no-bullshit; you never had to put on airs or try to be something you weren't. You could just be yourself, and so I was. Renetta was living at the house then, too, with Scott and Morgan. My niece was eleven years old now and had a great sense of humor—the same humor that had always run in my family, this wonderful irreverence that bonded us together. If my mother thought I'd made a miscalculation in the trajectory of my fame, she never showed her hand. But I would never have shared my anxieties with her about how lost I really was.

I called this time my ghetto homecoming, and I was determined that the world witness it. After all, I knew you always had to act like the star that you are, even when you're at rock bottom. I recorded an interview to be broadcast on *The American Music Show* where I talked about what was going on with me, Renetta facilitating. I was wearing a rayon shirt and polyester pants I'd made at that house, I was about twenty-five pounds overweight, and for the first time in my life, I had grown a beard. But I danced and sang to George McCrae's "Rock Your Baby" in

the kitchen of my mother's house like I was on top of the world, then interviewed my mother while she popped bubble wrap in one of her caftans. It was a final cry for help, my announcement to the world watching that I had lost my way.

On New Year's Eve, I was watching Dick Clark's special on ABC, featuring as performers the B-52s and Sheena Easton performing her hit "The Lover in Me." She was wearing a green dress that made her fiery red hair pop even more, and she was lip-syncing that song like her life depended on it.

She looked hot. She looked like a star. And I thought: *You know what? If that was me, I would turn that shit out.* And then, just then, a seed of an idea began to form. Why *couldn't* that be me? All dolled up, looking like a superstar—not defying gender norms with my hairy chest and messy wig in a cocktail dress, but the true high-femme sexy glamazon look like Sheena Easton served every time she stepped out onstage? Hadn't I always felt how people responded to me differently when I allowed myself to play the part of *that* girl? What was stopping me from letting *her* be the star?

———

I knew there was such a thing as a Saturn return. In astrology, the Saturn return is the transit that takes place in your late twenties. For me, it was the moment in *The Wizard of Oz* when Dorothy finally takes a peek behind the curtain and says: *Wait a minute. This is all there is? This isn't what I signed up for!* You have to recalibrate your path and decide who you want to be. Typically it begins at age twenty-seven, reaches its peak at twenty-eight, and takes a few years to wane.

My late twenties were made for wandering. And I under-

stood that I had to wander in order to find myself. But as much as I always felt like a lone wolf, I also knew that I needed other people to keep me moving in the right direction—to push me to where I was meant to go if I strayed too far off course. Not long after that, I was at home at my mother's house when the phone rang. It was Larry Tee.

"Ru," he said. "Enough is enough."

"What do you mean?"

"It's time to come back to New York," he said. He sounded like himself again, his old self—the man I'd known before he'd gotten swept up in Michael Alig's world. "What the fuck are you doing? Get your fucking ass back to New York where you belong. I will pay for your ticket. You'll pay me back in a week. And you'll pick up where you left off."

It was uncharacteristic for him, especially given that we weren't as close as we had been. I've wondered many times why he made that phone call. There were probably some opportunities coming up for him where it would have been advantageous for me to be there. Larry also knew that I was something special, and together we made magic, so if I had thrown in the towel and returned to my old life, that would only distance him further from his own aspirations.

But more than that, I think he missed me. And as a friend, what Larry did was the exact thing you hope someone would do if you ever got lost in the wilderness. Just like in *Oz*, it felt like when the Scarecrow tries to wake Dorothy out of her poppy-field daze. He was shaking me back to life.

So I said yes—yes to his offer and yes to coming back to New York and yes to whatever came next.

But this time?

I would do it as a high-femme sexy glamazon.

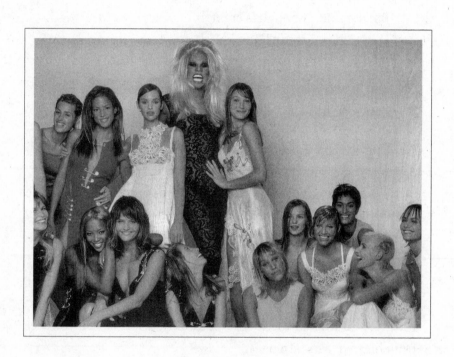

*"This was what I was made to do.*

*And when I was standing in a pizza*

*parlor on Sixth Avenue and I heard*

# Supermodel

*'Supermodel' playing on Z100, it*

*wasn't a surprise. It was like the*

*most obvious thing in the world."*

The eighties, particularly in New York City, are remembered for being an era of excess. At the time I started to embrace it, drag was a political statement; depending on the context, it could be read transparently as a middle finger to the consumerist, normative culture of Reagan and his followers. But my genderfuck anarchist drag had only taken me so far.

By the dawn of the nineties, the culture had only doubled down on the worship of wealth, beauty, and glamour that dominated the eighties. I didn't have money, but I could serve sex and fashion—no problem. So when I got back to New York, I shaved my legs. I shaved my chest. And I adopted a drag aesthetic that was striking and seductive—a style that I described at the time as somewhere between "Black hooker" and "*Soul Train* dancer."

My body was built for drag. I knew that. My proportions were just right for it: long, long legs and a tiny waist that I didn't have to cinch. I didn't need to wear stockings. I'd put on a bra, or even just a pair of rolled-up socks in a bra, and call it fashion. I'd wear short skirts or tube dresses that I could whip up on a sewing machine, do big Donna Summer hair, big lined lips, huge eyelashes, and trashy earrings. These were all the signals that I had learned telegraphed sex from the working girls in my neighborhood in Atlanta and in the Meatpacking District—and that I could easily borrow.

I got back up on the go-go box, made some money, and paid Larry Tee back for my plane ticket. Susanne Bartsch started booking me to appear with her crew at the Copacabana and elsewhere. That relationship was hugely important to me—Susanne was wildly connected across not just New York but the world. All the uptown people knew her as their link to downtown, and vice versa. For the parties she put together, she hired people who represented the cutting edge. To be a part of Susanne's world was

a fast track to walking in a Mugler show or booking a Japanese television commercial.

Larry Tee started a party at the World, a club in the East Village called Love Machine that Lady Bunny, Floyd, Lahoma, and I all worked—it was the first time the five of us had been together in a long time, since back in Atlanta. Soon we started to feel unstoppable—the "It" girls of New York nightlife, this Southern contingency that had come North to transform the scene. And finally, it seemed, people were really looking at me and asking *Who the fuck is she?* in the best possible way.

That spring, I was crashing all over New York, but Nelson's house felt like home base. I was in the kitchen there one day when Renetta called. "Mama has cancer," she told me quietly. There was a fireplace at Nelson's that had been sealed up and turned into a cozy nook with throw pillows inside it; I curled up in the nook, twisting the phone cord anxiously in my finger. The possibility of her death felt real and imminent.

This was a moment where reality came dramatically crashing in. Of course, my mother had smoked like a chimney, and held her grudge against the world fiercely. I knew that she had worked hard for that cancer. *But surely she's going to make it through this,* I thought. She would get treatment and beat it back. She had to. That was my mother's personality.

———

In June, I was sitting in the basement of the Pyramid when in walked an absolute Adonis—tall, chiseled, and charming. He sat down next to me, just as I had sat down next to Mark on that day in Atlanta all those years earlier, our knees brushing in the exact same place. It was almost eerie, the familiarity of it. "I'm David,"

he said. He handed me a flyer. "I'm having a party. You should come."

David, Lahoma, and I became fast friends. I learned that he had just broken up with a boyfriend and was newly single. I also learned that everyone else was as taken with him as I was. I was housesitting for a girl who lived above the McDonald's on First Avenue in the East Village. One night, David left his bicycle chained to the third-floor banister. It took him forever to come and get it; I remember the sight of it tormenting me for weeks. We fooled around on the bed there, just making out. By the time the birthday party on the flyer David had given me rolled around, things were too emotionally charged for me to even show up.

I knew that he got under my skin, although I couldn't have said exactly why at the time. Now I can see it was the same old story. My kryptonite had always been this: falling in love with a man who was charming, handsome, and completely emotionally unavailable to me. It was an echo of what I'd felt with Mark, which itself was just an echo of what I'd felt with my father. I was self-sufficient and intelligent; I could always pull it together and take care of myself. But these relationships with men made me come undone.

Larry Tee was starting a new weekly party called La Palace de Beauté in a building on Seventeenth and Broadway where Andy Warhol's Factory had once thrived. There was a lot resting on this party, not just for Larry, but for all of us: Floyd, Lahoma, Bunny, and me. Our stature in town hinged on whether this was a success, particularly mine. I knew that if this party went well, I could use it to springboard into the next thing. The weekly party phenomenon was dominating New York at the time. Instead of having just one club devoted to a sensibility, that same club would hire seven different promoters to throw different themed

nights every evening, each of which had their own identity, as a way to invigorate the nightlife scene. This would be ours. It felt as if we were a theater troupe and our show was opening—curtains up would be the first Tuesday of July.

The night before the opening, Nelson had a heart attack and died in his bed. The shock of his passing reverberated through our world. Nelson's death was an announcement that the terms of our reality could change—we could lose a cast member we'd seen as vital at any moment. He had been our link to everything that had come before us, our historian and our mentor; his death marked the last gasp of the Warhol-era New York that we all romanticized. With Nelson gone, Larry Tee and Lahoma would take over the lease on the house on Ninth Avenue, and I moved into Nelson's old room.

It felt weird now to proceed to the opening night of our party, but we decided to do it anyway in honor of Nelson. It was what he would have wanted. Randy and Fenton were just starting their own Tuesday party at a club across town on the same date. Late in the evening, I saw Randy in the crowd at La Palace. "What are you doing here?" I asked him. "I was going to pop by your place after my number."

He looked doleful. "Nobody showed up," he said. "It's not happening." I could see him looking around, defeated that ours was the better party. Everybody was there—the energy in the air was electric.

————

La Palace de Beauté became the premier dance night in New York. I would do a number every week, lip-syncing a song across a huge, brilliant stage. Larry Tee brought in stars from both downtown

New York and Hollywood. Liza Minnelli came, and Larry played her album *Results*, produced by the Pet Shop Boys.

I was still hanging out with David every night, but he was hooking up with everyone else in the scene, too. I found this gut-wrenching, even though I knew it was irrational. Every time I walked into a club, if I wasn't with him, I'd be scanning the room for the tallest person I could see, knowing that I'd be able to spot his head bobbing slightly above all the others. It was so rare for me to connect this deeply with someone. Why couldn't he see how special and important this thing between us was? How could he be so casual about it? It made me crazy. Finally, I told him that I couldn't see him anymore. It was just too painful.

The only option was to put all this wounded romantic energy back into my career, as always. Bunny had started putting on the drag festival Wigstock when she first moved up to New York. What had started as a ragtag, guerrilla thing with no permits in Tompkins Square Park had become a sensation. I had never performed in all the years she'd been doing it, but now that I'd hit my stride as a drag performer and the party had taken off, I knew that I had to.

That Labor Day, I performed two numbers: First I took on Whitney Houston's "So Emotional" in a one-piece tie-dye blue bathing suit and thigh-high black patent leather boots. Then I did "Don't You Want My Love" by Nicole McCloud, which—even though it hadn't been properly canonized—had all the makings of a drag classic: orchestrated horn hits that allowed for the performer to emphasize the song's musicality through their physical movements. The audience went crazy. I could tell from the way people looked at me, and the way they treated me, that something big was happening that day.

Just a few weeks later was the King and Queen of Manhattan Pageant, which took place every year. From the time I'd moved to New York, every fall this had been a major occasion: Club promoters, journalists, and folks from the top tier of the nightlife hierarchy would vote on the "It" people of the downtown scene during this pageant. It was something that all club kids revered as the pinnacle of nightlife success. The event was to be held at La Palace de Beauté that year, with all the nominees gathering in their most dramatic looks. I was wearing a silver lamé dress with a brassiere piece made out of hot pink velvet. Kenny Kenny was crowned king, and I was made queen. As they put the paper tiara on my head, confetti gushed from the ceiling of the club. I gazed up at it, raining down on me like a rapture.

The crown symbolized something bigger than the title. Becoming Queen of Manhattan meant that I had won over all the self-serious downtown New Yorkers who had been so cold to me when I'd first come to the city. I'd charmed the toughest audience in the world. If I could do that, I could do anything.

And soon I'd find myself in my biggest spotlight yet. I heard from a friend that the B-52s would be shooting a music video at a house upstate and they wanted me in the video. I had been up all night partying at the club with Lahoma, high on something strong enough to keep me awake until dawn, and I caught a ride on the chartered bus with all the hired extras out to Highland, New York. I was in a T-shirt that I'd fashioned into a halter top with white denim hot pants, which I'd probably found in the garbage, and a pair of mules that were, as ever, a few sizes too small. No stockings or bra, obviously—just pure sex. I led the extras in a *Soul Train* line and used what would become one of my signature moves, which Larry Tee described to me after see-

ing another drag queen do it: I would take my finger, lick it, then go over to a wall and rub it seductively in a circle like a spiral bull's-eye. Then I'd smack it real hard.

When the video came out, I could feel it catapulting me higher. Less than a year ago, I'd been homeless, bumming around California; now I was a downtown darling. I made the most of my reign by getting as fucked-up as possible. Every night, Lahoma and I would go to a liquor store on Hudson and buy a ten-dollar bottle of Popov vodka, then fill a tumbler with ice, vodka, and a little bit of orange juice—to be polite—and drink two of those while doing our makeup. Then we'd get to the club, find out who the promoter was, get some drink tickets, and have a few cocktails to catch up with everyone else. The next question was: *Who's got coke? Where's the coke?* We got hired to appear in a Robert Palmer music video, but we took quaaludes, passed out, and got fired. No matter—it was worth it for the story.

Larry Tee had a production deal through a label called Cardiac Records, and he wanted to sign me as an artist. I said yes. I'd had a record deal before, through Dick Richards's Funtone label in Atlanta, but this, I thought, would be something bigger.

During Pride weekend, I was strutting down Christopher Street in a sailor outfit—a pair of satin shorts with a shirt open to my belly button and a naval hat—when I saw David walk by, hand in hand with a Black guy who looked a lot like me. We made eye contact, and he had a strange look on his face of being truly gutted. He touched his hand to his heart as he walked past me, as if it pained him to see me. Later, he told me that he'd been thinking about me while he was having sex with the other guy. I think he was trying to impress upon me how much I meant to him. But hearing that only hurt me more. It was like a twisted consolation prize. I should have been on top of the world, but instead I felt

lonely and frustrated. I would walk around Manhattan alone at night, thinking about David, lost and heartbroken. And I was drinking more than I ever had before.

Susanne was now booking me to perform with her crew out of town. We were down in Miami, appearing at a party on Star Island that was thrown by the Ford modeling agency, and the supermodel Lauren Hutton, who I idolized, was there. I kept ordering tall glasses of vodka with a splash of orange juice, my drink of choice, when suddenly I realized—I'd had ten drinks, and I didn't feel a thing. Not one thing.

*Fuck*, I thought. It was time to get my shit together. I'd had too many long nights of partying, and I could feel that I was beginning to make the wrong moves—that this currency I'd been afforded as Queen of Manhattan was something I wasn't spending intelligently. Bunny had said to me once: "You're up on that stage, and you think you're funny. But you're not funny. You're just drunk." What if she was right? What if the excesses of this moment, of this lifestyle, of my own tendencies were getting the best of me?

When I got back to New York, I decided that I would not go to a club unless I was being paid to be there. I was going to stop using chemicals. And I was going to clean my act up.

————

Back in the city, I started going to the gym and taking aerobics classes. Once, Lahoma caught me coming home in my exercise clothes. "Bitch, you think you're Jane Fonda or something?" It smarted when he said it, like those kids in San Diego who grabbed me getting off the bus from the beach. I felt disconnected again from both Larry and Lahoma. I'd pay my rent on the house on Ninth Avenue, but I'd be gone all day long, only

returning home to sleep. Sometimes, I would hear them talking upstairs when they didn't know I was home, wondering out loud about what was going on with me. Again, I felt apart from the people who were supposed to be my tribe.

The single I had recorded with Larry Tee came out, but I wasn't happy with it; I didn't think it was good, and it didn't feel like it represented me. Global stardom, the kind I'd envisioned, eluded me still. I went to talk to Randy and Fenton, who knew a lot about the music industry from their time recording as the Fabulous Pop Tarts. They'd been trapped in a deal they'd had with London Records and had only just managed to pull themselves out of the trenches. Now they were getting into television production and turning an eye to business. So many of the kids in the East Village were all talk, planning to launch a rocket to the moon on Wednesday only to be blackout drunk by Thursday, but I knew that Randy and Fenton weren't messing around. They were making deals overseas; they had a legitimate office, employees, and equipment. It was undeniable that they were doing what they had set out to do.

They looked at the contract that I had signed with Larry. "It's just a one-off production deal," Randy told me. He studied me. I thought about that moment in the Marriott Marquis years back, when I'd seen in Randy's eyes that he really saw me—and that he could feel my potential. "If you're serious about this," he said, "why don't you let us manage you?" I knew it was the right thing to do, and so I said yes. I knew it might create some friction—particularly with Larry, who was very competitive—but my whole being knew it was the right choice.

Before I'd quit partying, I had planned a trip to Italy with Larry and Lahoma to perform as La Palace de Beauté, with Larry as front man. It wasn't an overly sophisticated act, but we

had some choreography and a track with background vocals we would play. But now that things had changed between us, and because of my cleaning up my act, I didn't want to go to Italy. I'd barely even see them in the city, even though we all lived together. I would spend most of my time at Floyd's place in the East Village, or I'd hang out with him at his job at the Film Forum arthouse theater, where I would feast on seltzer water and popcorn with an occasional oatmeal cookie. But it was too late to back out of the Italy plan now. We flew to Rome, where we stayed with a friend not far from the Coliseum.

One morning, I woke up early, at about five o'clock, while the rest of the group was still sleeping. A faint light was just beginning to peek through the curtains. I walked down to the Coliseum by myself through the empty streets of Rome and gazed out at it. The pillars were putty brown, but the light of the sunrise cast everything in a sherbet glaze. It was so ancient. So much of human history had taken place there, and yet it was still standing. It was majestic in its resilience. It was a star. Even though it was in ruins, time had not worn it away.

It occurred to me that I had surpassed my parents—that my world was already bigger than theirs had ever been. No one in my whole family line had ever stood at sunrise staring out at a sight this beautiful, this extraordinary. I was grateful.

That sense of wonder evaporated as soon as we got into the car to tour Italy. We went to Bologna and Florence, crammed into a tiny Fiat on winding Italian highways. I sat in the back seat with my Walkman on, listening to music. I could tell Larry and Lahoma thought I was being bitchy, which I was. I was angry that I had been sidetracked from my goal, which was my own stardom, instead stuck here playing backup in Larry's group and recording an underwhelming song through his label deal. I was

taking it out on them, but really, I was disappointed with myself for allowing it to happen.

In Milan, a friend pulled strings to get us into a Versace fashion show; we had last minute seats in the back of the bleachers. The experience was exhilarating, and it ended with the four biggest supermodels in the world stalking out in oversaturated dresses: Linda Evangelista, with a platinum-blond pixie, in shocking red; Cindy Crawford, hair bouncy and shiny, in a black halter; Naomi Campbell in electric yellow; and Christy Turlington, coquettish in a little black dress. They were mouthing the words to George Michael's "Freedom! '90." They were perfection. When you looked at them, you could hardly breathe.

Gazing down at them from the back of the venue, I wanted to be just like them.

———

The culture at the time was obsessed with supermodels, a fascination that had been bubbling for years. In the sixties and seventies, glamorous screen sirens like Sophia Loren, Elizabeth Taylor, and Marilyn Monroe had given way to more relatable stars: Sally Field playing a factory worker, or Jane Fonda appearing as the wife of a Vietnam veteran. Supermodels became the movie stars of the world as movie stars evolved into serious actors. It was back in 1978 that Cheryl Tiegs had appeared on the cover of *Time* with the headline THE ALL-AMERICAN MODEL, which signaled to me that modeling—and by extension, fashion—was a viable industry in which a person could have a career. Kids like me all over the world, little girls and boys from conservative towns who loved fashion, knew the names of all the top models whose faces appeared in advertisements.

It had reached its apex by the late eighties, with designer fashion becoming a bigger business than it had been previously: As Halston, Calvin Klein, and Versace became household names, so, too, did the supermodels who made their clothes look all the more glamorous.

Supermodels back then weren't meant to be relatable or inclusive; they were only seen as aspirational, gatekeepers of the most rarefied air. Fashion at that time celebrated the most elite forms of beauty, these long-limbed, superhuman beings who exemplified glamour. Yet, while the examples of beauty in the culture became all the more exacting, luxury fashion itself was a boom industry that had become more accessible to customers. As the couturiers whose designs had previously been available only to a select few began licensing their name to other products and producing housewares, fragrances, and accessories, it became more possible than ever for consumers to have a taste of luxury. The increasing ubiquity of those designer brands only served to make the supermodels, as ambassadors of those brands, more famous.

After we got back from Italy, I redoubled my efforts to launch my music career, working with both Randy and Fenton as my managers while writing demos with Jimmy Harry, the music director from the play I'd done in Atlanta who I had liked so much. I had always felt that my path to stardom would have to be through music, not acting; there was not yet a place in Hollywood for someone like me. Hollywood didn't "get" different then, any more than it does today. If I made enough of an impact with music, I thought, maybe I could transfer those credits to film and television.

I began working more closely with two other friends from the scene, who I'd met through Susanne: a makeup artist named

Mathu Andersen and a designer named Zaldy Goco, who were a couple. They were both high-fashion stylists with an elevated sensibility. Mathu was a Renaissance man, a maestro with hair, makeup, and photography, and Zaldy was a fashion monster, an FIT graduate and designer who had an impeccable eye. When I turned and saw my reflection in the mirror for the first time after they had worked their magic, I felt I had been reborn—and I couldn't wait for the world to see me.

I knew that Randy and Fenton were sending my demo out to labels, but I also knew that most executives were passing. Sometimes I would sleep at their place, a work-live loft on Varick Street. They'd given me a key, and I would crash there from time to time, since I didn't always want to go back home and encounter Larry and Lahoma.

One morning, I was just waking up when I heard the answering machine go off. It was a woman's voice. "Hey Randy and Fenton, this is Monica Lynch from Tommy Boy Records," she said. "I have to tell you—we got the RuPaul demo that you sent, and we want to do business with you." In that moment, I knew my life was going to change. The universe aligned so that the very same label that had coproduced the New Music Seminar—a vehicle to get unsigned acts signed—would be the label that ultimately signed me.

Word spread quickly that I had been signed by Tommy Boy as I began recording my album. Toward the end of the process, Larry called. "I've got a song I want you to hear," he said. He told me he had written it, inspired by the heightened new look that Mathu and Zaldy had given me. Gone were the Fourteenth Street miniskirts and hand-me-down wigs; enter custom-made gowns and high heels that, for the first time, actually fit my feet.

As strained as things had become with Larry, he was still my

friend, and I wanted to do right by him. "Sure," I said. "I'll listen to the song."

When Jimmy Harry and I listened to it, there were some funny lyrics inspired by Linda Evangelista's famous quote about refusing to get out of bed for less than $10,000 a day. But the best thing about the song was the title. We took that idea, which felt like it was right in the zeitgeist, and started writing our own version, as if we were bottling the feeling of how it felt to watch those women strut down that catwalk in Milan. It was to Larry's credit that he was able to crystallize the vision for what I was becoming—to connect the dots between my own persona and what the culture was obsessed with.

I recorded the version of the song that Jimmy and I had written, and Larry had inspired, in the apartment of a producer, Eric Kupper. We were in Battery Park City, on the twenty-eighth floor of a high-rise building with a panoramic view of the Hudson River. While recording, my eyes were set on the Statue of Liberty. As she towered high over the harbor, looking like the supermodel of the world, I thought about all she represented—a symbol of America, this place where ordinary people willed impossible dreams into reality.

————

Now I can see that everything was building toward this. Everything I experienced—the highs, the fears, the joys, the lows, the discoveries—had shaped me into the force I would become with that song and the change in my look. The psychic's prophecy that I would become a star? Here it was, becoming truth. This body, with its supermodel proportions, that was born to do drag—that had always stood out, that had never been masculine enough for

the world? Now it had its purpose. The love of performing that I had honed as a child to make my mother laugh? Now it would take its rightful place on the global stage. Even the fact that I'd always had an uneasy relationship to sex—now that would become my superpower. The drag scene I'd come of age in was always raunchy, sexually charged, blue. What if I took all that and made it mainstream? What if I made it so fun, so likable, so family-friendly that you could show it to your grandmother? What if I brought the same glamour that had enraptured me in that Versace show to every appearance I made—but I did it with a wink, a winning smile, and the spirit of sweetness I tried to embody, that I'd always found irresistible in others?

All my adventures, all those failed attempts at becoming something—I had just been gathering string. This was what I was made to do. And when I was standing in a pizza parlor on Sixth Avenue and I heard "Supermodel" playing on Z100, it wasn't a surprise. It was like the most obvious thing in the world.

The single wasn't a hit on radio. It didn't even crack the Top 40. But in that time the RuPaul idea was born, and people outside of my world were inspired to talk about me and androgyny and drag in a way that was unprecedented. Not long after that, the questions came: *Why you?* Drag had been around forever. Why had I been able to crack the code after so many false starts and almosts?

But I knew they would never understand the delicate choreography I'd done to make it all work. I'd mastered the art of naughty-lite: two spoonfuls of Diana Ross, a pinch of Cher, a shake of Dolly Parton, all sealed with Walt Disney's family-friendliness. Before, I had been blurry—confusing, a thing that only some people could understand. Finally, I had snapped into focus, just in time for the whole world to see.

The eighties, with all its excess and opulence, had also been marred by darkness: the heaviness of crack cocaine, the AIDS epidemic, the crashes of S&Ls in the markets. There was a yearning for levity in the culture, the very same irreverence and sense of play that had animated me my whole life.

A window opened. I stepped through it.

———

The supermodels of that era weren't just hired hands to wear clothes; they now were working in concert with the designer. They brought to the creative process an importance and influence never before held by models. What they represented was the power that came from having earned their freedom through beauty and strength. They were independent.

For so long, I had been trying to stand on my own. I had hated standing at the back of the stage with Larry Tee's band, had hated waiting in line for the world to recognize me. And now it had finally happened.

The next fall I was back in Milan for the Versace show. But this time, I wasn't in the nosebleeds with comp tickets. This time, Gianni Versace had flown me there to perform at the after party. During the show, he brought me backstage. I took a photo with the models, wearing a bright blond wig and a skintight dress. Naomi Campbell is at my feet. Christy Turlington is gazing up at me. And I'm grinning with delight, like I always knew this moment would come.

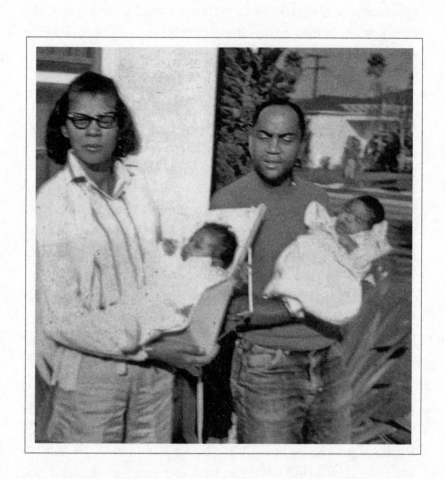

## ELEVEN

*"...in actuality*

*we can only ever*

*control ourselves.*

# Mama

*We must let go of the safety vest.*

*Or stop looking for one.*

*We must be all right on our own."*

The year I became famous, Martha Wash put out a song called "Carry On" that I listened to nonstop. It was a gospel-inflected house song with a rolling piano. *Still can hear the way Mama used to say / Never! No, never let your spirit bend.* I loved that song because I loved Martha Wash, but I also loved it because it was an ode to resilience. There is so much in life that threatens to make us buckle, to bring us to our knees. The song was a reminder to keep fighting—to not let go.

This, of course, like all the most important things in life, is a paradox. Sometimes we must let go. Letting go is the most profound thing any of us will do in our lifetime. Death is inevitable; it's a part of life, life's shadow. It remains taboo in our culture because we are ruled by ego, and the ego wants to believe that it can cheat death, that it can find some path to immortality. But deep down, we always know this is going to be a short run.

Not long after "Supermodel" came out, Randy and I went to California, and we drove to San Diego. He was the only person from my new life—from the version of myself that I had created after leaving home—that I had ever brought to meet my mother. When we arrived at the house on Hal Street, she was walking with a cane. "Oh, it's nothing," she said. "I slipped and fell and hurt my hip." Falling is often the beginning of the end, although I didn't know that at the time.

Mama liked Randy; she was kind to him. And it wasn't lost on me that the one person who I was bringing to meet her was the one person who I'd felt most clearly saw my potential, the same way my mother had. The person I trusted to help usher me into this next phase, whatever it was.

So much had died in the year I became famous, so many skins I shed, so many things I'd laid to rest. From the moment

I'd signed my record deal with Tommy Boy, for example, I was no longer broke. For the first time in my life, I had some money—which is not to say that I was instantly rich. But since that day, I'd never again felt the fear of homelessness or poverty. The fun had died a bit, at least in the freewheeling, irresponsible, slightly dangerous way I'd been living. Now that I was a public figure, I had to be accountable for my actions in a different way, knowing what was at stake if I got into any real trouble. I was America's drag sweetheart now. I couldn't go terrorizing the streets anymore.

There were things born, too—new things that materialized—but each birth also marked a death of something else. With money came new anxieties. With fame came new responsibilities. So it went, in the endless duality of all things, that you could not have one without the other.

———

Each of us is responsible for ourselves. This is an uncomfortable truth that many of us do not want to accept. We grow up wanting to believe that a benevolent force, maybe our parents, will take care of us forever. But in actuality we can only ever control ourselves. We must let go of the safety vest. Or stop looking for one. We must be all right on our own.

Sometimes the thing we are not able to let go of isn't benevolent. Sometimes we hang on to past hurts and old ideas. We refuse to let those die, that old darkness. But we have to let go—both of the things we despise and, often, the things that we love. Every ascended master will tell you the same thing: It's the ego that grips, and nonattachment is the path to freedom. But it never stops being difficult to let go—to say goodbye.

After "Supermodel" came out, MTV News wanted to do a segment on me. We rode in a limo from Times Square out to a mall in Jersey City. I laid out my philosophy for the veejay. "Everybody is a drag queen," I said. I quoted the queen that Mark had told me about all those years ago in Atlanta: "You're born naked, and the rest is drag." Then I ran around a mall in Jersey City, towering in my heels, while people reacted to me as if I were a rock star.

The next week, I went back to see my mother in San Diego. I knew that she was dying. She was in a bed in the living room of her house to make it easier for people to care for her. We turned on MTV and watched as the segment aired. She gazed in awe, and then she looked at me. "Nigga, you are crazy."

It was such a simple thing to say—there was nothing to it. But underneath it was an ocean of hidden meanings. In her voice, I heard the acknowledgment of the prophecy coming true, and this, the victory lap that she was taking even as she lay dying, in being my mother, the mother of this person who was now being covered on television like the celebrity I had become. It was the same living room that I had performed for her in— how incredible! And now I was on that screen! I could think of no greater magic than that. I felt, in that moment, that there was some divine force at work that had nothing to do with either her or me, in which we were merely players.

My only responsibility had been to hang on, and I had, such that I had come full circle back to the birth of the dream. And now my responsibility was to let go.

I stayed there that night, in the back room of the house on Hal Street. I woke up in the middle of the night, and I could hear her calling my name. "Come here," she said. "I need you."

"What's wrong?" I said.

"Ru," she said. "I'm so embarrassed, but I've messed myself and I need your help."

"Not a problem," I said. I cleaned her up. I carried her to the restroom. And I made it all better.

She had changed so many diapers for me. And I was there to help her in that moment. In all the things I have done in my life, this was one of the most profound displays of love and respect I have ever been fortunate enough to express.

That morning, a cab picked me up. I kissed her goodbye before I left. "I love you, Mama," I said.

———

She went downhill fast. Before she died, she had my niece Morgan call me. Mama had lost her hearing, but it was about what she needed to say. "Ru," she said, "I just want you to know that I love you so much and I am so proud of you."

A few weeks later, I was booked to perform at a gay rights march in Washington, DC, and the day was packed with speeches—men and women giving talks in stentorian tones about the gay rights movement. As the entertainer, I was set to close the night. Cybill Shepherd announced me. I took the stage as the sun was setting. People pushed forward to see me perform, kicking up enormous dust plumes on the ground that looked like sandstorms.

As the music began to play, the dust turned orange as the sun dipped low. In the distance, I could see a plane taking off at Dulles, its nose pointed gently toward the sky, and in that moment I thought, *Oh, my mother.*

Back at the hotel, Randy called me. "I watched you on C-SPAN!" he said. "Oh, and by the way—Renetta called for you."

I burst into tears. I knew that if she was calling, it could only be for one reason.

———

I had just started to make money when my mother died, but I wasn't yet at the place where I would start buying fancy suits. At the funeral, I wore black slacks with a navy blazer. I kicked myself for that for years. It was something that I cared so much about in part because of her. My mother would have noticed black and navy. Now I think of her every time I put on a beautiful suit. It's her aesthetic, crisp and intentional, that I embody when I get dressed up today.

Life can feel, sometimes, like an inevitable chain of occurrences, a train that runs on a track. Sometimes it chugs along at a glacial pace, and sometimes it's so fast it feels like a runaway train. Fame was like that, especially once I had removed obstacles from the track: self-doubt, drugs and alcohol, unhealthy allegiances to other people (most of which were only ever in my head). When I put myself in the engineer's seat, that train felt unstoppable, and life got exciting. But these milestones, like the death of a parent, become even more pronounced when you have the clarity to understand their significance. You have to pump the brakes, to stop and listen: *Hey, heads up. Life is happening.*

My mother never took care of herself. She was resilient enough to pick herself out of the darkness of her depression after my father left—to carry on. But in many ways, she was a frail little bird. The doctor said my mother died of cancer, but I believed she died of a grudge. She was world-weary and angry, even if she softened as the years passed. She couldn't let go of her darkness. It was her very refusal to let go that kept her stuck.

As far back as I could remember, my mother had said she wanted to be cremated. "Or better yet," she said, "leave my body on the curb, and let the city bury me. I've paid enough fucking taxes." But when it really came down to the wire, and she was faced with her imminent mortality, she insisted on a casket. I saw it as her Catholic background rearing its head for the last time, a tell that she wasn't as tough as she let on.

I had to learn from my mother. I had to do life differently. I had to let go. To old ideas, to my possessions, to even something as fundamental as this body that will someday turn to dust.

Life is just one stage. Death is the next. But all of it is a part of the whole, the truth, the source of all we are, made manifest to experience humanity for one brief second. I knew that. When Renetta called, I just hadn't thought we would get there so soon.

———

Or had I? My mother carried on for just as long as she could to see her child in full bloom. She had loved me so much. She had held on until the prophecy came true.

It makes me laugh now when I think about it, because it wasn't just out of love—it was also out of spite. She had lived for just long enough to be right.

I can hear her now. *See, you motherfuckers? I told you.*

"For the first time,

I found myself wondering:

What would it feel like

# Elevator

if I was the one being chased,

instead of the one doing

the chasing?"

**D**ing!

The elevator doors opened, and I stepped out into the lobby. It was art deco–inspired, everything peachy pink with gold hardware, here in my fancy new apartment in the West Village on Morton and Hudson Streets. Coming up in New York, I'd always lived in a walk-up, and now I had an elevator.

There had been a lot of new experiences. For example: All year I had been able to move through the world and hear my name, but not directed at me. How can I explain how weird and disorienting this is? I would be in a hoodie, that winter in New York, and I would step out of my building and hear a stranger saying, "And then RuPaul did this thing where—" And I would look up because they had said my name, and then just as quickly realize that they weren't talking to me. They were talking *about* me.

It happened again outside of Barneys in Chelsea. Barneys was famous for its elaborate Christmas window displays, and they had done a mannequin of me that year. I wanted to go see it. As I walked past, pausing, another group of people passed, walking in the other direction. "Oh, that's RuPaul," somebody said, pointing at the mannequin. "From the song 'Supermodel.'" I braced for further commentary—*What else would they say about me not knowing I was there?*—but instead they kept walking. Fame was a runaway train. After courting it for so long, treating it as more of an inevitability than a dream, now I found that I was part of the zeitgeist in a way that superseded me, in a way that I had not constructed.

I had been dating a hairstylist named Steven, an Italian guy who looked like Dean Martin and spoke with a thick Long

Island accent, and I'd brought him on some trips with me. He had come to Italy when I'd been invited as a guest of Versace to view their spring collection, while I took pictures with all the supermodels backstage—my hair by Oribe, my makeup by François Nars, a far cry from my old punky style. I'd brought him to Los Angeles, where we'd cruised along Sunset Boulevard in a convertible, and to England, where I shot a music video with my new friend Elton John that Randy and Fenton directed. I liked Steven, but I knew he didn't have what I needed, and vice versa. There was an emotional distance between us that I didn't know how to bridge. After we came back from England, we decided to split up.

Floyd was sympathetic about the breakup. "Come to Limelight," he said. "I'm go-go dancing. We'll take your mind off it." It was a Monday night in January, a dreary season in New York, and in the absence of anything better to do I'd said yes, throwing on corduroys and a T-shirt with a nondescript jacket and shuffling out onto the street. After I got famous, I had started separating clubwear from my everyday look, so I wouldn't announce myself as I moved through the world. Randy and Fenton both dressed in beige khakis and button-downs. At first, I'd found their normcore look boring; now, it had become aspirational.

At Limelight, a generic dance song thumping at 128 beats per minute, I did what I always did when I first entered a nightclub: I scanned the room for the tallest person I could see, which was typically David, who was still hanging around at six-foot-three, a few inches above most people in a crowd. I always wanted to make sure I saw him first, because, if I was being honest, I was still hung up on him. I looked around and there was no sign of him. *Phew.*

Instead, I saw a man who was a full head above everyone else in the room—easily seven feet tall. He was dancing goofily, almost flailing. I watched him for a second from a distance, then crossed the room to get to him.

At a closer vantage, I could see that he was wearing enormous platform boots, but he was still perhaps six-foot-seven without them—a giant. He was gorgeous and a little wild, with a thick unibrow and high cheekbones. He was wearing clothes that looked homemade—layers of cotton jersey, a tunic with a cropped vest over the top, and pants that didn't quite reach his ankles but had some type of beads hanging from them, a fringed flare. His dancing was crazy, almost feral. We made eye contact.

"I love the way you dance," I said.

"How do I dance?" he asked.

"Like an absolute freak," I said. He laughed. I gazed up at him. "Do you mind if I put my arms around your shoulders?"

He looked at me quizzically.

"I've never been able to reach up and put my arms around someone," I said. "Because I'm so tall. Can I do that?"

He smiled. "Sure," he said.

I hooked my arms around the back of his neck and, in an instant, he lifted me off my feet. I gasped; he put me back down. Then we both burst out laughing.

Off the dancefloor, we started talking. He was there with some friends from school—he was studying fashion, he said, at FIT, and it was his twenty-first birthday.

"Oh my God!" I said. "Happy birthday!" We only spoke there for a minute before I asked him if he wanted to go get something to eat.

We walked from Limelight down to Florent, between Washington and Gansevoort Streets. There was a light snow outside, but it was mild enough that it made the walk feel pleasant, even sweet. At the restaurant, we tucked into a booth, and he began telling me about his life.

His name was Georges, with an *s* at the end. He was raised in Perth in the west of Australia, the most isolated metropolis in the world. When he turned seventeen, he had hightailed it out of there to go to art school in Paris, then on to New York to attend FIT. His father was American, from Wyoming, and his family owned a ranch that he said he would inherit someday. To the extent that he was trying to impress me, which I knew he was, there was nothing sleazy about it. When we left Florent, we exchanged numbers.

The next day, I called him. "I have to go to London," I said. I was hosting the BRIT Awards with Elton John the following week.

"Oh," Georges said.

"I was going to go with my boyfriend, but we broke up," I said. "And now I have this extra ticket. So if you wanted to come with me, I could use a hand getting myself together for the awards."

I could hear him beaming through the phone. "I'd love to come."

————

*Ding!* The elevator doors opened, and Georges was waiting for me in the lobby. This time he was wearing a fuzzy little cropped shearling jacket—black, with no collar and three-quarters-length sleeves that were inexplicable for the season.

"I've never flown business class before," he told me as we settled in on the plane. I laughed. He was so huge—the thought of him cramming himself into a tiny economy-class seat was torturous. I felt immediately comfortable with him, maybe because there was something goofy and sweet about him. He had no guile. I could trust him instantaneously—and I had, since the moment he lifted me up off the dancefloor that night in the club.

In the same breath, I realized on that trip that he was very little help at all, either in getting me into drag or working as security. He was an innocent, wide-eyed and starstruck at everything. At the BRIT Awards, there was Kylie Minogue! There were the Pet Shop Boys! There was Björk! The excitement was whirling around us, and I could feel that this was a world he wasn't used to. If my hope was for him to look after me, it was clear that wasn't in the cards.

We were staying at the Halcyon Hotel in Holland Park, a converted Georgian townhouse with a rock 'n' roll reputation; it was where I'd been staying since I'd gotten famous and begun traveling to London often. I'd been there four weeks earlier, in the exact same hotel room, and I'd hidden a spliff in the bathroom ceiling—weed being my only remaining vice after swearing off booze and chemicals. Georges came to my room, and I showed it to him proudly.

"Look what I have!" I said.

"Go ahead," he said. "I don't smoke."

I lit it, smoking out the window. Then I looked over at him. Suddenly, I realized I didn't like myself high in his presence. I felt self-conscious. He was too sweet for me to be stoned around. I stubbed out the joint. "I'll finish it later," I decided.

The next night, I went to his room, and we talked until late

into the night. At one point, I was telling him about my breakup with Steven, and I began to cry. "I keep falling into the same pattern," I said. "With every man I've ever dated, it always ends up the same." I wasn't much of a crier. In fact, I couldn't remember the last time I'd cried in front of someone, let alone someone I hardly knew. It was unusual that I felt comfortable enough with this man to reveal my inner feelings.

From London, we flew with Elton to Düsseldorf, where we had another appearance. Elton had chartered a private jet. At one point, in flight, Georges stood up and went to the cockpit to look at something or say hello to the pilot. The look on his face when he came back—pure elation, shock at the absurd good fortune of his life—was priceless. He was twenty-one and enormous in this tiny plane.

When we arrived in Germany, we pulled into an airplane hangar as an officer jumped onto the plane to check our passports. Then we were ushered into a chauffeured car and driven away without so much as a pause at customs. I've aways been capable of experiencing excitement through the prism of someone else; this is lucky because I found myself habituating to things, getting overly familiarized to them quickly. It wasn't until the moment was reflected in the mirror of another person that I could appreciate it anew. So it was with Georges, who revealed himself to be puckish, playful as a puppy, as we navigated this new world of mine. The sheen on fame had already begun to tarnish for me, but not for him.

Not long after we returned to New York from London, we were walking home one night, having been out dancing.

"I really like you, Ru," he said.

"I like you, too," I said.

"Maybe we should go on a real date," he said. His eyes were bright. He was very open.

"Georges," I said. I hesitated. "I like you so much, but I think you are too young for me. I'm thirty-three. You're twenty-one." He looked briefly abashed. "Can we still be friends?"

He nodded. "Of course," he said.

———

*Ding!* The elevator doors opened. I walked through the lobby out to Morton Street, then took a left and walked up Seventh Avenue to Georges's new apartment on Jones Street. It was March, and spring was starting to come to New York, the flowers in bloom again.

He was still unpacking when I walked in, long limbs splayed out on the floor, a box of CDs making their way into a bookshelf. The apartment was a studio, a sort of cylinder with a tiny bathroom attached to it. "Hi, Ru," he said. "Look!" He showed me one of the jewel cases. My picture was on the front.

We sat on the floor. I realized, sitting there, that I *really* liked him. I got along with him. He was gorgeous. I felt so close to him. *What was I doing?* So when he leaned in and kissed me for the first time, I kissed him back. And it felt right, even though it felt different from the way men had felt before, because he felt young. Even though he was twenty-one and very much a man, there was something boyish in him that made me want to protect him from the cruelty of the world.

Every time I had fallen in love before, it required me to lose myself, to be entirely subsumed by a fantasy of what could be, which would just as predictably crater once reality set in. I had

always thought love would be a Nancy Meyers movie, some head-over-heels elation that would complete me—that in an instant, I would feel the love I had been looking for from my father and be made whole. But those feelings were always one-sided. It only worked for a short time because I was looking for those men to give me something that my father had withheld; if they had given it freely, I wouldn't have known what to do with it. All those other men had found it easy to be cruel in a way that I knew Georges could not. The most novel thing about him was his goodness—it radiated from him.

For the first time, I found myself wondering: What would it feel like if I was the one being chased, instead of the one doing the chasing? And, even more radically, what would it be like to give someone else everything that I had ever wanted to be given to me? My whole life I had been skeptical—a dubious inheritance from my mother that I could never quite shake, a suspicion of people's intentions. I was intuitive to a fault: I could feel into someone's strengths and weaknesses and navigate them like an obstacle course to get exactly what I needed. And I could feel Georges, but there was nothing to navigate. I trusted him. I was safe with him. I could not say how I knew that, but I knew it. He adored me, he admired me, he respected me. Maybe I had never felt that before from any man.

So I said yes. *Yes, Georges, let's be together. Let's see what happens.*

After that March, Georges and I would go out every night and do things together: chicken marsala at Stingy Lulu's in the East Village; dancing at the Limelight, which I hated but returned to night after night; long walks out to the piers. New York can be so lonely, but it didn't feel that way anymore. Having a per-

son somehow unlocked a whole new level of New York for me, in a way I hadn't known existed. On the nights we didn't spend together, we would kiss goodnight at the corner of Seventh Avenue and Bleecker Street and go our separate ways. It was fun having a boyfriend. Every man I'd ever been with, it had always felt fraught—I was never truly myself with them. I always felt like I was performing. With Georges, I felt like me.

Once, in those early months, there was an eclipse in the middle of the day. We were lying in my bed in the apartment on Morton Street, and as it happened, we could see how the light had changed, in this psychedelic fugue. It felt like we had stepped through a portal together that would forever change how we saw New York and how we saw each other.

———

The moments that shape your life aren't always the ones you expect. In those first few months of being with Georges, there were so many dizzying highs. I was booked to perform my nightclub act all over, and soon he was coming with me—to Los Angeles, where we'd dine at the Chateau Marmont, or Miami, where we'd get Cuban sandwiches and café con leche at David's. After a concert at Radio City Music Hall, I got to introduce him to Diana Ross, who kissed him right on the mouth, leaving a purple lipstick stain and blowing his mind forever. And he came with me to Detroit, where I performed for Aretha Franklin and she wrote me a check that was addressed to "Ruth Paul." I felt secure with him, more so than I had ever felt before. Even in my most stable, least turbulent relationships, I would toss and turn, restless, in bed with a partner. It was as if my body knew I wasn't entirely

safe. But with Georges I slept soundly, and so did he, as if sheltered by the sanctuary we created for each other.

Yet there was still that nagging feeling, the waiting for the other shoe to drop. The knowing that surely something had to go wrong—of course it would. Something always did. And as I had done with Mark, and then with David, I created little tests for men to confirm their devotion to me, booby-trapping the path, convinced they'd let me down and leave me waiting on the front porch.

We were coming home from a club one night to the apartment on Morton Street, and we were bickering. At the club, we had seen someone I knew, another light-skinned Black dude with freckles, and it had come out that Georges had been out on a few dates with him. We got into it as we were crossing the lobby of my building.

"I just don't appreciate having this information," I said sharply. Why had Georges even told me? He should have known that it would make me insecure. This was the problem—he was just a big kid, not mature enough to think through this sort of gaffe. "Maybe you shouldn't come up," I said.

*Ding!* The elevator doors opened. I stepped inside, then turned to face him.

He looked directly at me, almost through me. "Do you want me to go home?" he said.

In that moment, I could feel the hurt in his heart. His woundedness, his concern at having upset me. I felt everything that was in him, and I loved it all.

"No," I said. "Come up."

———

*Ding!* Those little moments of awareness pierce us sometimes as we move through life, and if we are lucky, their tone is clear as a bell, as it was that night. In that instant, I became aware of the little boy within me who wanted to measure how much more important that guy at the club had been than I was. But I could read in Georges's eyes, standing at the divide of the elevator door, that I was the most important man in his life. And when I let him on to the elevator that night, I was saying goodbye to something, the same way I had let go of my mother's hand one sunny morning all those years ago as a little boy, leaving one phase of life and entering a different one.

I had never felt truly at ease with my parents, narcissistic as they were, because their needs superseded whatever mine were. All those weekends waiting for my father on the porch. All those times my mother was checked-out and unavailable. All of it illustrated to me that I didn't matter—not fully. And so I had put him through tests, asked him to jump through hoops, and now here he was jumping through the final one, and I let him. I do not blame myself for doing it; it was the saga of the hurt child, the howl of a wounded puppy. But from that moment, Georges had my heart.

———

Then it was January again, just after New Year's. We had spent Christmas in Miami, but before we went away, we put up a live Christmas tree in the apartment in New York. Then, from Florida, I had gone somewhere to do a gig, and Georges flew back to the city.

I was walking in with my luggage when I saw one of our neighbors coming down the block. I held the door open for her

so she could follow me inside. As we crossed the lobby, I saw that there was a chain of pine needles all along the floor, clear as a trail of bread crumbs. "Jesus," I said to the neighbor. "Who could have done this?"

*Ding!* We got into the elevator, where there were more pine needles. I pressed the button for the third floor, and when the doors opened, I saw that the pine needles led right to our door.

The culprit—it was Georges! And then I thought, *Of course it was.*

The neighbor eyed me, and I looked, a little guiltily, back at her.

Then I laughed out loud. I stepped out into the hallway. I walked down to our unit and turned my key in the lock. And I opened the door back into our home, where I knew he would be waiting for me.

THIRTEEN

"I had spent so much of

my life shape-shifting for

any given situation.

# Mirrors

Was it even possible for me

to feel my raw emotions as

the chameleon I'd become?"

Miami had always been the next frontier. The first time Renetta went, back in 1972, it was to accompany an older friend of hers to the Republican National Convention. She had come back with stories about Miami Beach—about the Fontainebleu, the glamorous hotel where she had stayed, and the Eden Roc, which rivaled it in opulence, and about the beaches of Florida, so different from San Diego where we'd grown up. It made me see her as very adventurous: to cross party lines, since we had always been progressive, and to explore this part of the country that I had never seen.

In the early '80s, Miami was at a crossroads. Gone were the manicured lobbies and well-to-do tourists, replaced by high crime and drug trafficking. When I went to south Florida for the first time in 1981, it was to pick up a car in Stuart—a white Mercedes 450SEL. But I wanted to see Miami, so I drove south from Stuart before driving the ten hours back to Atlanta. Pulling into Miami Beach back then, there were shantytowns, men skulking in the shadows, an uncontrollable energy that felt dangerous. I drove to Bass Park, where I had intended to get out of the car and walk to the water, but after taking a good look around, I realized I was too scared to even step out onto the street. I drove up Collins Avenue, gazing at all the old hotels that had seen better days, these once-majestic symbols of American grandeur. I was familiar with the Fontainebleu and Eden Roc from watching *The Jackie Gleason Show* on television, each episode of which opened with a bird's-eye view of Biscayne Bay: *Live from Miami Beach, it's* The Jackie Gleason Show! How sad, I thought—now Miami Beach was a slum.

But by 1984, something miraculous had happened. A television show called *Miami Vice* had become an international

phenomenon, and in the span of a year Miami's reputation had changed. It became a go-to destination, a place where the fashion elite wanted to photograph models, where cool Euros wanted to come sun themselves on a white-sand beach, and where grumpy New Yorkers would ditch their black jeans for tropical-hued Emilio Pucci swimwear. When I went back to Miami in 1986, it was for Andy Gibb's birthday party, where Larry Tee, Lahoma, and I had been booked to perform at a club named OVO at the Warsaw Ballroom. I had always been a Bee Gees fan, and it was surreal to be there for him. A year later, a friend from New York moved down to Miami and began living in an apartment building that would eventually become the Versace mansion. I would fly down, do coke with her—because this was when I still partied like that—and go to the beach. Eventually, I began booking more gigs there, whether it was with La Palace de Beauté or later as a part of Susanne Bartsch's revue, where we would stay in a monolithic condo building on the beach, 100 Lincoln.

There was something magical about Miami to me, because it was all water. I'd always been sensitive to water, always called to the beach, since I was a little boy in San Diego. Water represented the subconscious, the endless undulations of the mind, and the hidden meanings submerged under the surface. Every time I went back to Miami, it felt like a dream. The light would hit the buildings just so, and the moodiness of the afternoon thunderstorms struck like a surprise, and then just as quickly we were in a tropical oasis again. There was something dangerous and beautiful about it.

Once I became a celebrity, Miami was my biggest market, with Chicago a close second. In the Miami area, I could perform in two clubs in one night. I would do a gig at the Warsaw Ballroom at midnight, get in a limo, and drive up to Fort Lauderdale to

perform at the Copacabana at one-thirty. Back then, those gigs paid ten thousand dollars, or maybe twelve. It was good, easy money, and they treated me like the star I had become. We flew first class, stayed in the best hotels, ate at elegant restaurants.

The money had never meant that much to me; all it meant was additional security. Even when I didn't have a dime, I always felt rich, because I knew that I had imagination. Having money to me was like having a tank full of gas—it didn't mean much if you didn't know where you were going or didn't have the curiosity to enjoy the ride. Money made things easier—much easier. But no matter how poor I'd been, I had never felt as impoverished as the rich people I knew who had no imagination, whose capacity for fun was stunted.

And there was no one more fun than Georges. We would splash around in the sea at the Raleigh Hotel. We would rent a boat and fly out both of our families to float around Biscayne Bay for an entire day, eating chicken salad sandwiches and drinking ginger ale. Georges and I would put on matching printed bikinis and jump in the sea; we were both so tall that we could stand on the floor of the bay and our heads would still float above the water. We would go to Bal Harbour or root around in the outlet shops in Sawgrass Mills for heavily discounted Gucci. We would rent bicycles and ride along the shore all day. We danced at a disco called, absurdly, Fire & Ice, where La Bouche's "Be My Lover" thumped endlessly on the dancefloor. Once a week I would bump into Lea DeLaria or Crystal Waters in the airport, either arriving as I was departing or the other way around; we must have been on the same circuit.

———

After a few years of traveling to Miami, I decided it was time to buy a place down there, and so Georges and I bought a condo overlooking the ocean on the seventh floor of 100 Lincoln, the same building where I had stayed with Susanne. It was the kind of enormous building that could be seen from space, where you'd have to walk half a mile to get to the elevator bank. It was half-filled with residents who had been there since the sixties and let their dogs shit in the hallway, and half-filled with people like us—urbane young people who wanted to modernize their units in this tropical idyll.

This would also, I thought, be something Georges could run point on. When we met, he'd been studying fashion. I put together the music for his final fashion show at FIT, which consisted of a mash-up of Tina Turner's "Disco Inferno" and "Baby I'm Burnin'" by Dolly Parton. He showed a small collection of ten pieces or so, and it was beautiful—black-and-brown satin stripes, with tapered waists and rich fabrics. After he graduated, he got a job working as a designer at J.Crew. But the logistics quickly grew complicated: It was impossible for him to work at a corporate job while I was jetting around the world, and the truth was I wanted him with me, because he enhanced my experience of going to Vienna, or Calgary, or to my family reunion where he was literally the only white person there. And so after a while, he quit his job and just came along on my trips. And yet, in that, I knew I had diminished his sense of personal purpose. Being with me couldn't be his full-time job.

Renovating this condo in Miami, I thought, would be an ideal project for Georges. He loved it down there; he had an artistic sensibility and an eye for design. And so this would make a perfect North Star for him, give him something to do that would

make him feel useful. It would be something that he could point at and say: *I did this.* And then it would be ours. We pored over tile samples and wallpaper swatches, working to create our dream getaway.

At first, he was flying from New York to supervise the project. But then he started spending so much time in Miami, he ended up just renting another apartment in the same building. There seemed to be an endless string of problems—which wasn't uncommon for a renovation, but I had heard through a mutual friend that some of the people he was hanging out with down there were shady. And it looked as though each time I saw him, he'd gotten a little bit skinnier.

———

Georges and I had never had a conversation where we had strictly outlined the terms of our relationship, but it was understood that he was not to hurt my feelings, nor was I to hurt his. Neither of us would ever have done anything to make the other feel uncomfortable when we were together, nor would we have attempted to police each other's behavior when we were apart. We were both men, after all. But I had a feeling, a felt sense, that Georges was doing things in Miami that I wouldn't like—illicit things with sketchy people. Yet I wasn't interested in knowing the lurid details, because I would have to face something I wasn't yet ready to see. It was easier to just keep my nose to the grindstone.

It didn't help that our lives were becoming increasingly separate: I had rented a place in Los Angeles—the guest house of a friend of a friend, up in Coldwater Canyon—where I stayed when I was auditioning or taking meetings. I believed that being in LA would help expand my brand, and besides, I liked

it. Because it is the entertainment capital of the world, people assume that LA is a social place, but in Los Angeles I found a pocket of solitude that I'd been seeking. In LA, I was alone in a car for much of the day, a mode that felt comfortable to me and, of course, familiar.

I began meeting with an acting coach, because I suspected that I wasn't able to get in touch with my emotions well enough to become a real actor. I had spent so much of my life shape-shifting for any given situation. Was it even possible for me to feel my raw emotions as the chameleon I'd become? I felt emotionally blocked in certain ways, and I was afraid that the blockage would come out on camera. "I'll help you as much as I can," my acting coach said, "but you might also like working with my therapist."

I went to see that therapist, whose name was Donna. The moment I walked into her office, I felt comfortable; I could tell that she was highly intelligent and capable. As we began talking, I knew that it was going to become an important relationship in my life.

Renetta was getting remarried in Las Vegas, so Georges and I had a plan to rent a house there and stay for a week. But when he arrived in Vegas from Miami, he was emaciated. He slept all day. He slept the whole trip. When we went back to LA, it still seemed like he was sleepwalking.

As I drove him to the airport to fly back to Miami, we began arguing in the car. He was so angry, and I didn't understand why. We were coming down La Cienega through Baldwin Hills, approaching the oil fields, almost to the airport, when the argument reached a breaking point.

"Let me out," he said.

"What?" I exclaimed.

"Just stop the car right here," he said. "Let me out." I convinced him to let me take him the rest of the way so he didn't end up standing on the curb. But he was distant, agitated, and weird.

I was planning to come see the progress on the apartment in Miami a few weeks later, but I wasn't sure how much more tension I could stand with him. I felt seasick the whole flight there, thinking about the water in Miami—those undulating tides, like the great ocean of the subconscious, and all the secrets buried there. When I arrived, Georges looked gaunt—not skinny, like the boy he'd been at twenty-one, but sickly. I had barely dropped my bags when he looked me dead in the eye. "I have something I need to tell you," he said. "I am addicted to crystal meth."

In that moment, everything came crashing down. But in the same breath, it all came together.

I knew what this meant. Crystal meth meant anonymous sex. It meant high-risk behavior. It meant brain damage. It meant an extraordinarily high degree of danger.

I called my therapist. "What should I do?" I asked her.

"Get him into rehab," she said. "Immediately."

I took Georges to Jefferson Memorial Hospital. We parked outside and walked to a grassy area, and I pulled out a joint. "This is going to be our last one," I said. We lit it and smoked it together.

As he was checking in, I suddenly realized that he wasn't even lucid. "I want my own room," he said to the woman doing his intake paperwork. "I need my own room."

"That's fine," she said. "But if you are suicidal, we cannot give you your own room. So I'm just saying that up front. Are you suicidal?"

"Yes!" he said.

I looked at him in amazement. *She just told you that she can't give you what you want if you tell her that!* He was in serious trouble—more serious than I had even realized.

After I left, I went to go see a friend in Miami who was sober. "You did the right thing," he said. "There was no other choice for him. This is just what has to be done."

The next day, I went back to the hospital to visit him. A doctor met me in the lobby. "I can allow him off the premises to go to a twelve-step meeting if you want to take him," he said.

So we looked up the location of the nearest meeting, which was at the South Beach Clubhouse. Walking in, it looked like every bad movie about alcoholism I'd ever seen. Hollywood has so authentically replicated the look and feel of a twelve-step meeting, from church basements and random community center rec rooms down to the beige paint on the walls and the metal folding chairs stacked up. The room was so packed that some of us were standing. I stood close enough to the door that I could bolt at any moment if I felt the urge. I was there as a supportive partner only. This was for Georges, not me.

A woman then stood at the podium and began to speak. She was seventy-one years old, she said. She talked about her cocaine use and her life in the club scene, and how she felt invisible in her family, and how she never felt quite right for this world. Booze, she said, had been a way for her to maintain her sanity in a life that felt intolerable. She was a middle child, and her parents' relationship had been tumultuous. Everything she said rang true to my own story. *Is this some sort of hoax?* I thought. *Everything she is saying is mine.*

She was talking about her life, but she was telling my story. There was something under her words, a truth that she was

allowing to be revealed, that resonated with me in a way I could not describe. She knew me. She was me, and I was her. She gave voice to things I had always felt but had never heard articulated.

The awareness didn't take long. It came on strong and clear and loud, almost instantaneously. This was where I belonged. When you hear your story told through someone else's mouth, you know you've arrived at the right place.

This was where I belonged.

It felt like a fantastical trick had been played on me. Georges was the one in rehab. And yet I was also hitting rock bottom.

I had walked right into the house of hidden meanings.

I took a seat.

———

There had been clues. There are always clues. I had been stoned every day I could since I was ten years old. After cleaning up my act the year after I was crowned Queen of Manhattan, the partying had crept back in, little by little. I had started getting high again here and there. As I'd become famous, there was always a bottle of champagne backstage, and then as my workload increased, I had been smoking more and more weed, until I was smoking first thing in the morning.

There was the time I had been in Monte Carlo on my way to meet Elton John, and I was looking through my bags and found weed stuffed into a container. I had been flying commercial, and if customs had found it, I would have been arrested. There was the time I was going up to Vancouver to shoot a movie, and at the Canadian border, they searched my bag and found a bottle with little half-smoked roaches, something that I'd completely

forgotten was in there, and a bag with remnants of cocaine. An officer there pulled me aside. "Look," he said. "We know who you are. And we're going to let you go. But you'd better be careful."

And that year, the same year that Georges was hitting rock bottom in Miami, I'd been buying coke from the sleaziest dealer in New York—a guy who later sold footage of celebrities high on heroin to the tabloids—and snorting it all by myself.

I was doing my nightclub act, promoting my products, and shooting movies. I was exhausted all the time. And the only way I knew how to feel connected to the little part of me that was still left was to get high. Hadn't I always known that this day would come—that I would have to admit to myself that I was an addict, too? Even my therapist, in our third session, had said: "You know, when you come in here stoned, I'm only getting about sixty percent of your full capacity."

Or maybe I couldn't see myself because I was also unaware of the depth of Georges's addiction. As soon as he told me the truth, I realized that I had been in deep denial. I had allowed myself to miss every one of those clues. It forced me to ask: *Why?* It had to be because I was too afraid to face the fact that I wasn't connected to myself, either—that I was never fully present in my life. I had used Georges as my conduit to life, to my success, to joy. I had since we'd first met, since he lifted me off my feet on that dancefloor at the Limelight, to his enormous, goofy grin when he'd crawled through the cockpit of that private plane. He was my lens to the world—eyes that allowed me to see how wonderful my life had become.

If he was in this much trouble, what did that say about me?

————

Georges and I continued going to meetings together while he was in treatment. But I still felt disconnected from him. He was angry with me, and I didn't understand why. Now I see that he was angry about being made to play small, to stand in my shadow. Crystal meth lifts you up so high when it's working, and then once you come down, in the wake of all that surging dopamine, all you can feel is what a piece of shit you are. He'd been so young when we met; he'd had such promise in his life as a designer, an artist, and a creative person. And he had given all that up to carry my purse. How could he forgive me? How could we forgive each other?

I flew back to Los Angeles before he left rehab. When I called him, he told me to look in all the places in the house he'd hidden crystal meth. It was stashed everywhere—in practically every room. He asked me to flush it all, and so I did.

When he was finished with treatment, I wanted him to come out to Los Angeles. But he was resistant.

"I think I need to stay here and continue my sobriety," he said.

"I don't think that's such a good idea, Georges," I said. "Why would you want to stay in the belly of the beast?" There was silence on the other end of the line. "We have to salvage this," I said. "We have to find a way to save what we have."

"I just think this is where I need to be," he said.

"Then we need to split up," I said. "And we need to start unraveling what we've built."

Silence again.

"Okay."

———

I went back to Miami after we'd broken up to see what still needed to be done to the apartment. Everything was shoddy. I would flip a light switch, and the lights would come on in another room. The hot-and-cold water taps were reversed. A wall had been lined with mirrors to reflect the view of the ocean. On that wall, a mirrored outlet plate had been screwed on too tight, cracking the glass. I caught a glimpse of my reflection. I couldn't look away anymore.

I sighed. It looked like everybody working on the apartment had been on meth—not just Georges.

The contractor was never coming back. And neither was my old life.

Now I was fully submerged.

"I had to be

motivated by joy.

By colors, music, laughter,

# Home

dancing, and creativity—

all the things that made

life worth living."

The sound of the freeway had always made me feel peaceful. You could hear the rush of traffic from the house I'd grown up in on Hal Street, and I'd found it comforting as a little boy, the idea that people were always in motion, always traveling toward their next destination. I loved the sound of it there, soothing as a lullaby. So when I saw the house in Lake Hollywood in Los Angeles close enough to the 101 that you could hear it, gentle as white noise, I knew it was the place for me.

Georges was actually the one who found that house, the spring before everything fell apart. But Georges wasn't coming with me into my new life, which was different from the old one in so many ways. It wasn't just that I was sober for the first time since I'd been a child. Everything had changed.

My ambition, which had motivated me my entire life, now had to take a back seat. The new focus was on healing myself. I stepped into therapy in a way that I never had before. I went to a twelve-step meeting every day, sometimes twice a day. In those rooms I heard my story told again and again, just as I had at that first meeting in Miami. It sounded different every time in someone else's retelling, populated with the details of their own life, but the emotional truth was always the same. People spoke about feeling disconnected and alone, needing to numb the discomfort of being in their own skin, and then eventually having to face themselves in the cold light of sobriety. I never tired of hearing those stories—it was extraordinary to me that so many people could be speaking the same truth, one that rang so true to me.

I had been living out of a suitcase for so long, perpetually in motion. Now, I knew, I needed to sit still. What would it be like, I wondered, to have a home life? To really get to know my nieces and nephews? To revisit where I'd come from?

It was curious to be in Southern California again—to smell the air and witness the way the light hit the trees and the buildings, all of which brought me back to my own childhood, allowing me to revisit those years. To return to the scene of the crime, to unfold all the things that I had tucked away in my consciousness, and to come back to the house of hidden meanings once more.

In this house, I would clear out the cobwebs. I would expose what needed to be revealed.

In therapy with Donna, I came to understand that the house I had grown up in was a frightening place. I would never have invited anyone into that house, because I could not subject someone from the outside to what we dealt with in my mother's world of darkness. We were so ashamed of it. In being sober, I got to create my own house for the first time. And what I wanted to do now was open up my doors.

So I would order seventy-five pieces of chicken from Roscoe's and have a smorgasbord, with a stripper pole out by the pool, a stage, a box of old high heels, and a stack of old wigs. Friends would come over and lip-sync Britney Spears songs in the backyard. I'd throw game nights, barbecues, and theme parties—like my New Jersey–themed party, where everyone was required to speak in a thick Jersey accent. Once I hosted a Night of a Thousand Chers, where everywhere you turned there was a different Cher—Desert Storm Cher! Cowboy Cher! You name it—we had *that* Cher! And incredibly, we did all of this sober. The house filled with laughter from new friends who I'd met in twelve-step meetings and my sisters with their families. The sight of Renetta arriving at my Sunday afternoon hip-hop party dressed like Lil' Kim in a lime-green catsuit made me happy beyond words. My sisters became a key part of how I reclaimed that sense of home now, all these years after leaving it. I knew it was cathartic for

them, too, that we were together again celebrating life in a way we never could in the house on Hal Street.

I understood that my dissociative self was born the day my mother tried to set fire to my father's car, and from the moment I had started using drugs, I had been chasing that dissociative state—trying not to be fully present in my body, trying to separate myself from the pain and trauma that lurked in the shadows. I had anesthetized myself for almost thirty years. Sober, it was safe for me to be back in my body for the first time. Now I could change my relationship to home. I had to experience the way it felt not to be ashamed of what was happening in my house—of the crime scene, the open garage door, and the whole neighborhood gathered around watching it all play out.

To open up my house was the opposite of how I had always felt inside, which was that I didn't want anyone to see. And it was part of how I began to build a trusting relationship with the child within me that I had left behind because I found his woundedness so intolerable and so embarrassing. The best therapy I could imagine was to throw him a party every night of the week—to pick him up off that porch and take him for a ride, to go bowling or line dancing or eat baby back ribs or see strippers at a terrible male strip club in Reseda called Bananas on Wednesdays or just have all of my friends come gather around in my backyard, talking until late at night over the soft rush of the freeway.

What happened in my house needed to be fun and light and free. It needed to be something of which I could be proud. And it wasn't like watching it on a television. It wasn't like being on a television, either. It was just for me.

———

The breakup had devastated me, the same way that I knew my mother's had devastated her. She had clocked it when I was a little boy: "Ru, you're too goddamn sensitive, and you reminisce too much." Now that warning took on a deeper meaning, because she had been right. When you are so sensitive, a breakup like that will floor you—it will bring you to your knees. To have opened myself to someone so much was like a merging: He became me, and I became him. When I went to see Bea Arthur's one-woman show in San Francisco, I was given two tickets, but I went alone. All through the show, I looked at the empty chair, thinking, *This is Georges's seat*. I missed him all the time.

And yet, even though we were no longer together, Georges and I still talked every day. I understood that he was growing up, too. He had been kept in a kind of perpetual adolescence by me, and now he was free to live his own life in Miami, to build his own recovery without me, to paint and make his own money working as a bartender and date other people, which we both were doing, and figure out who he wanted to become. He would come out to visit, and we would go roller-skating at the Moonlight Rollerway, or drive up to San Francisco and ride bikes across the Golden Gate Bridge.

Sometimes we talked about getting back together. But I felt, for the first time, that I wasn't sure what I wanted anymore, and that was all right. For so long I had been motivated by one destiny—fame. But now that I had gotten it, what else was there?

My whole life, I had always been special. In twelve-step meetings, they called this a condition of terminal uniqueness—this sense of being so different from everyone that it felt like a death sentence. But what I wanted now wasn't to be singular, unique, the guy who always stuck out, taller than everyone else, with a name that not another motherfucker alive could carry.

Because the more I spent time with friends and in meetings and out in the world, the more I was learning that I wasn't so different after all. I had always known that, on some level—that there was only one of us here, that everything was connected. The ego, that sense of separateness, of self-importance, of self-seriousness, serves only to alienate and divide. But I, too, had fallen into that trap.

The work now, for me, was just to be a part of the whole.

"I might be done with show business," I said to Georges once.

"No, you're not," he said.

"I really think I am," I said. "Everything I set out to prove, I've proven. What else is there for me to do?"

The thing that had propelled me forward in my career for so long, I knew, was wanting my father's approval. But that spell had been broken. I couldn't allow myself to be propelled forward by that anymore. If I came back to show business, it had to be for a different reason. What I had learned in my time away was that I couldn't be motivated by fear of not being enough.

I had to be motivated by joy. By colors, music, laughter, dancing, and creativity—all the things that made life worth living.

And the ability, as I'd learned when I was a little boy, to create magic from nothing.

———

I looked out at the freeway. So many drivers speeding along to their next somewhere.

How extraordinary to take it all in from up here—to see that the road was wide open.

I loved this house. I loved being in my body.

I was where I belonged.

# Epilogue

The sun is setting when I get back to my hotel in Atlanta with cardboard boxes stacked in the trunk of my rental car. I carry them into the lobby and pack them carefully, studying their faded adhesive labels, scrawled with the air date of the show and the names of the performers. My name is everywhere. I see it a hundred times as I line the cassettes up, then seal the boxes with packing tape.

There's over a decade of footage on these tapes, all the stupid and brilliant things I did when I was young—the costumes I wore, the choreography I improvised, the interviews I gave in the style of the star I was convinced I would become. I write my address in Los Angeles on the boxes and leave them with the concierge, trusting they will find their way back to me.

———

Up in my room, I pack my suitcase. As the sun starts to dip over the horizon, I look out the window at that building across the street, the building I saw them erect all those years ago when I was young and inexhaustible, back when everything was fresh.

Now it's all rubble, cinder blocks and dust. I think about all the people who passed through those walls, the memories they made, and how strange it will be for them to walk past one day and realize it's all been replaced. The shock of looking up and realizing that the world you thought you knew is no longer around. Or would they even notice? The streets of Atlanta used to be full of people who saw one another. Remember the days when Bunny and I paraded up and down these very streets with nowhere to be, past the pimps and hookers and club kids whose names we all knew, to symphonies of catcalls and jeers, disco playing on a distant radio? The whole city flowed in a kind of effortless choreography. Now everyone just looks at their phones as they go from place to place, sleepwalkers in a waking dream.

I look out at that building, out at that street, and I feel afraid. I know that change is a constant—I know, I know. But what if the world just keeps getting worse and worse? What if they tear me down like that building, after everything I've built, just to put up something new in my place? I don't want to be disassembled, forgotten, a relic of the past. The sorrow rises in me and becomes unbearable. The passage of time is inescapable—there is no stopping that train. I am homesick for an era that's gone, for a past that will never come back. The world is different now, and I don't know where I belong in it anymore. I feel old and tired and scared.

I don't know anyone here anymore. What if no one remembers my name?

---

But then, standing in this hotel room, I turn. I go back to the house of hidden meanings one more time. And I look for something different.

Because I know that underneath that fear is love.

Love for all the people I got to meet, the club kids who survived the scene with me. Love for my mother, whose voice I hear in my own each time I use one of her turns of phrase. Love for the men who broke my heart, all those ghosts of my father, and love for Georges, the man who restored my faith in love.

Love for this body that crashed on park benches and strangers' floors all those years, this body that did high kicks and twirls in grungy clubs all over the world; this body that I put through hell, then somehow found the grace to keep sober for nearly twenty-five years; this body that still carries me today.

Love for the little boy I was, waiting on that porch.

Love for whatever God is out there in the universe that gave me a life this rich.

———

I look out the window at the building being demolished, and it doesn't seem so serious anymore. After all, I learned a long time ago—nothing in life really is.

I laugh to myself. *It's just Mama's living room. They're all gonna love you.*

I zip up my suitcase.

I'm already home.

# Acknowledgments

This book would not be possible without the following people: Sam Lansky, Carrie Thornton, Cait Hoyt, Ben Dey, Jonathan Swaden, Robert Minzner, Jessica Boardman, Randy Barbato, Fenton Bailey, Tom Campbell, Thairin Smothers, Alicia Gargaro-Magaña, Rafael Bruno, Jay Marcus, and David Petruschin.

# About the Author

RuPaul Andre Charles is an actor, musician, television personality, and internationally beloved drag queen. He produces and hosts *RuPaul's Drag Race*, which has received twelve Primetime Emmy Awards, including six for Outstanding Host, and has been the inspiration for international versions in fifteen countries and several spinoffs, including the popular *Drag Race All Stars* and *Secret Celebrity Drag Race*. He also hosts the podcast *RuPaul: What's the Tee?* with Michelle Visage.